MADAME DE POMPADOUR
IMAGES OF A MISTRESS

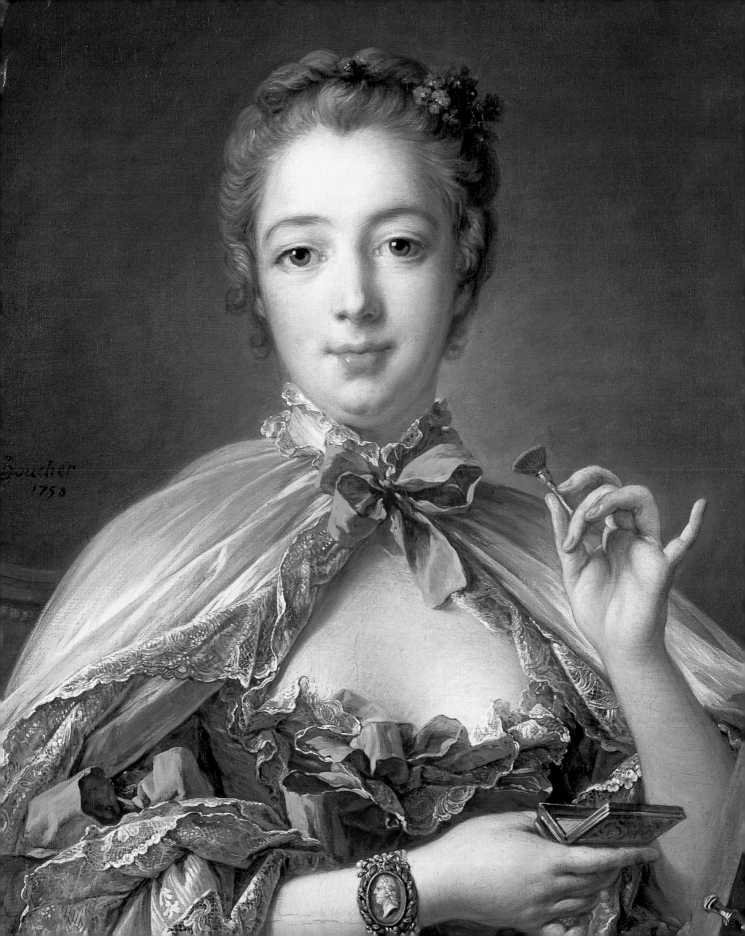

Madame DE POMPADOUR

IMAGES OF A MISTRESS

COLIN JONES

NATIONAL GALLERY COMPANY, LONDON
DISTRIBUTED BY YALE UNIVERSITY PRESS

This book was published to accompany an exhibition at the
National Gallery, London
16 October 2002 – 12 January 2003

Exhibition sponsored by ExxonMobil

First published in Great Britain in 2002 by
National Gallery Company Limited
St Vincent House, 30 Orange Street,
London WC2H 7HH

www.nationalgallery.co.uk

ISBN 1 85709 977 X Hardback 525257

ISBN 1 85709 992 3 Paperback 525294

British Library Cataloguing-in-Publication Data
A catalogue record is available from the British Library
Library of Congress Catalog Card Number 2001095564

Publisher Kate Bell
Editor Jane Ace
Designer Roger Davies
Picture Researcher Xenia Corcoran
Production Jane Hyne and Penny Gibbons

Printed and bound in Great Britain by Butler & Tanner Ltd

All measurements give height before width

COVER
François Boucher
Madame de Pompadour, 1756
Oil on canvas, 201 × 157 cm
© Collection of Bayerische Hypo- und Vereinsbank, Alte
Pinakothek, Bayerische Staatsgemäldesammlungen, Munich

PAGE 1
After Jacques-François-Joseph Saly
Hebe, before 1783
Marble, 100 × 30 × 20 cm
The Victoria and Albert Museum, London

PAGE 2
François Boucher
Madame de Pompadour at her Dressing Table (detail),
signed and dated (probably in the twentieth century)
'fBoucher/1758'
Oil on seven pieces of canvas, 81.2 × 64.9 cm
Bequest of Charles E. Dunlap, 1966
Courtesy of the Fogg Art Museum, Harvard University Art
Museums, Cambridge, MA

Contents

Sponsor's Foreword

Once again it is a delight to be involved with the National Gallery, one of the greatest art galleries in the world. Esso UK, now part of the ExxonMobil group of companies, began this special partnership back in 1988, and since then the Gallery has never failed to present us with exciting and fascinating exhibitions to sponsor.

This year it has surpassed itself by presenting a truly magnificent exhibition that transports us into the splendour of the eighteenth-century French court, throwing a spotlight on a period of extreme refinement and artistic richness and a woman of rare distinction. *Madame de Pompadour: Images of a Mistress* is an educational and inspiring exhibition that tells the remarkable story of her progression from Parisian bourgeoise to Grande Dame of the royal court through the work of the finest contemporary painters and craftsmen.

Our involvement with the National Gallery forms part of a wider ExxonMobil community investment programme through which we endeavour to support and enrich the lives of the communities in which we work. We hope that our sponsorship of this exhibition will enable many to discover the delights of Madame de Pompadour's commissions. It is our pleasure to play a part in exhibiting such an array of treasures.

Ansel Condray
Chairman
ExxonMobil International Limited

Sponsored by **ExxonMobil**

Director's Foreword

Drouais's portrait of Madame de Pompadour, painted in the last year of her life, has presided over the French eighteenth-century room at the National Gallery ever since its acquisition in 1977, commanding the same attention and admiration as the Marquise did in her lifetime. It has long been the Gallery's ambition to unite this painting with Boucher's magnificent full-length portrait of 1756 from Munich and other images of her, and so we are delighted to be able to collaborate with colleagues in Munich and Versailles on an exhibition devoted to Madame de Pompadour's patronage of the arts. The exhibition has inevitably taken a slightly different form in each place. The more restricted space available in the National Gallery necessitated a smaller selection of works, while the context of a picture gallery suggested a tighter focus on the image Madame de Pompadour projected of herself. For that reason, and because Madame de Pompadour is in greater need of introduction in this country, we asked the historian Colin Jones to write the present book. This not only provides a fascinating account of her life but also places the works of art with which she surrounded herself in the context of her struggle to hold her place at court.

We owe special thanks to our colleagues, in particular to Xavier Salmon in Versailles and Prince von Hohenzollern and Helge Siefert in Munich who co-curated the exhibition with Humphrey Wine, and to the exhibitions staff of the Réunion des musées nationaux who undertook its organisation. The list of those who have offered advice and information is too great for them to be named here, but we are nevertheless deeply appreciative of their contribution. We are grateful to the many lenders who have generously entrusted their works to us and made possible so many fascinating juxtapositions. Our thanks also go to Swarovski for their generous support of the display cases created for the exhibition. An ambitious undertaking of this kind would be impossible without major financial support and once again we are indebted to ExxonMobil. Through their continued sponsorship of our exhibitions, they help us to introduce paintings to an ever-wider audience. Thanks to them, we hope that the remarkable Madame de Pompadour will become better known and better understood in this country.

Charles Saumarez Smith
Director of the National Galley

Author's Acknowledgements

OPPOSITE
Detail of fig. 40

I am very happy to acknowledge debts I have incurred in writing this volume. The original idea behind it derived from conversations with Patricia Williams at the National Gallery Company and my agent Felicity Bryan, to each of whom I extend my thanks. At the National Gallery, Humphrey Wine provided shrewd advice throughout and Caroline Campbell carried out invaluable research. Dr Wine kindly directed my footsteps to Waddesdon Manor, where Rachel Akpabia was a most courteous and helpful guide to the institution's rich collection. Alden Gordon kindly supplied a pre-publication view of his and Teri Hensick's work on *Madame de Pompadour at her Dressing Table* (fig. 41) and offered helpful advice. Mark Bryant, Tom Crow, Jessica Kedward and Richard Wrigley helped with stray queries. David Bell, Gregory Brown, Neil MacGregor, Neil McWilliam, Erica Langmuir and Julian Swann kindly read and commented on the typescript, as did my wife, Josephine McDonagh. Warm thanks go to all of these, and also to the staff of and colleagues at the Columbia University Institute of Scholars, Reid Hall, Paris, where most of the writing was done and to which I was attached as Visiting Fellow while on sabbatical leave from Warwick University: particular thanks are due to the Institute's Director, Professor Danielle Haase-Dubosc, and to Michaela Bacou and Maneesha Lal for providing such a congenial and friendly intellectual atmosphere.

Colin Jones
September 2002

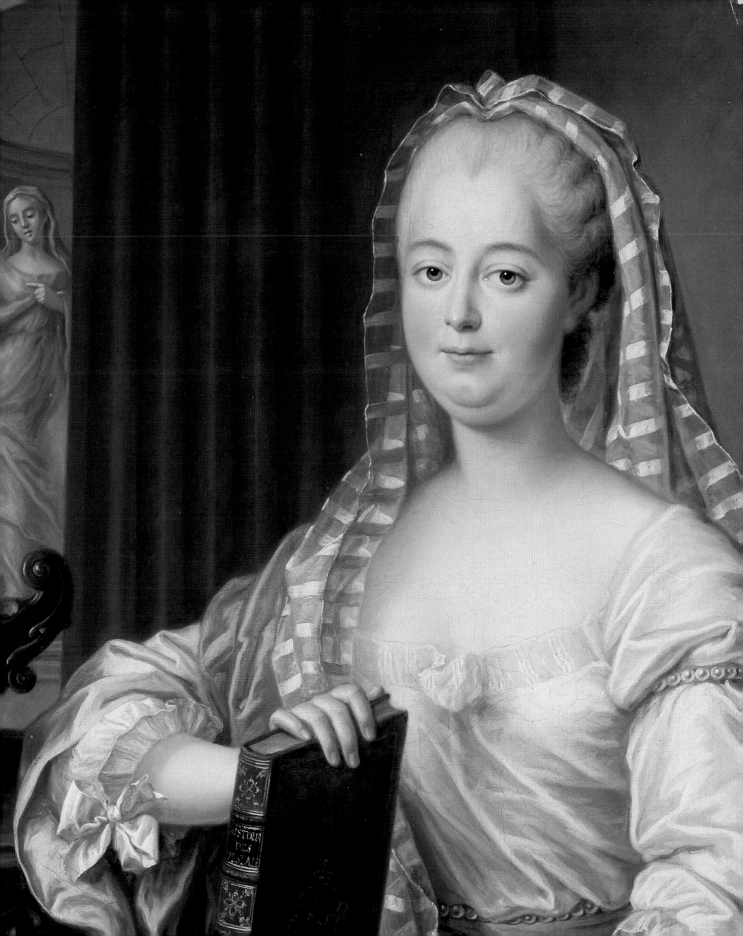

Introduction

The royal mistress's way of thinking is serious business in this country.[1]

It is unclear whether prince von Kaunitz, Austrian ambassador at the French court in the early 1750s, was most struck by the quasi-institutional status of royal mistress in France, by the fact that her views carried weight in the political world – or else by the extent of influence currently enjoyed by the incumbent of that position, Jeanne-Antoinette Poisson, marquise de Pompadour. Her lover – King Louis XV, who ruled from 1715 to 1774 – was hardly the first French ruler to have extra-marital relations: a venerable tradition stretched back to and included Clovis, the very first king of the Franks in the late fifth century. It was in the Renaissance courts of the sixteenth century that the position of royal mistress was given a measure of political recognition and stability. The duchesse d'Étampes (with Francis I), Diane de Poitiers (with Henry II) and Gabrielle d'Estrées (with Henry IV) all used that recognition to influence politics and, moreover, to promote their own and the monarchy's policies. Much the same was true of the mistresses of Louis XV's predecessor, Louis XIV, namely, Louise de La Vallière, Madame de Montespan and finally Madame de Maintenon (whom the king secretly married).

If there was nothing unusual about official royal mistresses playing a role in state business, most contemporaries regarded Madame de Pompadour as enjoying far more influence than her predecessors. From 1745 until 1764, when her early death ended her tenure, she extended her influence to all aspects of royal policy – court patronage, domestic and international affairs, as well as serving as unofficial minister of culture. Her achievements were all the more remarkable considering that after 1750 her sexual relationship with the king ceased. It was indeed unusual for a royal mistress to be distinguished by her chastity – though in fact the marquise continued to play a role in the king's sexual life through conniving in the secret supply of virginal *ingénues* for the royal pleasure.

OPPOSITE

Detail of fig. 96

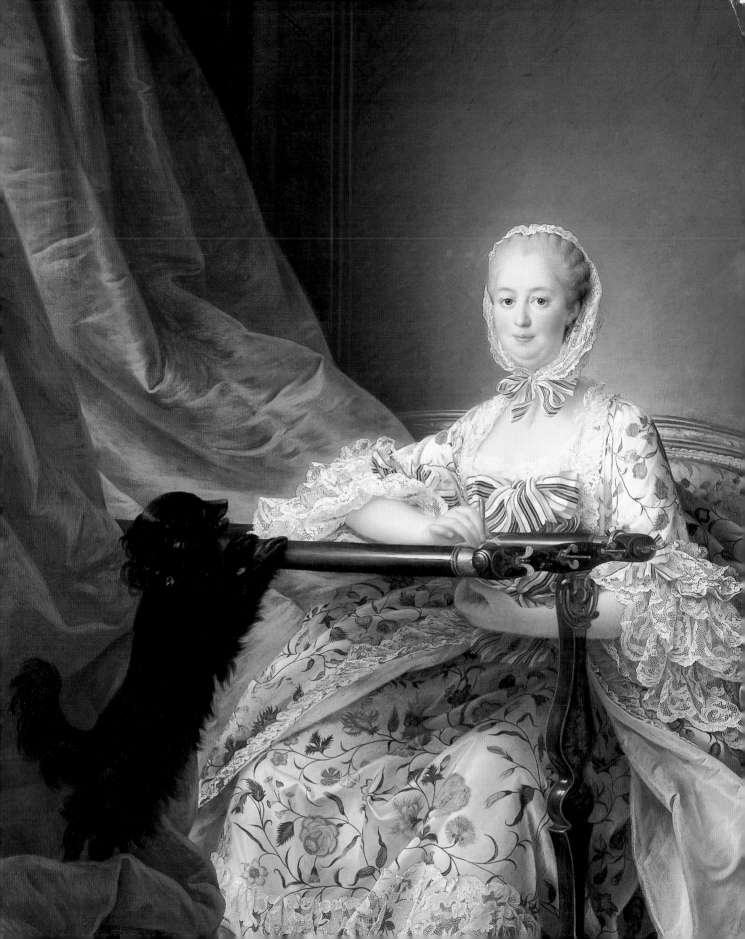

In the past royal mistresses had invariably been attacked for taking a role in state business. To some extent, such criticism could be helpful for the monarchy: mistresses acted as a lightning rod, diverting criticism away from the king. As one contemporary guide to court conduct put it, favourites of any kind could constitute 'a shield against hatred'.[2] Pompadour seems to have been unusual, however, not only in attracting an enormous volume of censure both during her own lifetime and for many years after her death, but also for associating Louis XV with (rather than protecting him from) the hail of attacks. In particular she was charged with diverting her royal lover from a dutiful preoccupation with the welfare of his subjects. She was in addition accused of introducing low, bourgeois behaviour to the court; of allowing the penetration of the state by materialistic and avaricious financiers; of 'feminising' court culture and turning the political elite away from virile pursuits; and of spending outrageously on personal extravagance, much of it in the ornate Rococo style which would be forever associated with her name.

The marquise de Pompadour was a far more nuanced personality and her influence much more complex than this charge sheet would suggest. As we shall see, this Parisian 'bourgeoise' reinvented herself as an aristocratic dame. A promoter of financial interests in state business, she was also successful in building bridges of support and alliance to many of the most ancient and prestigious families in France. Although accused of emasculating courtly life, she made a cult of servile fidelity to her royal lover. A devotee of private pleasures and the 'godmother of the Rococo'[3], she also ardently supported the state engaging in large-scale cultural projects, and was an early promoter of the Neoclassical style which from the mid century was replacing the Rococo as the height of good taste.

If Pompadour was – and continues to be – misunderstood, she partly had herself to blame. One of the most striking features of her two decades as royal mistress was the extent to which she promoted her own image (and to some degree that of the king too). Her image was a confection of propaganda and public relations – which echoed techniques at which Louis XIV had been a past master.[4] The image in question was her visual representation: the projection of Pompadour proceeded through the creation and diffusion of herself in painting, sculpture and other media. If it is consequently difficult to penetrate the dizzying cloud of images she produced, that was indeed part of the point. To separate 'image' from underlying 'reality' is purposeless, for the image of Pompadour was a crucial part of her substance, and she would not have achieved what she did without her skills in the arts of image management.

Elise Goodman's recent analysis of Pompadour's portraits spotlights one important sector of her image projection.[5] Innovative scholarship on the politics of eighteenth-century France over the last two decades also provides a context for re-evaluating the complex role of Pompadour and her images within the state.[6] What makes the study of those images, across the whole range of Pompadour's activities artistically interesting as well as historically pertinent is that she presided over a period which was, it has been argued, 'a moment of perfection in French art'.[7] The marquise was fortunate (and well-funded) enough to be able to draw on a pool of exceptionally gifted talent – her beloved Boucher, but also Nattier, Vanloo, Greuze, Chardin, Drouais, Oudry, Vien, Pigalle, Falconet, Bouchardon and others, including a whole host of masters of the minor decorative arts. What they made of Pompadour stands as testimony not only to what she and her contemporaries thought about her and her image, but also to what posterity has made of a royal mistress whose way of thinking was indeed, as Kaunitz reminds us, 'very serious business'.

1 The Making of a Royal Mistress

From the very start of her adult life, Jeanne-Antoinette Poisson – born in 1721 and from 1745 the marquise de Pompadour – exuded an easy, seductive charm that left its mark on the men who made her acquaintance (fig. 1). She was, as courtier Dufort de Cheverny (1731–1801) later recalled, 'a woman any man would have wanted as a mistress'. He went on: 'she had an oval face, very regular features, a magnificent complexion, quite superb hands and arms, eyes which were pretty if on the smallish side, yet which possessed a fieriness, an intelligence and a brilliance that I have never seen in any other woman.'[1] Though nostalgia doubtless lent enchantment to Dufort's view, this idyllic description is echoed in a sketch that Maurice-Quentin de La Tour (1704–1788) made of her in the mid 1750s (fig. 2). Even before she had met King Louis XV, she made a great impression on the wit and magistrate, President Hénault. He told the *salonnière* Madame du Deffand that he had met at the Opera 'one of the prettiest women I have ever seen', and he went on to rhapsodise on Jeanne-Antoinette's accomplishments: 'she understands music perfectly, sings with all the gaiety and good taste imaginable, knows by heart a hundred songs and takes part in plays [staged in her private residence].'[2] Austrian ambassador Kaunitz (1711–1794) was entranced too by her *air de nymphe*, while Louis XV, for his part, was in no doubt: his mistress was 'the most charming woman in France'.[3]

To adapt to, and subsequently to adapt, the role of royal mistress required much more than beauty and charm. Over two decades, until her death in 1764 at the early age of forty-two, Jeanne-Antoinette Poisson extended the range of the royal mistress to include the roles of royal lover, close friend, personal confidante, policy consultant, governmental aide, ministerial adviser (some even considered her as effective principal minister) as well as outstanding artistic patron and cultural impresario. In so doing, she redefined the status and power of the royal mistress, and made herself quite indispensable to the king. Hers was not entirely a solo performance – at every stage of her life, as we shall see, she had powerful male supporters and backers. Yet these alone would not have sufficed to account for her

achievements, which were highly personal. Her success involved the endless making and re-making of her own image, a process in which her early assets – seductive charm, pristine beauty – were always to the fore. When time eventually and inevitably took its toll on her attractiveness, her image was manipulated so as to hide the fact. From the beginning to the end of her reign as royal mistress, image was a crucial part of the substance of Pompadour.

With very few exceptions, power was a male preserve in the highly patriarchal society of eighteenth-century France. Women were conventionally and unthinkingly placed under the authority of men, and there were relatively few niches in which they could thrive – which made the achievement of the exceptions all the more impressive.[4] Jeanne-Antoinette had class as well as sex against her. Her social background was far lowlier than was the norm for those who had access to power – and this applied not only to the men within the customary charmed circle of social and political influence but also to the women who had achieved the position of royal mistress in the past. If Jeanne-Antoinette was not quite the plebeian nobody from nowhere that scurrilous court gossip often suggested, her background was bourgeois at best, and both unconventional and spotted with scandal. Whereas earlier royal mistresses had been drawn from amongst the aristocratic denizens of the royal court, her father, François Poisson (1684–1754), was the youngest of nine children of a weaver from Champagne. He made his fortune in the service of the four Pâris brothers, who had emerged from humble origins in the Vivarais in the last years of the reign of Louis XIV (r. 1643–1715) to become the core of an enduringly powerful financial dynasty. The eldest brother, Antoine Pâris (1668–1733), a towering force of nature nearly seven feet tall, had his portrait painted by Hyacinthe Rigaud (1659–1743) in a pose that highlights the commanding and unrestrained energy typical of the Pâris clan (fig. 3). Their activities ranged from provisioning the state's armies (in which Poisson specialised) to financial wheeling and dealing to provide credit for the state to fight wars. In 1718, when Poisson married Louise Madeleine de La Motte (1699–1745), witnesses to the marriage contract included the Pâris brothers, the duc d'Orléans (regent of France 1715–23, following Louis XIV's death), and a government minister. The new Madame Poisson's father, who supplied meat to the Paris Hôtel des Invalides, was also a Pâris client. Gossip had it that relations within the circle were more than financial. Poisson's work took him travelling a great deal, and Madame Poisson managed to fit in at least a dozen lovers, including Jean Pâris de Montmartel (1690–1766) the youngest of the Pâris brothers, a bishop, a minister, a *valet de chambre* of the king and, in particular, Charles-François Lenormant de

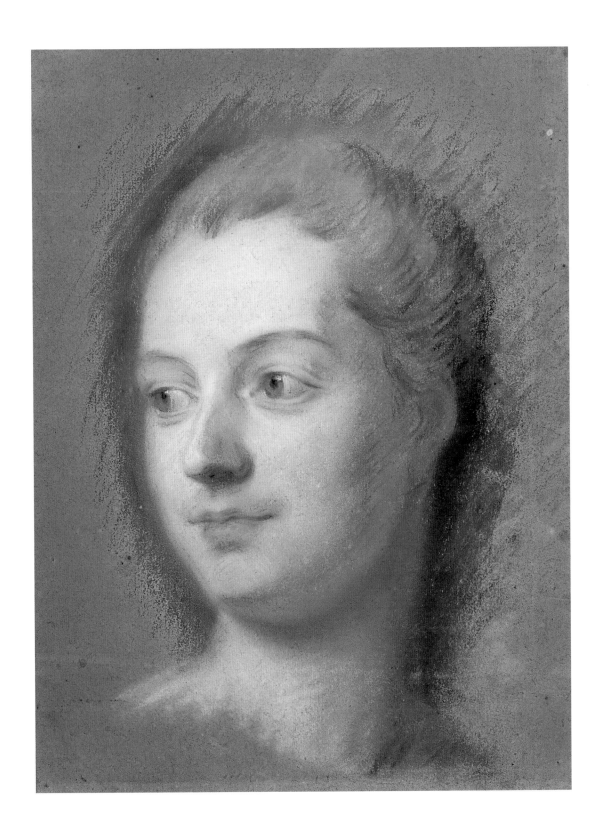

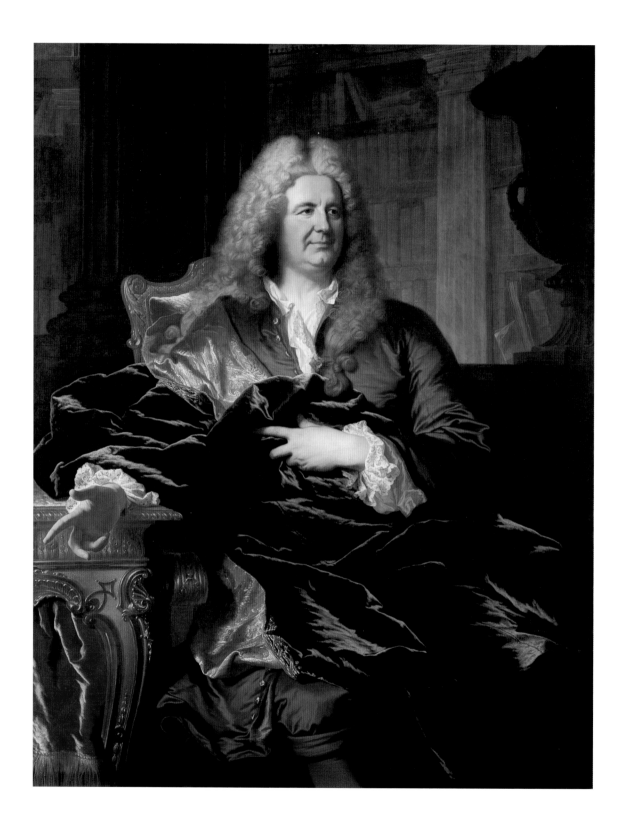

Tournehem (1684–1751), one of the high financiers known as *fermier-général*, who were responsible for collecting royal indirect taxes.

When Jeanne-Antoinette was born to Madame Poisson, on 29 December 1721, it was unclear who had fathered the child – Poisson, Tournehem or Pâris de Montmartel. Tournehem certainly took a caring and protective role towards the family when François Poisson was involved in a serious financial imbroglio in 1727. Poisson may have been merely assuming responsibility for misdemeanours by the Pâris clan, but the incident necessitated him leaving the country to avoid prosecution for fraud. Madame Poisson lived on in Paris in straitened circumstances with her son Abel-François (1727–1781) while Jeanne-Antoinette was placed as a boarder in the Ursuline convent at Poissy. The death of Madame Poisson's parents may have contributed towards the family's financial recovery after 1730, though her status as the wealthy Tournehem's lover also helped. Tournehem took an avuncular shine to Jeanne-Antoinette, who was withdrawn from the Ursulines and given a fashionable and expensive private education in Paris: the celebrated dramatist Crébillon *père* taught her elocution, the opera star Jélyotte singing, and the best ballet dancers deportment and dance.

Although Madame Poisson still found society doors closed to her as a result of her scandalous life (which her husband's return from prudent exile did nothing to amend), the young Jeanne-Antoinette, with the blessing of Tournehem, moved in the most cultured Parisian circles. She became an *habituée* of the literary salon of Madame de Tencin (1682–1749) on the fashionable rue Saint-Honoré. Here she met the cream of the Paris literary world – Fontenelle, Montesquieu, the abbé Prévost, Marivaux, Piron, Duclos, Helvétius – men who were early contributors to the Enlightenment, the wide-ranging philosophical movement aimed at social improvement and human betterment. Also present were interested courtiers such as the duc de Richelieu (1686–1788), government figures such as the hostess's brother (who would be made cardinal in 1739) and foreign visitors such as Chesterfield and Bolingbroke. Hospitality was also offered to artists, and Jeanne-Antoinette probably got to know the painters Boucher (with whom her name would subsequently be linked in the most fruitful of artistic collaborations),[5] La Tour, Nattier, and Drouais, as well as the engravers Cochin and Mariette. Madame Geoffrin (1699–1777), wife of a wealthy industrialist, attended these gatherings, and developed her own salon, which Jeanne-Antoinette also attended.

We gain some sense of the character of salon sociability in Charles-Gabriel Lemonnier's (1743–1824) painting of *Madame Geoffrin's Salon in 1755* (fig. 4). Under the

3
Hyacinthe Rigaud
Antoine Pâris, 1724
Oil on canvas, 144.7 × 110.5 cm
National Gallery, London

watchful eyes of the hostess and a statue of the author, the assembled great and good hear a reading from Voltaire's (1694–1778) tragedy *The Orphan from China*. It was in such a setting that Jeanne-Antoinette developed her performing talents. She had been a soloist at convent, and in the 1730s developed into an accomplished harpsichordist and singer. At a gathering hosted by the wife of war minister d'Angervilliers, she is said to have sung an aria from Lully's opera, *Armide*, so movingly that one of those present, Madame de Mailly (1710–1751), known to be King Louis XV's mistress, rushed forward to embrace her – a gesture of much retrospective irony.

Tournehem's sponsorship of Jeanne-Antoinette's cultural apprenticeship reshaped the identity of his protégée, making her a highly desirable marriage partner. She was already firm friends with the comtesse d'Estrades (1730–1789), wife of one of Tournehem's nephews, and on 9 March 1741 Jeanne-Antoinette married another of his nephews, Charles-Guillaume Lenormant d'Étiolles (1717–1799), whose wealth and status Tournehem had carefully nurtured and whom he had selected as his heir. This marked an important mutation in Jeanne-Antoinette's social position. Her husband's father and grandfather had both purchased nobility through the system of venal office-holding, and although this kind of nobility 'of the Robe' lacked the prestige of the ancient 'Sword' nobility, the new Madame d'Étiolles could henceforth claim noble status.

Jeanne-Antoinette gave birth to a son in December 1741, but the baby died shortly afterwards, followed in March 1744 by the birth of a daughter, Alexandrine (named after Madame de Tencin). As was customary for women of rank, she put the baby out to wet-nurse. In Paris, the Étiolles lived with Tournehem in his splendid *hôtel* on the rue Croix-des-Petits-Champs, but Jeanne-Antoinette also resided at the family château at Étiolles, north of Corbeil, around twenty miles from Paris. Tournehem encouraged her to develop a salon of her own there, which attracted figures she had met at Madame de Tencin's (Fontenelle, Crébillon, Montesquieu) as well as Voltaire, the most brilliant literary figure of the early Enlightenment, and the scientist and mathematician Maupertuis. Her patron also had a theatre built for her in the house, which was said to rival the Paris Opera in size. Here she developed her singing and acting in performances for her salon guests, who also included local noblemen.

Close to Étiolles were woods to which the king, a keen huntsman, would come each year in search of game. Women were allowed to follow the hunt on foot and it is likely that the king at least glimpsed the attractive local chatelaine in the early 1740s. Perhaps even then she had particular ambitions in mind. It was recorded of

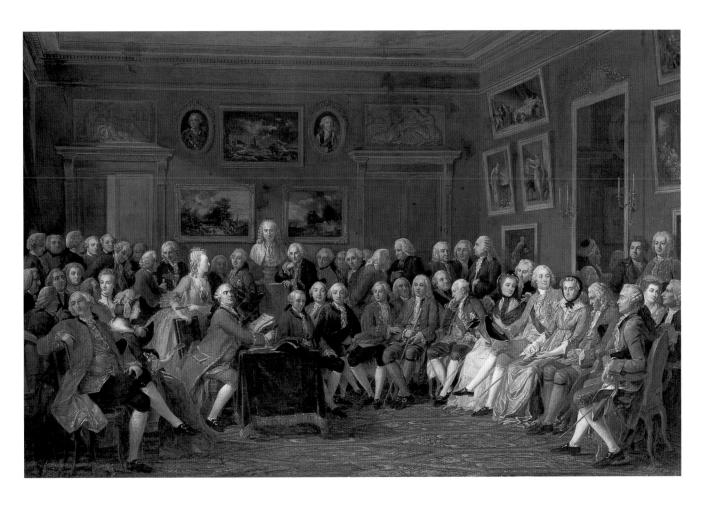

4
Charles-Gabriel Lemonnier
Madame Geoffrin's Salon in 1755,
1812
Oil on canvas, 58.1 × 77.7 cm
Châteaux de Malmaison et
Bois-Préau, Fontainebleau

Agnes Sorel, the mistress of King Charles VII (r. 1422–61), that 'an astrologer had predicted to her that she would be loved and served by one of the most valiant and courageous kings in Christendom'.[6] The story that much the same happened to Jeanne-Antoinette might be thought a mere literary topos – were it not for the fact that the list of her pensioners towards the end of her life included one 'Dame Lebon', who received six hundred livres 'for having predicted to [Jeanne-Antoinette], at the age of nine, that one day she would be the mistress of Louis XV'.[7] Even at convent Jeanne-Antoinette had been known as *'Reinette'* ('Queeny'), a name that stuck. If this gave her aspirations of a sort, it may also have stirred the minds of those around her. Tournehem was reputed to have claimed that, even though she was married to his nephew, she was still *'un morceau du Roi'* ('king's game').[8] Backers such as this were invaluable in any campaign to get the king to make a woman his mistress. The duc

de Richelieu, notorious roué and political intriguer, had been responsible in the early 1740s for putting one mistress into the king's arms. That mistress was, Richelieu noted, 'not only a woman, she was a party; she went to her first meeting with the king accompanied by a group of clients for whom love's signal was also the signal for their own credit'.[9] The Tournehem-d'Étiolles faction was certainly not the only group with such aspirations, nor was Jeanne-Antoinette the only candidate for the king's favours.

All agreed that the king needed a cheerful diversion. Despite a veneer of affability and court-bred grace, Louis XV was a highly melancholic soul. Throughout his life those who came into contact with him remarked on his morbid temperament. His gloomy concern with mortality and suffering was evident in his conversational gambits that were composed, according to the duc de Choiseul (1719–1785), of 'burials, sicknesses, deaths and surgical operations'.[10] Louis's early life had been more an affair of funerals than weddings. A collective portrait of Louis XIV and his heirs shows the young Louis XV, still in leading strings and dress, being watched over by his nurse, the duchesse de Ventadour (1656–1744), in the company of his great-grandfather Louis XIV, his grandfather the 'Great Dauphin', and his father the duc de Bourgogne (fig. 5). The young Louis XV was not even in knee-breeches before all the adult males in the picture were dead. His grandfather died of smallpox in April 1711, followed in rapid succession by his father, mother, uncle and elder brother. 'Maman' ('Mummy') Ventadour kept the doctors away from the young heir, who at five years old succeeded as ruler on the death of his great-grandfather Louis XIV in August 1715. There was little respite from arbitrary mortality: the king's uncle, the duc d'Orléans, who served as regent from 1715 to 1723, died of a heart attack before the king was out of his teens, and his principal minister, the cardinal Dubois, expired under the surgeon's knife around the same time.

These sombre experiences imparted to the young king a pessimistic outlook, a sense of isolation mixed up with hurt disappointment in those he loved and an overriding despair at the ephemerality of human happiness. A lofty disdain for others disguised a profound sense of inadequacy and shyness. He was, one court chronicler penetratingly asserted, 'an isolated being in the midst of a crowd, for whom the crowd has no meaning'.[11] The individuals with whom he got on best were those who appeared most indestructible – notably the hale and hearty duchesse de Ventadour and his childhood tutor, cardinal André-Hercule de Fleury (1653–1742), whom in 1726 he promoted to a post of ministerial primacy (fig. 6). The seventy-three-year-old cleric continued in this position until his death on the eve of his

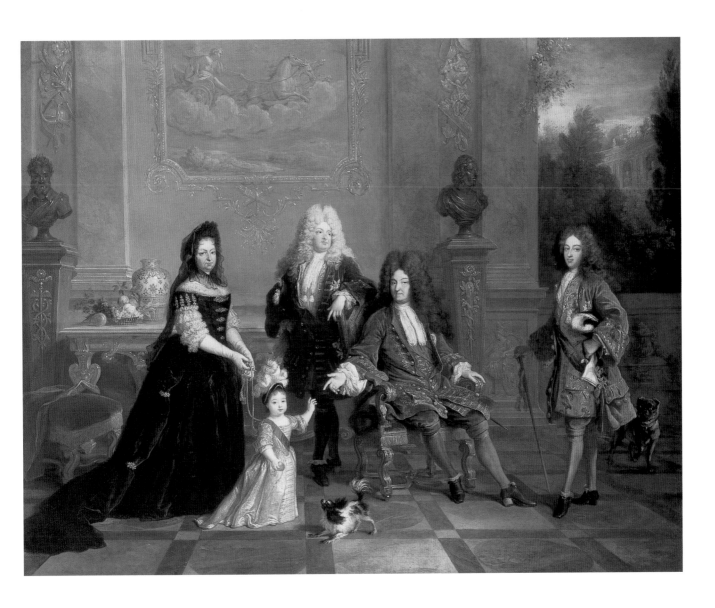

5

French, about 1715–20

Madame de Ventadour with Portraits of Louis XIV and his Heirs

Oil on canvas, 128 × 161 cm

The Wallace Collection, London

ninetieth birthday in 1743.[12] 'Once I love', Louis once confided, 'I love well' (and, he might have added, long).[13]

Louis's dutifulness towards his kingly role was undercut by a sense of his own inadequacy compared to his predecessor. Under Louis XIV's long reign, France had increased markedly in size as a result of royal conquests, becoming the strongest state in Europe. Propaganda on behalf of the 'Louis the Great' had always made much of the fact that the king of France was *Rex christianissimus* (Christendom's 'Most Christian King') and ruled by divine right. A symbol of the quasi-sacred role that French kings assumed was their allegedly miraculous power to cure individuals suffering from scrofula, or 'the King's Evil'.[14] The 'Royal Touch' was demonstrated on the scrofula-ridden hordes at all major ceremonial and liturgical functions. Louis XIV also established a palace at Versailles, creating a temple to his own glory as 'Sun King'. In this stunning architectural and artistic site, the ruler played out the rituals of his power. France's high aristocracy were transformed into obedient servants dancing attendance on their 'absolute' and quasi-divine master. The daily *lever* (rising) and *coucher* (setting) of the 'Sun King' were minutely choreographed ceremonies in which courtiers disputed the honour of holding the king's shirt or lifting the candle to light him to bed. He ate in public too, with visiting Parisians and tourists all agog.

On Louis XIV's death in 1715, the regent had moved the court to Paris, but Louis's decision in 1722 to move it back to Versailles showed an adolescent wish to emulate his great-grandfather, whose court rituals were to be conserved intact. Yet Louis's character proved resistant to the more public aspects of court life, in which even a visit to the privy became an occasion for discussion and display. Perhaps more than he had anticipated, Versailles was a haunted house in which spectres of 'Louis the Great' mingled with memories of the young king's dead loved ones. Consequently, while retaining the fossilised round of his great-grandfather's extremely public court rituals, he ordered private rooms to be constructed adjacent to the state apartments. From 1735, this location was developed into a suite of rooms known as the *Petits Appartements*, into which he retreated only with select friends and intimates. He also rotated his court among other royal palaces in the Paris region which were less bound by the official constraints of ceremonial ritual.

Louis's quest for privacy did not, however rule out his deep sense of duty, even as regards the most intimate details of his personal life. The choice of his marriage partner was a public rather than a private issue. This was all the more so, in that the absence of any direct Bourbon heir meant that the kingdom was only his own

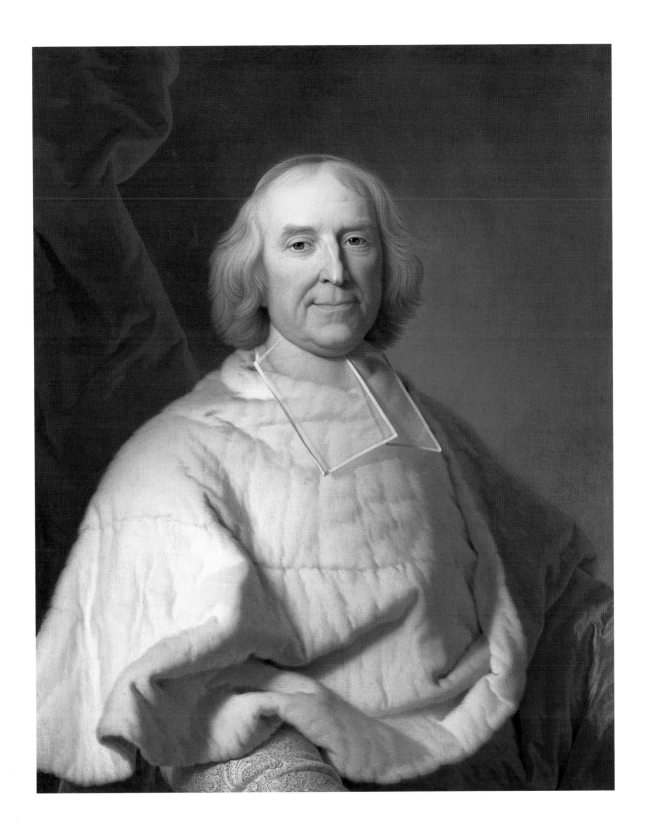

heartbeat away from a profound political and constitutional crisis.[15] Characteristically, he held back the tears and accepted without demur, when in March 1722 his uncle Orléans informed him that he would be betrothed to a three-year-old Spanish princess, who arrived ceremoniously in Paris clutching bejewelled dolls. That dynastic considerations overruled personal predilections was reiterated a few years later when Orléans's successor as principal minister, the duc de Bourbon (1692–1740), unceremoniously sent the Spanish princess home and presented him with a new fiancée, in the homely form of Marie Leszczynska (1703–1768). To some eyes, Marie was not a true royal match: she was the daughter of Stanislas Leszczynski, who had ruled as elective king of Poland from 1704 to 1709 before being overthrown and spending the rest of his life wandering around Europe living on pensions provided by charitable fellow rulers. Stanislas fainted with joy when told that France required his daughter to be its new queen.

Married in September 1725, king and queen did their dynastic duty. Louis is alleged to have given his new partner 'seven proofs of love' on their first night together.[16] Marie gave birth to ten children between 1727 and 1737, including, in September 1729, a male heir. But despite appearances, marital relations between the royal partners soon cooled. Fleury's competence in government reduced the need for the king to become overly engaged with matters of state, and, with his marriage deteriorating, Louis threw himself into a bachelor's life of outdoor pursuits. He maintained three packs of hounds (Louis XIV had made do with one), and was an unflagging hunter who in a day's shoot could bag between 200 and 300 pieces of game. He accounted for no fewer than 3,000 stags during Fleury's ministerial stewardship.

In 1737, the royal court was astonished to learn that the king had extended his predatory instincts towards the opposite sex, and that since 1733 he had been conducting a sexual liaison with the comtesse de Mailly, the eldest of the five daughters of the marquis de Nesle. Only cardinal Fleury – who possibly connived in the relationship – and the queen knew of the affair. The *Petits Appartements* had successfully insulated aspects of the king's life from his court. The cardinal preferred the idea of a more established mistress to the passing sexual encounters, the *passades*, that the king's *valets de chambre* Bachelier and Le Bel had been arranging for their master. Furthermore, Fleury noted, Mailly was utterly devoted to the king, personally pleasant (indeed 'highly loveable', it was later recalled, when she 'had a glass in her hand'[17]) and completely uninterested in politics.

By the early 1740s, it had thus become clear that Louis had developed a strong personal need for private pleasures as well as public duties – and a taste for secrecy. Yet, as if to play into his inbred melancholia, his quest for sexual contentment met with obstacles. Mailly was rapidly sidelined when the king began a relationship with her sister, the marquise de Vintimille, in 1738.[18] In September 1741, Madame de Vintimille died giving birth to a baby that her husband renounced and which was widely believed to be the king's. The king had not, however, finished with the Nesle clan. His roving eye soon alighted on Vintimille's two younger sisters, the duchesse de Lauraguais and the prematurely widowed marquise de La Tournelle.

Around this time Jean-Marc Nattier (1685–1766), painted a portrait of the latter as 'Daybreak', holding a torch symbolising dawn and a jug dribbling watery dew (fig. 7). Nattier specialised in painting idealised portraits of the royal family and court as well as members of the plutocracy. His subdued palette, highlighting pearly greys, mild blues, greens and pinks, and his use of diluted mythological motifs were aimed to flatter his subjects. The mask of make-up worn by fashionable women – whitish face cream, with a line of rouge running from the side of the mouth to just under the eye – also contributed to a certain uniformity in these portraits.

La Tournelle (1717–1744) was, however, tougher and more individual than Nattier made her look, and took a good deal of royal wooing, the duc de Richelieu supplying her with advice on negotiating strategy.[19] She eventually surrendered to the king's entreaties, on the understanding that she would be officially recognised as *maîtresse en titre* (royal mistress), elevated to a lofty place in the court hierarchy as lady-in-waiting to the queen and receive a large personal allowance. She also demanded that her sister, the marquise de Mailly, be expelled from court. Her aristocratic family had few qualms about letting disregarded Mailly eke out a wretchedly poor existence until her untimely death. In 1743, La Tournelle was made duchesse de Châteauroux and given prized lodgings at Versailles just above the king's apartment.

Louis's taste for hunting and mistresses made a bad impression on Parisian opinion. The young abbé de Bernis (1715–1794) remarked that 'corrupt as they are the people want their kings to love their wives'. Royal mistresses, he added, had never in the past caused taxes to fall.[20] The king's serial predilection for the Nesle sisters was widely accounted reprehensible incest as well as adultery. Louis was, however, too complex a character to take his pleasures in his stride. He felt guilty about being unfaithful to his wife (though this did not make him act any more civilly towards her) and remorseful that he could not live up to the religious standards he regarded as part of his job. Although he was a regular attendee at mass, he stopped taking

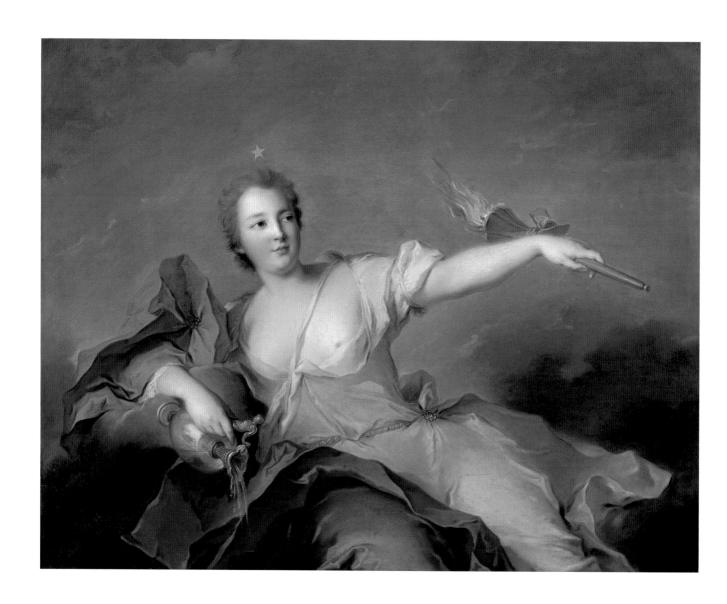

7
Jean-Marc Nattier
Marie-Anne de Mailly-Nesle,
about 1740–44
Oil on canvas, 81 × 101.2 cm
Musée National des Châteaux
de Versailles et de Trianon

communion, even at Easter, and from 1738 renounced the practice of touching for the King's Evil, on the grounds that God would not work miracles through an unabsolved vessel.

This spiritual guilt was endorsed in one of the key episodes in his reign, which had occurred in 1744, just before his first meeting with Jeanne-Antoinette.[21] The king had retrieved a good deal of popularity by going to the front to lead his army in the War of Austrian Succession (1741–8). Like Louis XIV, he took his mistress on campaign with him. When the royal entourage was passing through Metz, however, the king

fell violently sick, and seemed to be on the point of death. His chaplain, the archbishop of Soissons, urged him to mend his ways, to dismiss his mistress and to live within the bonds of matrimony. The prelate withheld the last rites until the king promised to do his bidding. This spiritual blackmail seemed to work: Louis despatched the 'concubines', Lauraguais and Châteauroux, and vowed to live a changed life if he survived his illness. On his recovery there was a public outpouring of affection for the monarch, who from this time was dubbed *le Bien-Aimé*. When 'the Well-Beloved' passed through Paris on his return from the front, celebrations in his honour were of unparalleled enthusiasm.

Yet Louis found it impossible to remain either spiritually or carnally continent. Now bereft of the seemingly indestructible Fleury, who had died in January 1743, and with the octogenarian duchesse de Ventadour also sickening to die (which she did in December 1744), Louis needily recalled Châteauroux, to much public displeasure – only to be faced with a further tragedy, as his mistress suddenly took ill and died in December 1744.

The court was now full of individuals seeking to find a new sexual partner for this complex, immature and dependent man, who was undoubtedly the most eligible adulterer in his kingdom (fig. 8). Richelieu was very much to the fore in this respect, with the Pâris brothers and Madame de Tencin also likely to be involved in the plotting. Much of the traffic passed through Le Bel (1696–1768), who had become the king's *premier valet de chambre* in 1744. He had facilitated the king's sexual encounters in the early 1730s, before Madame de Mailly became the royal mistress – and was alleged to have been a lover of Jeanne-Antoinette's mother. He seems now to have been aided by Binet, *valet de chambre* of the dauphin (Louis's son and heir), who happened to be related to Madame d'Étiolles. The story has it that the valets sang Jeanne-Antoinette's praises so sweetly to the king, that he agreed to extend her an invitation to the masked ball to be held at Versailles on 25 February 1745, in association with the marriage of the dauphin to the Spanish Infanta, Marie-Raphaëlle. With her husband conveniently on a business trip in southern France, Jeanne-Antoinette would attend alone.

The ball was held in the Great Gallery of the Versailles palace, and was the high point of a lavish round of festivities of a kind that had fallen out of favour under the austere financial stewardship of cardinal Fleury. A moment of surprise early in the evening saw the sudden appearance of eight men dressed as the ornamental yew trees from the palace gardens. One of the eight pieces of mobile topiary, shown in a superb engraving of the ball (fig. 9), contained the king. He is portrayed chatting to a

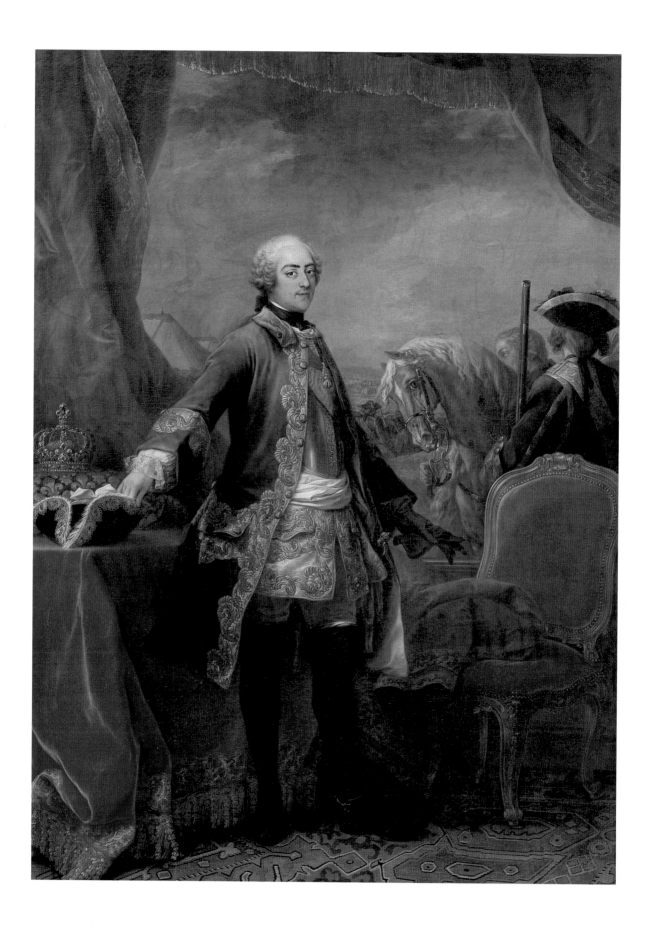

LEFT

8

Carle Vanloo

Louis XV, 1748

Oil on canvas, 277 × 183 cm

Musée National des Châteaux

de Versailles et de Trianon

OVERLEAF

9

Charles-Nicolas Cochin the

Elder after Charles-Nicolas

Cochin

Decoration for the Masked Ball

given by the King…on the

Occasion of the Marriage of Louis

Dauphin de France to María

Theresa Infanta of Spain, 1746

Etching and engraving,

45 × 75 cm

The British Museum, London

pretty young huntress to the right of the scene, while towards the left a shepherdess, widely believed to be Jeanne-Antoinette, encounters some Turkish drolls. By the end of the round of festivities some days later, no one was unaware of the fact that the king had a new mistress, and that the court world was witnessing – in the words of Danish envoy Count Bernsdorff, who had been present at the ball – 'the beginning of the adventures of Madame d'Étiolles'.[22]

Few courtiers expected the relationship to last. Falling as she did somewhere between the court-based Nesle sisters whose noble ancestry dated back to the eleventh century and the obscure women of Louis's *passades*, Jeanne-Antoinette had a problem of image and identity. 'Rumour has it', the Paris Police Lieutenant, Feydeau de Marville (1705–1787), smirked, 'that Madame d'Étiolles will not be long in place, and it is held that she is a silly little fool… She is not a baronne, a comtesse, or a marquise; she has taken home from the court only regrets for all the foolish things she has done.'[23] The joke, however, was on him. Within weeks of the February festivities, the king had placed Jeanne-Antoinette in the former apartments of Madame de Châteauroux and listened sympathetically to his new mistress's request for a formal separation from her husband – who was quite distressed by the whole business. In July – with the king away at the front leading his armies against the Austrians – she received the title of marquise de Pompadour, along with the estate in the Limousin of the same name which had belonged to the now extinct Pompadour line and which Pâris de Montmartel obligingly purchased for her (fig. 10). These were the makings of a position that, for the next two decades, the marquise de Pompadour would strive to make impregnable.

RIGHT

10

Charles-Nicolas Cochin and

Gabriel de Saint-Aubin

Design for an ex-libris with the

coat of arms of Madame de

Pompadour, 1745–55

Chalk, wash and ink on paper,

5.8 × 11.9 cm

Private collection

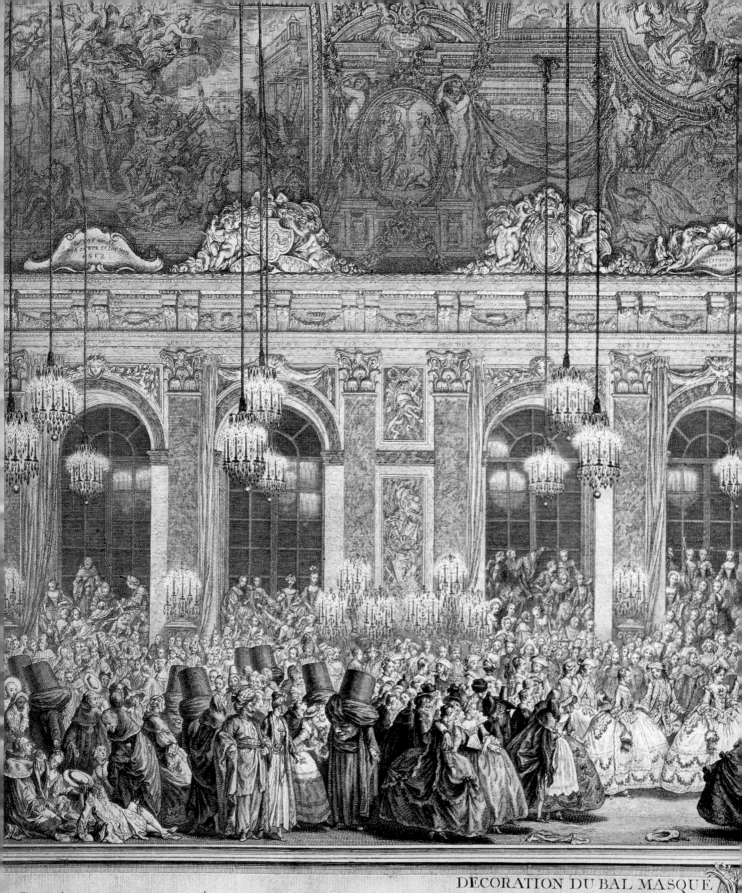

DECORATION DU BAL MASQUÉ
Dans la grande Gallerie du Château de Versailles, à l'occasion du Mariage de LOUIS DAUPHIN DE FRANCE
Cette Feste Ordonnée par M.Le Duc De Richelieu Pair de France en exercice de Premier Gentilhome de la Chambre DU ROY.

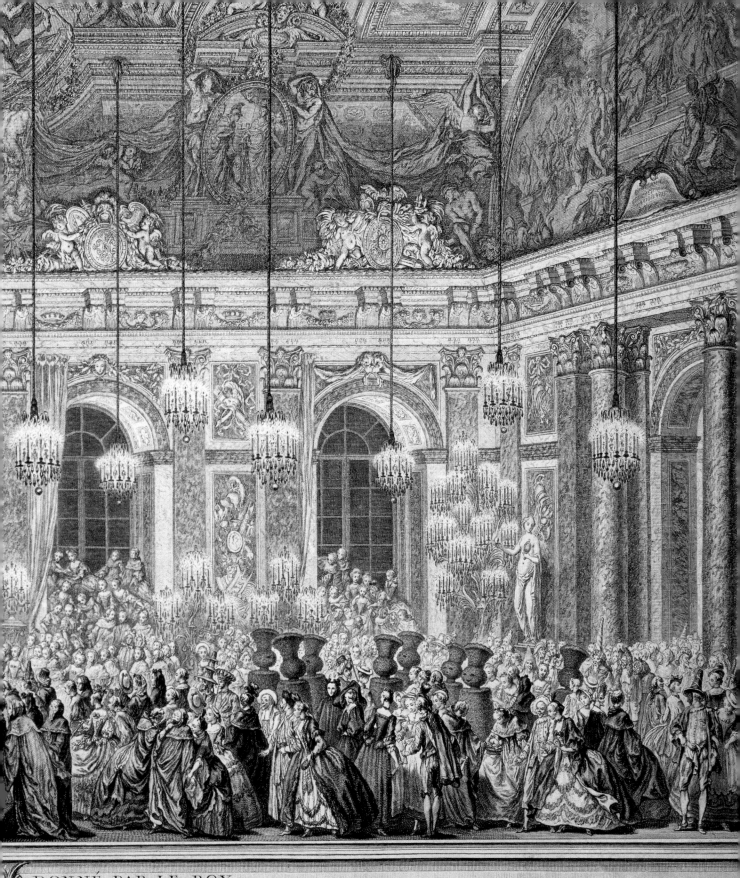

DONNÉ PAR LE ROY

AVEC MARIE THERESE INFANTE D'ESPAGNE, la nuit du XXV au XXVI Fevrier. M.D.CCXLV.
a été conduitte par M.DeBonneval Intendant et Controlleur general de l'Argenterie Menus Plaisirs et affaires dela Chambre de Sa Majesté

2

Discretion and Fidelity

Madame de Pompadour spent the summer and early autumn of 1745 away from her new lover, who was on military campaign in Flanders: the Metz experience of 1744 had made her accompanying him seem ill-advised. She lived in her château at Étiolles – which by now had been ruthlessly stripped of her husband's effects – receiving from the infatuated monarch almost daily missives, each sealed with a device marked with the words 'Discretion and Fidelity'.[1] Her dual tasks for the summer were to comprehend what was, and what might be, involved in being the king's official mistress, and to devise means of ensuring that her relationship with the king was more than a transient dalliance. Both objectives involved a thorough reconstruction of an image that was far removed from the courtly norm.

The notion of an official *maîtresse en titre* was not acknowledged in constitutional manuals, political handbooks, or guides to court etiquette and behaviour. The *Almanach royal*, for example, listed every imaginable court official and administrative flunkey – but did not refer to the royal mistress.[2] This omission was partly out of respect for the dignity of the queen, but also partly homage to the spiritual aspect of the Most Christian King. To acknowledge the ruler's extra-marital activities would suggest that his divine aura smacked more of Mount Olympus than Mount Calvary. Yet despite the official veil placed over the irregular sexual activity of successive rulers, the fact of that activity was an open secret. Historians still recalled the political role which Agnes Sorel, lover of Charles VII, had played in the final stages of the Hundred Years War against England, but it was really in the Renaissance court of Francis I (r. 1515–47) that the *maîtresse en titre* came to be accepted as part of the political furniture, with her own status and place within the court hierarchy. Francis's long-established mistress, Anne de Pisselieu, made duchesse d'Étampes in 1533, brooked any resentment from his queen, Eleanor of Austria, and served as governess to the royal children as well as interfering in appointments to ministries. Towards the end of Francis's reign she became embroiled in rivalries with the

OPPOSITE

Detail of fig. 26

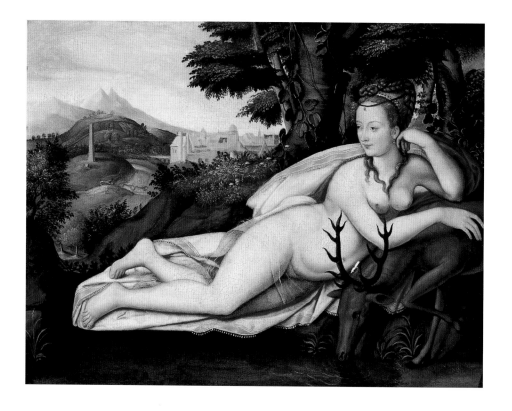

mistress of Francis's son and heir, the future Henry II (r. 1547–59) – such that on Francis's death in 1547 the cry went up, 'The king is dead! Long live the new mistress!' That new mistress, Diane de Poitiers, was twenty years Henry's senior, but played the beauty card with great adroitness, exploiting the skills of artists to idealise and indeed to mythologise her own and her consort's power (fig. 11). The first ruler of the Bourbon line, Henry IV (r. 1589–1610) has been documented as having had fifty-six mistresses – the actual number was in fact far greater – but he made Gabrielle d'Estrées his official consort, expecting his ministers to accept without reservation d'Estrées's involvement in political, constitutional and ceremonial affairs (fig. 12).

The reign of Louis XIV gave a new twist to the royal mistress's tale. The three women who held the position consecutively – Louise de La Vallière, Madame de Montespan and Madame de Maintenon – had divergent characters and each made something different of the role. La Vallière, it seemed, dreamt only of 'being loved by the king and loving him'³ and presented a picture of somewhat vacuous amiability. Her successor in the royal favour, Madame de Montespan, was an altogether more accomplished and forceful character. Both patron and practitioner of the arts, she supported Molière, Racine, Corneille and La Fontaine, and also acted, sang, danced

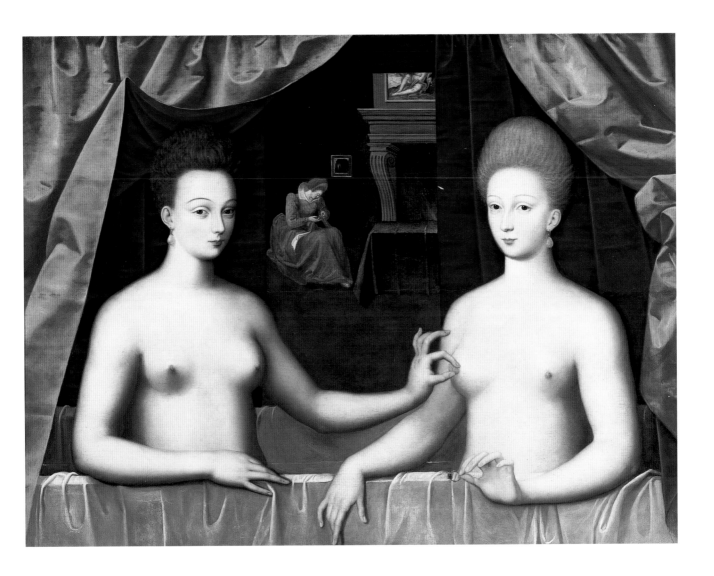

12

French, 1595

Gabrielle d'Estrées and her Sister bathing

Oil on wood, 96 × 125 cm

The Rothschild Collection, Musée du Louvre, Paris

and produced and directed operas and ballets, besides showing a keen interest in architecture, gardens and interior design. An anonymous engraving (fig. 13) shows her reclining pensively on a daybed, while cherubs theatrically part curtains to reveal the magnificent *grande galerie* of the château at Clagny for which she commandeered the services of the king's *premier architecte* Jules Hardouin-Mansart and renowned garden designer André Le Nôtre.[4] Madame de Maintenon was Louis's last mistress, and indeed he contracted a morganatic marriage with her, probably in 1684 (fig. 14). She led Louis towards a somewhat prudish piety: under her influence, for example, many of the statues in the gardens at Versailles acquired strategically-

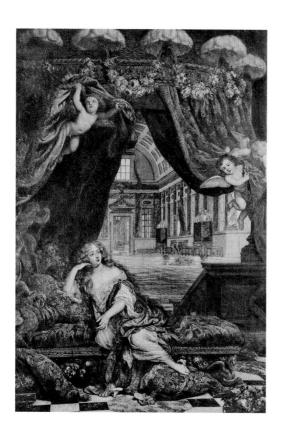 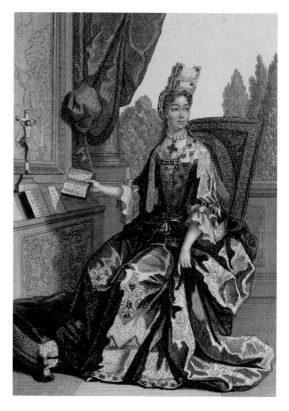

placed fig leaves. Yet, widow of the burlesque poet Paul Scarron, Maintenon was a witty and clever woman who extended her patronage to writers and artists. She was also more powerful than Louis's other mistresses and sat quietly embroidering in the corner while Louis did his *travail* (business) with each of his ministers. Her closeness to the king and the fact that she was believed to influence his political decision-making won her respect – but also much unpopularity.

Quite how much Pompadour appreciated the tradition of royal mistresses in the summer of 1745 is unclear. Unlike Pompadour, other official mistresses (rather than passing lovers) had previously been drawn from the existing entourage of the royal court or the high nobility.[5] What is certain however, is that she was very keen to learn the etiquette and ritual of court – and to avoid the fate which had overtaken the poor marquise de Mailly.[6] Whatever her background, a discarded royal mistress had a very long way to fall. Amongst her accomplishments, Pompadour was already very widely read: Voltaire said that 'she ha[d] read more at her age than any old lady at [Versailles]'.[7] She now had extracts made from the memoirs on Louis XIV's court by Saint-Simon and Dangeau, and worked her way through Hénault's history of France. Later, she

would be one of the keenest subscribers to a multi-volumed edition of Madame de Maintenon's letters. One of her summer readings, for it was in her library[8], may have been the *History of Louis XI*, which Charles Duclos (1704–1772) had published the previous year. Of royal mistress Agnes Sorel, Duclos noted: '[a] rare example among those who enjoy the same favour, she loved Charles [VII] solely for himself and never had any other aim in her conduct than the glory of her lover and the happiness of the state.'[9]

That emphasis on selflessness was echoed in other advice that Pompadour received at this time which urged her to dedicate herself to 'the greater glory of God and the happiness of honest folk'.[10] The advice-giver was the abbé de Bernis, who was summoned to visit Étiolles over the summer of 1745, along with Voltaire, so as to provide information and knowledge which would equip the new marquise for exposure to the court. Only too willing to play Henry Higgins to Pompadour's Eliza Doolittle, the two were also not loth to put forward the interests of their peers: 'I advised her', Bernis later recalled, 'to protect writers; it was they who gave Louis XIV the title of "the Great".'[11] Besides the instruction they provided on the history of the monarchy and affairs of state, there was also much to learn about the history of noble families and court faction. They also worked on Pompadour's oral and written expression. Voltaire, it was said, taught her 'how to write [letters]…and how to make appropriate replies'.[12] They sought too to correct her pronunciation and to dignify her turn of phrase. The Austrian ambassador, the prince de Kaunitz, observed at this time that Pompadour was 'full of false airs, [and] had an insufferable air of bad company about her'.[13] This had to be changed. Denizens of Versailles often referred to it as *'ce pays-ci'* ('another country'), which had its own mores, language and codes of comportment. Besides the complex Louis-Quatorzian rituals that framed their lives, courtiers also had a special and rather affected code for pronouncing certain words and names: it would simply not do, for example, to pronounce the name of the duc d'Estrées as anything other than 'd'Étrées'.[14] All this had to be learnt swiftly. Whereas the Nesle sisters were already established in court circles when they became the king's lovers, Pompadour had to start from scratch.

The deadline to which both Bernis and Voltaire were working in their civilising mission was mid September, when Pompadour would be officially presented at court – a long and gruelling ceremony of forced politeness in which all eyes would be scrutinising her for some mistake, error, or wrong note. In theory, only the most ancient nobility had the right to court presentation, although there were ways around this when the king so wished. The duc de Choiseul – who was far from being Pompadour's enemy – recalled the shock her presentation made in court circles: to bring in the wife of a financier

William Wynne Ryland after
François Boucher
*Cartouche with the coat of
arms of Madame de
Pompadour*, before 1759
Etching and engraving,
59.8 × 40.6 cm
The Rothschild Collection,
Musée du Louvre, Paris

OPPOSITE 16
Louis Tocqué
*Abel-François Poisson, Marquis de
Marigny*, 1755
Oil on canvas, 135 × 104 cm
Musée National des Châteaux
de Versailles et de Trianon

camouflaged as a person of high rank 'seemed monstrous…
indecent [and to] violate all rules of good conduct, justice and
protocol'.[15] The fact that Pompadour had not only acquired the
Pompadour property but had also adopted its family coat of
arms (three silver towers) was seen as an appallingly arriviste
error (figs. 10, 15). Family arms were particular to persons
rather than property, and were not regarded as transmissible
by sale. It was also thought scandalous that the king prevailed
over the aged princesse de Conti to act as official presenter of
the new mistress (in return for the favour, it was said, of the
crown paying off her sizeable gambling debts). The princess's
son, the prince de Conti (1717–1776) – Louis's cousin and a
prince of the Royal Blood – probably never forgave
Pompadour for this affront to his family escutcheon.[16] Despite
this outrage the new marquise passed her test with flying
colours. Moreover, the dignity of her low curtsies and her
adroit handling of her presentation to the queen were viewed
as particularly impressive.

To remain in place, now that she had been formally
inducted into the royal court, Pompadour would need to
retain the affection of the ruler. She would also need to fit in at court (a mission for
which Bernis and Voltaire had well prepared her) and alter the attitudes of those who
could bring her down.

Court resentment of Pompadour – both as a social upstart and a member of the
subordinate sex – was sharpened by the fact that she now enjoyed a position of
influence that could ensure that those who had backed her were well rewarded.
Tournehem was appointed *directeur des Bâtiments, Arts et Manufactures du Roi* which
involved the commissioning and management of artistic work at all the royal palaces
and supervision over state manufactories. It seemed odd for Tournehem to give up
the lucrative position of *fermier-général* (which he handed over to Pompadour's
husband to smooth the separation proceedings) for a post about which, as he freely
admitted, he knew next to nothing. Yet the direction of the *Bâtiments du Roi* gave him
control of a significant area of public life, and necessitated regular meetings with the
king – a favour enjoyed by very few individuals besides ministers and high court
officials. Pompadour's brother Abel – now known as Monsieur de Vandières – was
given the reversionary right to the post (fig. 16).[17] To intense court annoyance,

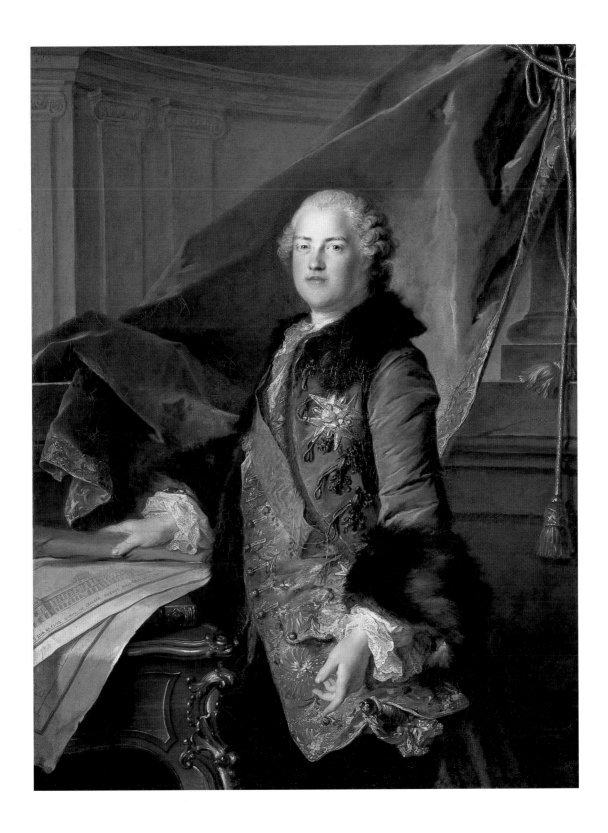

Vandières also took advantage of his appointment as *capitaine de la Garenne des Tuileries*, a largely honorific post involving protection of the royal forests, to become the king's hunting companion and commensal. Pompadour had thus helped both her uncle and her brother to have direct and unmediated access to the king. Although Pompadour nourished great plans for the future of her daughter, Alexandrine, she made sure that the child was kept out of sight at court, where her own appeal to the king was as a lover rather than a mother. François Guérin's (1711–1797) sketch of tranquil mother and daughter was probably less a reflection of reality – by her own admission, Pompadour was too busy to have much time to herself – than wishful thinking (fig. 17). From 1750, Alexandrine became a boarder at the convent of the Assumption in Paris, which provided schooling for the daughters of the best families in France.

A commission was established to investigate Pompadour's father's alleged misdemeanours in the 1720s and, to no surprise, François Poisson was fully exonerated. All his property was returned to him, he was indemnified against any losses and he was awarded letters of nobility, based on land that he bought at Marigny. Other family business was soon transacted. Tournehem's daughter, who had married the comte de Baschi, was now presented at court, and her husband promised preferment, while Tournehem's niece, the comtesse d'Estrades, became a lady-in-waiting for the king's daughters. Pompadour played a role too in finding Pâris de Montmartel (to whom, according to police intelligence, she 'owe[d] most of the favour she has'[18]) a new wife. The bride was from the respected ducal family, the Béthunes, which completed Montmartel's rise to the top.

Pompadour's gaining of the king's favour allowed an influx into court life of professional financiers, many of which were linked to her and indeed had backed her in the 1745 encounters with the king. Beneficiaries included Joseph Pâris-Duverney (1684–1770) and Pâris de Montmartel – two individuals who, in one well-informed analysis, 'do not want to stand out and who, at bottom are extremely influential at Versailles in that they set the whole machine [of state] in motion'.[19] An early casualty of their influence was the *contrôleur-général des Finances* (finance minister) Philibert Orry (1689–1747), who had been in the post under Fleury since 1730 – the longest period of service of a finance minister in the whole century. Orry had become locked in conflict with the Pâris brothers, particularly over the provisioning of the capital and the armies, which since 1741 had been engaged in the Wars of Austrian Succession against Austria, England and the Netherlands. In December 1745 he was replaced as finance minister by the highly competent career bureaucrat Machault

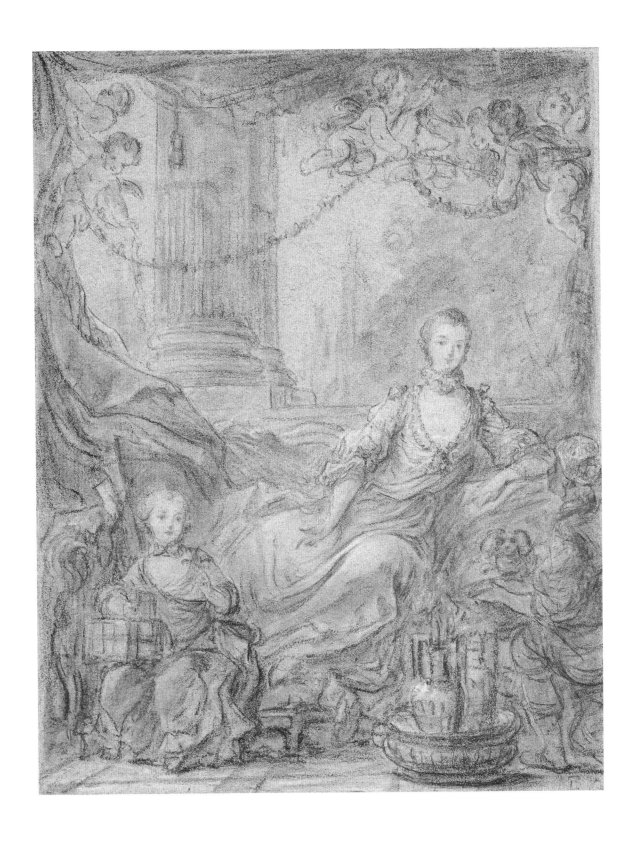

d'Arnouville (1701–1794), who was well aware to whom he owed his promotion. Orry was also conveniently dismissed from the post of *directeur des Bâtiments du Roi* that, as we have seen, was passed to Tournehem.

Pompadour's incursion into ministerial politics (for even if the Pâris clan was working in the wings she was widely attributed responsibility for Orry's dismissal) broke with one of the informal rules of governance that cardinal Fleury had inherited from Louis XIV. In establishing his elaborate court system at Versailles, Louis XIV had tried to staff his ministries with individuals from noble families of often recent minting, who had achieved their status in administrative and legal service, rather than ancient lineage. Jean-Baptiste Colbert, the king's main ministerial factotum from 1661 to 1683, was a good example of these 'Robe' nobles. Another was the Phélypeaux dynasty, which provided at least one minister in the government from the early seventeenth to the late eighteenth century. In 1745, the Phélypeaux in place were the comte de Saint-Florentin, minister for the Royal Household, and the comte de Maurepas (1701–1781) who was promoted to Navy minister as a seventeen-year-old in 1715. On the other hand, the king drew on the oldest noble ('Sword') dynasties for officers in his court. This segregation of Robe and Sword, administration and court, was never hermetically complete even under Louis XIV, but that court dynasties should be kept from meddling in ministerial affairs was one of Fleury's cardinal rules. As effective principal minister until 1743, he was the junction box of all leads to the king, and was able to adjudicate claims and petitions in ways that balanced factions, kept Robe and Sword apart and served the dynasty's interests.

Pompadour had thus broken this governmental divide-and-rule principle almost from day one of her introduction to power. Given the absence at the helm of state of someone with Fleury's competence and experience, who also enjoyed the trust of the king, the way was open for a period of factional struggles and governmental instability.[20] The potential for disharmony was initially attenuated by the fact that the marquise's influence on politics was relatively mild for several years, though she established herself as an important source of patronage for court, military, and even ecclesiastical posts. The inter-marriage which she encouraged of members of the Sword and Robe (on the lines of the Béthune-Montmartel match) was characteristic of a merger of old court and new money that predated Pompadour, but which her accession to the post of official mistress both sanctified and extended. She also accelerated the fusion by helping to infiltrate financial officials into posts in the administration and the court ceremonial hierarchy.

An excellent testament to the social process in train was the client base of portraitist Jean-Marc Nattier (1685–1766). His uniformly prettified images extended from princes, princesses, and old nobles to the scions of high financiers such as the Languedocian savant, collector and bon viveur, Joseph Bonnier de La Mosson (fig. 18). It was inevitable that he should include Pompadour in his compass. Nattier's portrait of her as goddess Diana the huntress was clearly the same mode as his portrait of the earlier mistress, the duchesse de Châteauroux: similar colouring, the hair swept back from the face and the obligatory mythological reference (fig. 19). The hunting topos was fairly hackneyed, having been exemplified by numerous sitters since the time of Diane de Poitiers. Nattier painted eight of them. Yet it seemed apposite for Pompadour, given the woodland setting in which king and mistress had first come to glimpse each other – and given too an initial acquaintance in which Pompadour had been as much predator as prey.

Queen Marie Leszczynska, however, whose portrait Nattier painted in 1748 (fig. 20), was stoutly opposed to these new influences and had her own reasons for hating Pompadour. By the mid 1740s, the queen was becoming the focus of a loose *dévot* ('devout') group who were resentful of the dominance of financial interests in state policy and urged for policies more in keeping with traditional Catholic piety, to which Marie herself was attached. They were the most recent exemplification of a *dévot* tradition which had roots in the sixteenth and seventeenth centuries, and which opposed the Bourbon dynasty's long-established policies of territorial aggrandisement, a large standing army (and high taxes and arcane credit arrangements to pay for it), centralisation of authority and the cult of the monarchy. The *dévot* grouping included the dauphin (who had turned into something of a prig) and his five surviving sisters, who were deeply hostile to the woman they referred to as '*Maman Putain*' ('Mummy Whore'). Other members included the bishop of Mirepoix, who advised the king on ecclesiastical appointments, plus many courtiers – such as the court chronicler, the duc de Luynes (1695–1758) and his wife. Also associated were individuals with

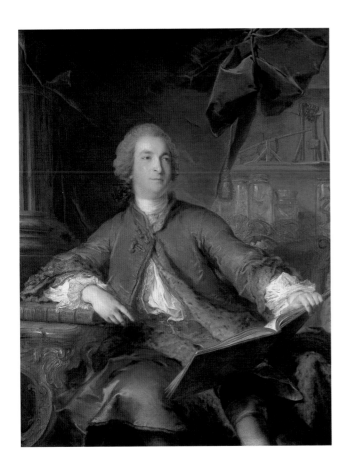

18
Jean-Marc Nattier
Joseph Bonnier de La Mosson, 1745
Oil on canvas, 137.9 × 105.4 cm
Samuel H. Kress Collection
1961, National Gallery of Art,
Washington

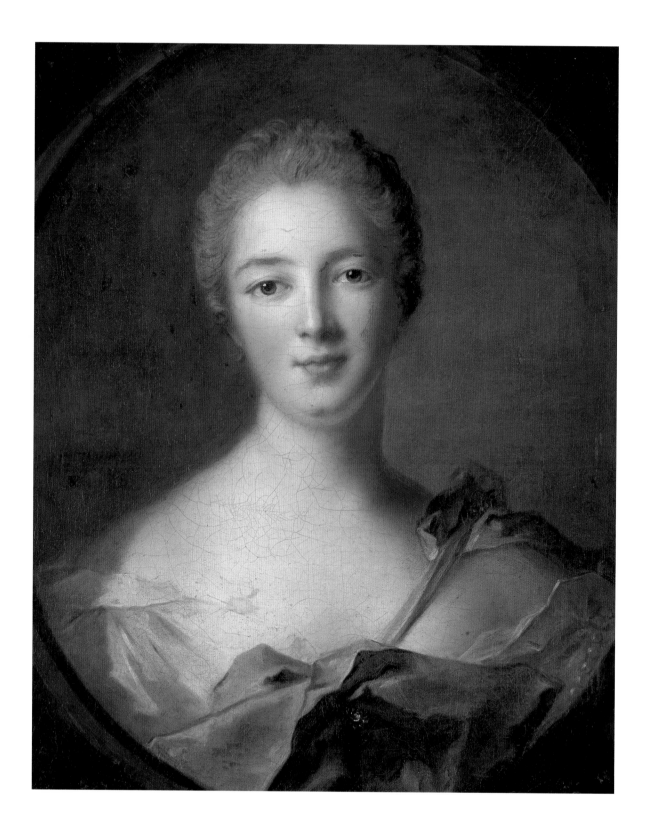

administrative careers, such as the war minister, the comte d'Argenson (1696–1764), and navy minister Maurepas (although one could never accuse the latter of piety). The queen was not closely involved in politics herself – indeed the sardonic marquis d'Argenson (1694–1757), the comte's elder brother, strongly commended her for her 'fecundity, piety, sweetness, humanity, and in particular her enormous inaptitude for state business'.[21] Yet her wish to remain as the king's spiritual and marital conscience was attested by the way in which she handled Nattier. Resisting his somewhat facile mythologisation of his subjects, she demanded to be painted in '*habit de ville*' (bourgeois dress). Nattier's portrait (the last for which the queen agreed to pose) bears comparison with Jacques-André-Joseph Aved's (1702–1766) portrait of Madame Crozat, which had been displayed at the Paris Salon of 1741. In Aved's painting the alert and kindly wife of a high financier is shown in her lace bonnet working at her tapestry, with a mundane teapot in the background (fig. 21). Nattier's portrait presents the queen almost as a bourgeois *dévote*, with her lace bonnet and red velours outfit, going about her daily business. Marie's refusal to countenance Nattier's customary artistic idiom was a quiet rejection of the values represented by the advent of Pompadour.

Nattier's portraits of queen and mistress thus represent two contrasting images of femininity in the court of Louis XV. Pompadour was intelligent enough not only to accept the queen's resentment of her but also to realise that if she wanted to stay in place, especially with a lover as racked by spiritual and marital guilt as Louis, she had better find a way of getting on with wife as well as husband. This was all the more pressing in that she soon had to confront a major issue of tension with the queen over the marriage plans of the Dauphin, whose Spanish wife died tragically in 1746. Pompadour now entered into intrigue with Pâris-Duverney and the maréchal de Saxe (1696–1750), the cosmopolitan military commander, who was in the service of France. The cabal sought to have Saxe's step-niece, Marie-Josèphe of Saxony, the daughter of the king of Poland, accepted as royal partner. Marie resented her husband's mistress interfering in her son's wedding plans – all the more in that they favoured the house of Saxony, which had kept the queen's father from the Polish throne.[22]

The marriage took place in 1747. By then, however, Pompadour had launched a charm offensive to circumnavigate the queen's hostility. She persuaded the king to pay off the 40,000 écus gambling debts Marie had run up, and sought extra funds for her to commit to Catholic charities. The queen's quarters in the palaces at Choisy and Fontainebleau were poorly maintained, and Pompadour prevailed upon Louis to

OPPOSITE 20

Jean-Marc Nattier, *Marie Leszczynska, Queen of France*, 1748
Oil on canvas, 138.9 × 107 cm, Musée National des Châteaux de Versailles et de Trianon

BELOW 21

Jacques-André-Joseph Aved, *Madame Crozat*, 1741
Oil on canvas, 138.5 × 105 cm, Musée Fabre, Montpellier

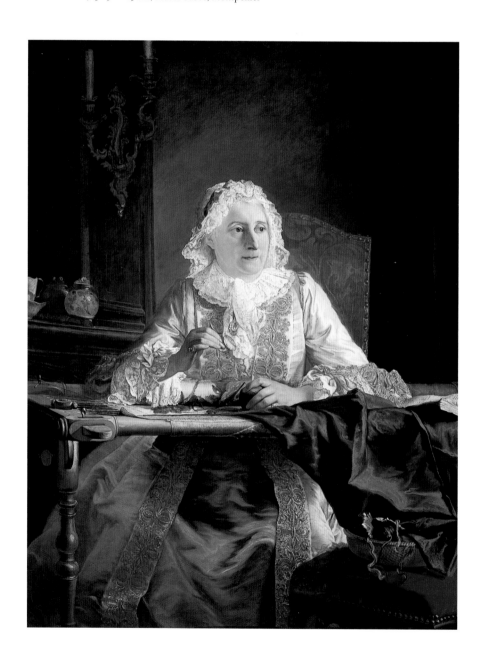

have them decorated and modernised. She showed boundless respect to the queen in all the minutiae of court life, waiting patiently while the king had a ritualistic game of cards with his wife in the evenings. She also encouraged the monarch to develop a warm relationship with his daughters – an excellent way of alleviating Louis's propensity for marital guilt. She had to endure snubs, but managed to secure *entrées* to the queen's chamber (the right to make visits to her quarters) and in late 1746 permission to ride in her carriage. The royal children were still very resistant to Pompadour's blandishments, but Marie responded in kind to Pompadour's good-heartedness. The Nesle sisters had been uniformly unpleasant to the queen, regarding the ancient status of their own French nobility as far superior to the ersatz foreign royalty offered by the Leszczynskis. Unlike her predecessors, Feydeau de Marville noted, Pompadour 'is not assuming the task of introducing breaks and disturbances in the household, for which she is held in much gratitude'.[23] By adeptly neutralising her main female rival at court for the king's affections, Pompadour had also removed much of the imminent danger from the *dévot* faction, which was eager to use the image of the humiliated and pious queen as a propaganda weapon against the powerful new intruder and the interests backing her.

All that Pompadour achieved in the first years of her position as mistress would have been as nothing if she had failed to continue to attract the love and devotion of the king. Her Pygmalionesque training and her intelligence had turned the beautiful but somewhat raw Madame d'Étiolles, with her social and linguistic gaffes, into the accomplished courtier and delightful companion of whom the ruler evidently felt inordinately proud.

The key to Pompadour's success seems to have been a re-imagining of herself as royal mistress on the basis of a shrewd analysis of the king's character. Louis required his private life to be shielded from court glare. And, as was widely recognised, he needed to be constantly diverted by a range of activities that kept his morbid propensities under control. Parisian barrister and political chronicler Edmond Barbier noted that Louis had 'a great tendency to be bored wherever he is. It is the great art of Madame de Pompadour to seek to dissipate that mood'.[24] This involved Pompadour staying close to the monarch at all times, and exemplifying a discretion and constancy which he prized (as indeed he had highlighted in his letters to her in the summer of 1745).[25]

Pompadour skilfully embedded herself into Louis's daily life. A private staircase complete with stairlift joined Pompadour's apartments (which were extensively redecorated in 1748) to those of the king, situated one storey below. Although she

disliked gambling and was not a keen hunter, she suppressed her reservations, sitting through the king's nightly gambling parties and usually joining in herself, and she also rode to hounds alongside him. Courtiers who saw Louis only in the context of stuffy court ceremonial were not always aware that when he passed out of the state rooms into the *Petits Appartements*, he got down to government paperwork, or indulged in a number of intellectual hobbies. He had developed a library, a map room and a geographical gallery, and though he was bored by literature and needed Pompadour's instruction in the arts, he had keen scientific interests, notably in astronomy, geography, architecture and surgery (dissection clearly chimed with his underlying morbidity). The *Petits Appartements* had a small dining room and terrace, and it became Louis's evening custom to hold select dinner parties at which between twelve and twenty guests, who were usually hunting companions and court ladies in Pompadour's favour, dined informally without valet service, then withdrew to have coffee, which the king was often pleased to make for his guests himself (fig. 22). At these *petits soupers*, the king was relaxed, informal – and still highly infatuated with his mistress. The duc de Croÿ (1718–1784), who was present at one of these occasions, recorded:

The king was gay and outgoing, though always with a grandeur which he did not choose to hide… He appeared very much in love with Madame de Pompadour, and, putting aside any embarrassment, did not hold back in this regard, out of intoxication with her or whatever.[26]

Pompadour sought to share Louis's pleasures in the study as well as the bedroom. Her own apartments had an outside terrace in which she had trellises for plants and birdcages built. A passionate gardener herself, Pompadour also encouraged Louis to take up the pursuit. The king became an amateur ornithologist as well as a keen botanist: Croÿ records being impressed by the menagerie that Pompadour set up for her own and the king's pleasure at the Versailles hermitage, and especially remarked on 'a type of pheasant, golden-yellow and fiery-coloured'.[27] Pompadour had the bird's portrait painted (fig. 23) by Jean-Baptiste Oudry (1686–1755)[28]. She also worked with Louis on the planning and design of the châteaux in which they spent more and more time. She kept up with war and public affairs too. Aware of Louis's lack of self-esteem in these matters, in which he was only just emerging from the tutelage of the late cardinal Fleury, she realised that he needed support and encouragement, and would value advice from someone he felt he could trust.[29]

Pompadour, the marquis d'Argenson sourly noted, 'amuse[d] the king so that he ha[d] not a moment for reflection'.[30] One of the new mistress's favourite distractions

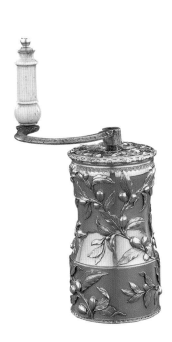

22
French, 1756–7
Coffee Grinder believed to have belonged to Madame de Pompadour
Gold, steel and ivory,
9.5 × 5.2 cm
Musée du Louvre, Paris

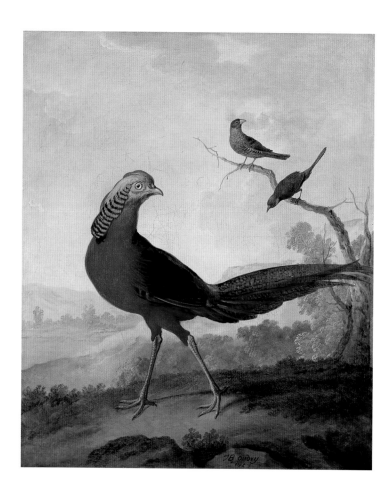

23
Jean-Baptiste Oudry
A Golden Chinese Pheasant, 1753
Oil on canvas, 65 × 54 cm
Private collection

for her lover was amateur dramatics, into which she threw all her energy, and which she turned into a high spot of the Versailles round. As was often the case with Pompadour, such activities had multiple values in her campaign to become an indispensable fixture in court life. The performances kept the king amused – and there was much breast-beating on her part if Louis expressed any hint of ennui or displeasure towards the performances – and also kept Pompadour forever before his eyes (fig. 24). She invariably took the star parts in the productions, showcasing that '*air de nymphe*' which so struck the prince de Kaunitz.[31] The rehearsals and performances also allowed a new community of fellow-performers to be formed outside the stifling rituals of court etiquette. By cutting across existing hierarchy, Pompadour was able to forge new friendships and alliances. It was in such informal settings, in which protocol and precedence did not need to be respected, that she worked best.

Four seasons of performances were held at Versailles, starting in January 1747 with a performance of Molière's classic comedy on religious hypocrisy, *Tartuffe* – a choice which may have been a calculated anti-*dévot* snub, but may simply reflect the fact that the play is extremely funny and almost bound to please. At first, performances were held in the gallery adjacent to the Staircase of the Ambassadors – a space which allowed only around a dozen in the audience. From 1748, however, a better arrangement was worked out for a mobile stage and seating to be set up on that grand staircase. Pompadour drew extensively on the props and costumes of the royal department of the *Menus Plaisirs*, which stimulated brusque objections from the duc de Richelieu, who as first gentlemen of the king's bedchamber was supposed to control this department, which was responsible for the paraphernalia for all royal ceremonies. Pompadour overrode the objections and ploughed onwards. Her

24

Sèvres eyeglass, about 1757–60
Soft-paste porcelain, ivory,
board and glass, 8.5 × 4.5 cm
Musée du Louvre, Paris

performances did not come cheap – the cost of the 1750 season was around a quarter of a million livres. This included payment for the professional musicians and actors who participated in the performances and who ensured a good standard was achieved. Around a third of the players, however, were amateurs – most of them grand courtiers who in other circumstances would not pass the time of day with Pompadour: the ducs de Nivernais and Duras, the comte de Coigny, and the young duc de Chartres, a Prince of the Blood, who became the duc d'Orléans in 1752. Conversely, the success of the venture, and the king's approval for it, meant that competition for tickets to performances was intense. The king usually made the choice of the audience under Pompadour's advice: the prince de Conti, whom Pompadour saw as a political threat with a grudge against her over the use of his mother as 'godmother' to her court presentation, was ostentatiously excluded.

Over the four seasons of its existence at Versailles, Pompadour's troupe put on some fifty-four pieces, around a half of which were operas and opera-ballets, about a quarter ballet-pantomimes, and the rest (invariably less successful) tragedies. The playwrights used included many of the best currently writing, such as Voltaire (who wrote poems in Pompadour's honour), Gresset, Moncrif and Rousseau, who to his considerable embarrassment was invited to attend a performance of his *Le Devin du village* (known in English as *The Cunning Man*) in 1753.[32] Pompadour took the best parts and was the best performer by all accounts – including her own: 'We played the tragedy, *Alzire,* for the first time. They are saying that I was amazing'.[33]

Charles-Nicolas Cochin (1715–1790) made an engraving of a performance of *Acis et Galatée* – probably in 1749 – with Pompadour on the stage at a highly-charged moment, while in the audience the king follows the play with the script in his hand, surrounded by the royal family (who, queen included, were also won over by the new craze) and various courtiers (fig. 25). This play, like many others that the company performed, celebrated the victory of love in a variety of mythological, pastoral and antique settings. Despite some novelty turns (a breeches part as a pink-jacketed Colin in Rousseau's *Le Devin du village* for example), Pompadour's roles were rather narrowly focused: partners of sun god Apollo (Eglé, Issa), Venus (to Adonis), Dawn, Love, Europa and Egine (all severally matched with Jupiter), a vestal virgin, and sundry nymphs and attendants of Diana. Rapprochements were very much part of the performance, and invariably redounded to the image of Pompadour. As she walked on in the first act of Jean-Baptiste Gresset's (1709–1777) *Le Méchant*, the

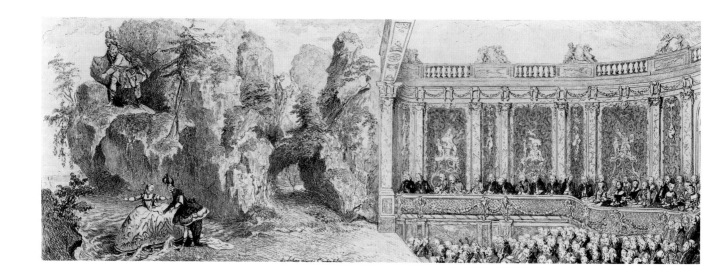

marquis de Gontaut ('her chief eunuch', courtiers snidely whispered) apostrophised her: 'And there you are, on time, and still as lovely as ever.'[34] One did not require the insight of Voltaire to understand the subtext.

One of the successes of the 1750 cycle was Houdard de La Motte's play, *Issé*, first performed before Louis XIV in 1697, and revived in 1741–2, with stage sets painted by François Boucher (1703–1770). By 1750, the plot had become irresistibly Pompadourian. Issa, a shepherdess, loves a shepherd without realising he is Apollo, the sun god, in disguise. Apollo has to turn himself into a human in order to win her love. Boucher was called upon to make the rapprochement even more striking. He was commissioned, probably directly by Tournehem, to paint a canvas on the theme. His *Apollo and Issa* is generally regarded as featuring the face of Pompadour on the Issa character (fig. 26).[35]

This kind of self-conscious artistic quotation was in fact becoming more frequent around 1750. From 1745, the king's infatuation with Pompadour had been so intense – and Pompadour's stage management so adept – that her physical image was never far from his side, even if dressed as a nymph or a goddess. From 1750, however, a clear modulation began to take place in the way that Pompadour managed the production and display of her image. New strategies were evolving – perhaps had to be evolved – for around this time, the sexual relationship between king and mistress was drawing to a close. It now fell to Pompadour to prove to herself and to others that she had succeeded in making herself a permanent fixture in Louis's life and that there was indeed a role for an official royal mistress beyond sex.

26

François Boucher
Apollo and Issa, 1750
Oil on canvas, 129 × 157.5 cm
Musée des Beaux-Arts de Tours

3

The Many Faces
of Jeanne-Antoinette

By the late 1740s, the strain of the frenetic programme of activity that Pompadour had assumed to keep the mind of the king occupied – and his hands off other women – was beginning to take its toll. 'We are always on the road', she had gleefully told the comtesse de Lutzelbourg in February 1749, referring to the busy round of visits to châteaux and country houses on which she accompanied the king.[1] But she admitted soon afterwards: 'The life I lead is terrible. I hardly have a moment to myself. Play rehearsals and performances and twice weekly visits [to other châteaux].'[2] Court life was clearly palling. 'The more I live [at court]', she told to Richelieu, 'the more I detest it and hold it in contempt.'[3] 'Apart from the happiness of being with the king', she wrote to her brother a little later, 'everything else is just a tissue of nastiness, platitudes, and indeed of all the wretchedness of which we poor humans are capable.'[4]

The strains she felt beneath the façade she presented to the world were exacerbated by personal criticism. By meeting the king's desire for a private life the favourite threw herself open to the charge that she was distracting him from his duties of state. The accusation seemed anodyne as long as public affairs were going well. In 1745, for example, the king showed great courage on the battlefield, contributing in some measure to the victory over Anglo-Dutch forces at Fontenoy, one of the greatest French military triumphs of the eighteenth century (fig. 27). He returned to Paris to renewed acclamations of 'le Bien-Aimé', leaving his commander, the maréchal de Saxe, to consolidate the French position on the northern front. Yet there was enormous disappointment in 1748, for the Treaty of Aix-la-Chapelle ended the War of Austrian Succession but brought the French scant gains. Louis appears to have regarded France by this time as a 'satisfied' state. It was, as the marquis d'Argenson echoed, 'too big, too rounded off, too well-placed for trade to prefer territorial acquisitions to a good reputation'.[5] The king feared that the state would be weakened rather than strengthened by territorial gains that generated resentment

OPPOSITE
Detail of fig. 29

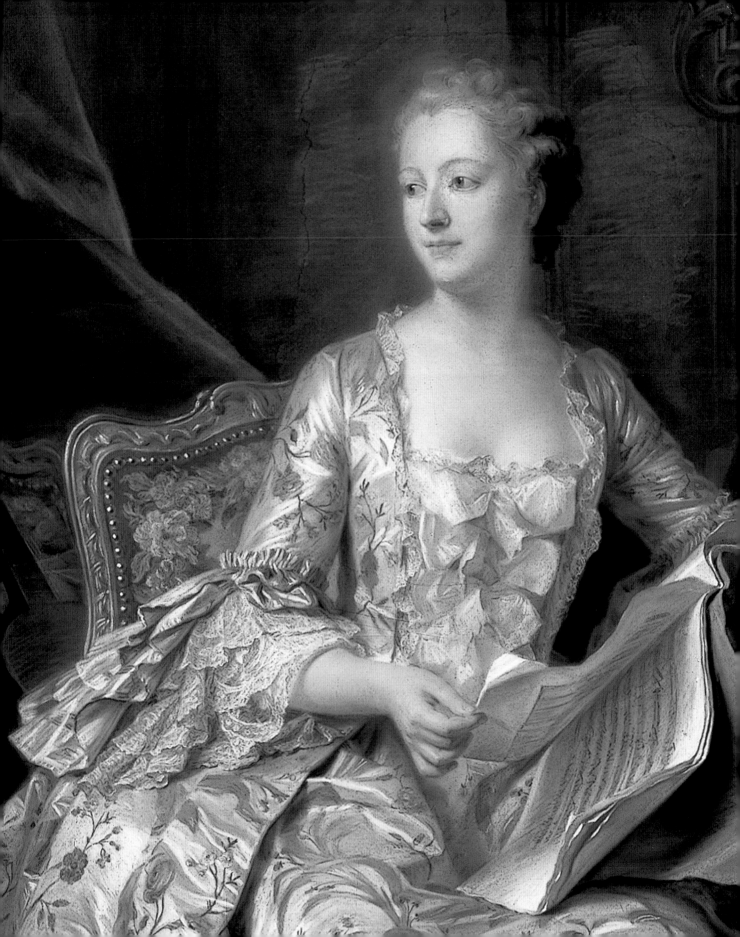

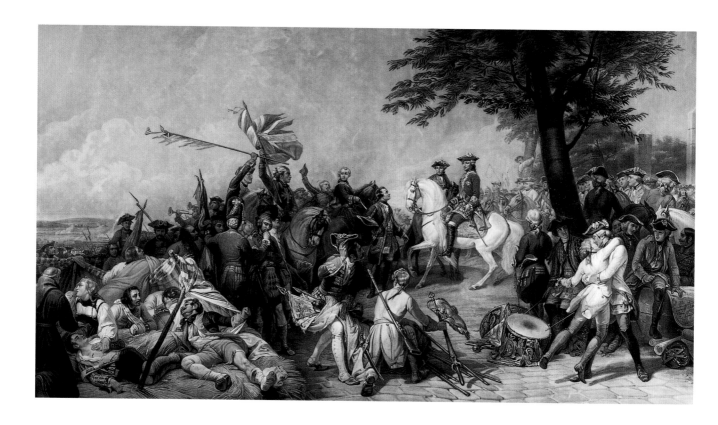

from European rivals and further conflicts. His evident pride in being able to approach peacemaking magnanimously 'as a king and not as a merchant'[6] did not impress much of the country, which by the end of the war was suffering real privations and expecting territorial gains in recompense.

Despite state censorship, satirical verses began to circulate which attacked not only the king, but also his mistress and the financial milieux with which the government was now associated:

> Coward! You waste your subjects' wealth,
> And measure days by evils you commit.
> Louis, slave of minister and slave of woman too,
> Learn the fate that heaven prepares for you…
>
> Who now can recognise his king?
> Your wealth is wasted by charlatans' wild expense,
> Your subjects are robbed, your treasury fleeced…[7]

Further productions took more directly against Pompadour:

Great seigneurs debase themselves
Financiers enrich themselves
All the Poissons enlarge themselves
It's the reign of the good-for-nothings…

A petty bourgeoise, brought up saucily
Measures everything by the yard
And makes the court a hovel…

This subaltern whore
Dares govern the king
And hands out honours
In return for cash…[8]

In the civil wars of the Fronde in the middle of the seventeenth century, anti-governmental pamphlets were published attacking the young Louis XIV's principal minister, the cardinal Mazarin (1602–1661). The Mazarinades, as they were called, seemed to have a successor in the growing numbers of 'Poissonnades'. By 1749 'these damned songs'[9] stung Pompadour quite as much as their predecessors had stung Mazarin. Some of the writings – equally scornful of her alleged greed, low birth, financial wastefulness, debauchery and physical appearance – were sent directly to her as poison-pen letters. She turned to the Intendant of Paris, war minister the comte d'Argenson and Paris Police Lieutenant, Nicolas Berryer (1703–1762), whom she had helped to have appointed in 1747, to track down the authors of these pieces and throw them into the Bastille or some other royal prison by *lettre de cachet* (royal warrant). Pâris de Montmartel agreed to pay 250 livres per month to police spies for help in the search. In late 1750, the chevalier de Resseguier was gaoled for epigrams found in his possessions, which caught much of the general tone:

Poisson, leech's daughter, leech herself,
In her palace, beyond fear, beyond remorse,
Lays out her great happiness for all to see:
What she's stolen from the people,
How she's abased her king.[10]

Pompadour gained a good deal of sympathy amongst her intimates for the way in which she was being treated in the Poissonnades, and government ministers and officials showed themselves helpful and cooperative – with one striking exception: the comte de Maurepas. The enquiries which the police were making in Paris increasingly suggested that there was an informer at Versailles who provided the most private court information to the pamphleteers and may indeed have had some writers in their pay. Maurepas, a known collector of such poems, was the obvious candidate, in that he was openly scornful of Pompadour, even flippantly mentioning on one occasion the possibility of poisoning royal mistresses. A horrible ditty seemed to provide the proof that Pompadour wanted:

> Iris, you enchant our hearts
> With your manners noble and bright
> You scatter flowers on our path
> But only flowers white.

White flowers were the traditional accompaniment to funerals, but in addition *fleurs blanches* was also a contemporary medical name for vaginal discharge, or leucorrhoea, from which Pompadour may well have suffered though knowledge of this was limited to very few. Supported by rival courtiers only too pleased to see the end of Maurepas's tenure of office, Pompadour threw herself on the king's good intentions and persuaded him to dismiss Maurepas. This was a major victory in the war of courtly faction, and caused extreme distress to the *dévot* faction – the queen cried for two whole days at losing the company of Maurepas.[11]

The strain of this episode on Pompadour appears to have been physical as well as mental. A serious attack of whooping cough as a child had left her with frail health and weak lungs. A series of chest infections and head colds along with fevers and migraines began to blight her life. From 1748–9 she very rarely went hunting with the king. In a tear-stained conversation with the older duchesse de Brancas, which was recorded in the admittedly much later and somewhat questionable memoirs of her lady-in-waiting, Nicole du Hausset (1713–1801), Pompadour confessed to problems of waning sexual appetite. She suffered, she is alleged to have stated, from a 'very cold temperament' that put her in real danger of losing the affections of the king. She feared the latter regarded her as 'a cold piece of meat', and 'would become disenchanted with her, and take another lover'. That she had up to three miscarriages in these years probably also affected her sexual relations.[12] She had consequently, she said, begun to consume substances (truffles, chocolate, aphrodisiac drinks) that she

hoped would warm her up. Madame de Brancas gave her a stern talking to, threw some of the offending concoctions in the fire and advised her to pull herself together. Her doctor put her on a regimen of careful digestion and a little light exercise. It is moot how much these helped her to come to terms with her gynaecological problems or a temperament that Madame du Hausset described as 'very frigid in regard to love'.[13]

Even after Maurepas's dismissal, the underlying psychological strains and medical conditions continued. In 1750, possibly a little later, sexual relations between king and mistress ceased. The fact that no courtier was able to put an exact date on this occurrence demonstrated how successful Pompadour had been in making herself a fixture in Louis's life. It did, however, mark a new phase in her programme of image promotion. Hitherto the king had enjoyed the physical beauty of Pompadour at first hand. Now this had stopped being the case, the marquise became much more assiduous in placing before the king's eyes portraits of her own idealised beauty in painting, sculpture and other arts. Before, Pompadour the actress had played many parts; henceforth, she generated exemplary images of womanhood reflecting her identity and her idealised likeness. The performance of Pompadour's identity did not cease; but the marquise overlaid it with the proliferation of her own image in the décor within which she and the king lived.

In the first years of their relationship, Pompadour had taken surprisingly little interest in how her image was represented. Nattier's 1748 portrait was so much the standard issue from this painter that it suggested that he rather than his sitter set the rules about how she was portrayed. A similar insouciance towards the production of her image was evident in the dealings over a portrait of her which was intended for despatch to Italy for diplomatic purposes. In 1749, Pompadour had been instrumental in organising a two-year visit to Italy for her brother Vandières. This was partly intended to sharpen up his artistic tastes in preparation for his taking over from Tournehem as *directeur des Bâtiments du Roi*, and he was accompanied by the engraver, Cochin, art connoisseur and critic, the abbé Leblanc, and the Lyon-based architect, Jacques-Germain Soufflot.[14] The visit was also intended to make more of a gentleman of young Vandières, who had more rough edges than his sister, and to introduce him to minor diplomatic roles. It was agreed that he should have copies of portraits of the king and of Pompadour in his possession so that he could demonstrate to Italian notables the esteem in which he was held at the French court (and of course simultaneously signal the place of Pompadour in the king's affections). A copy of a portrait of Louis by Carle Vanloo (1705–1765) was organised,

but one by Boucher of Pompadour proved more difficult to arrange. Eventually it was despatched in April 1750. 'It looks a lot like the original', she told her brother. 'But it resembles me very little.'[15] Despite her apparent indifference to her likeness at this time, Pompadour's view was in fact changing, and from this time onwards she grew ever more concerned with multiplying representations of herself and regulating the way in which she was presented.

What appear to be two surviving sketches (one at the Louvre in Paris and another at Waddesdon Manor in Buckinghamshire) relating to a lost Boucher portrait of Pompadour represent a straw in the wind: first, in regard to the setting in which Pompadour is placed and, second, in regard to her use of Boucher, who was to become her artist of choice throughout the 1750s (fig. 28, see also fig. 1).[16] The Louvre portrait shows Pompadour in a luxurious domestic interior. Her silk robe is given width and volume by panniers that, taking up a considerable amount of the canvas, highlight the slimness and delicacy of her face, arms and neck. She wears roses, traditionally the flowers of love, in her corsage and hair and they are also strewn about the floor. More remarkable than these and the rich domestic accoutrements, are the markers of artistic and intellectual pursuits also evident in the painting. Pompadour stands at a harpsichord while at her feet lie a globe, a scrolled architectural sketch, drawing and engraving tools, and leather-bound volumes seeming to bear her heraldic arms. The portrait marks her out not simply as an object of love, but as a *femme savante* – a woman of breeding with a mind of her own and with claims to erudition: in all a worthy successor to Louis XIV's Montespan and Maintenon, whose portraits similarly stressed cultural accomplishment.[17]

This *femme savante* image became a leitmotif in many of the portraits that the marquise commissioned throughout the 1750s. It is less pronounced in the Waddesdon painting (fig. 1), where Pompadour inclines towards a dressing table and has a flowery hat in her hand. But even here engravings and sheets of music are depicted on the floor. The theme is more strongly emphasised in Quentin de La Tour's extraordinary portrait of her (fig. 29). Pompadour, who probably knew La Tour from the days of their attendance of Madame Geoffrin's salon, had first tried to commission a portrait from the irascible artist around 1750, but it took time to persuade him and the picture was not completed until 1755. The marquise is not simply represented as a *femme savante* but as a symbol of the Enlightenment. The light seems to radiate from her head, the seat of reason, and she is surrounded by the offshoots of the civilised arts. Displayed on her table is the fourth volume of the *Encyclopédie* – Denis Diderot (1713–1784) and Jean-Baptiste Le Rond d'Alembert's

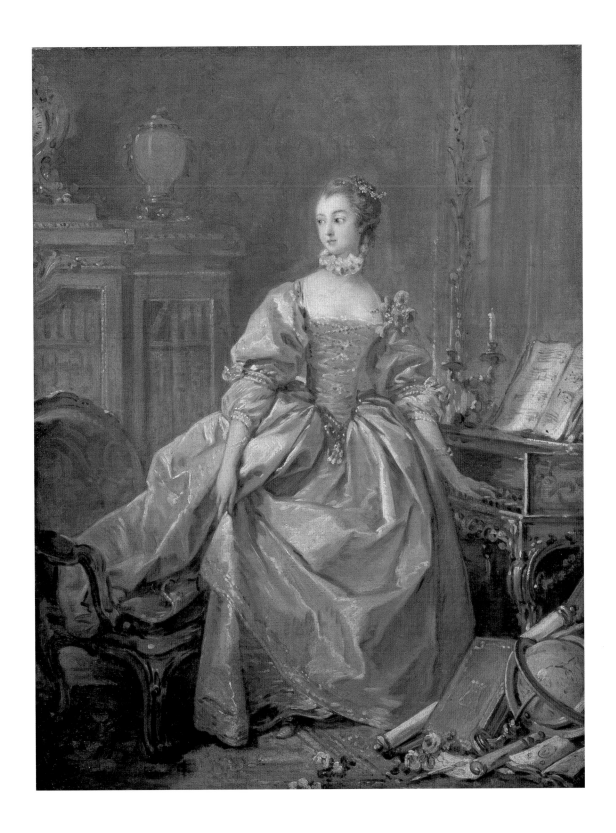

(1717–1783) great multi-volumed Bible of the Enlightenment, which started publication in 1751. Also on view are *The Spirit of Laws* (1751), the monument of political science published in 1748 by another old Geoffrinist, Montesquieu, and Voltaire's *La Henriade* (1723), which the author had dedicated to the thirteen-year-old Louis XV, and which stressed the first Bourbon king, Henry IV's, commitment to social welfare. Another visible title is *Il Pastor fido* (1590) by Giovan Battista Guarini, one of the classics of the pastoral tradition, which had provided the idiom of the plays that Pompadour produced in the late 1740s. It was also a literary antecedent to the pastoral artistic style, mastered by Boucher, on which Pompadour drew for decorating her residences.[18] A guitar, a musical score, a globe and a portfolio of drawings or engravings (embossed with her coat of arms) complete the collection.[19]

The La Tour portrait demonstrates that Pompadour had begun to take seriously the advice given her by Bernis in 1745 to protect men of letters. She had been, it was said, 'a great success with the old *philosophes*' at Madame Geoffrin's salon in the 1730s.[20] In the Poissonnades affair, however, she had not hesitated to deploy state repression against authors critical of the government. Perhaps as many as thirty writers ended up in gaol on royal *lettres de cachet* because of her actions against them. Clearly things had changed. Now the marquise made a point of developing a *philosophe* client base, which if nothing else countered the charge that the Poissons were greedy and lacked intellectual interests. The king's resistance against intellectuals of any kind required that she adopt a rather oblique approach towards the literati. Rather than entertain the leading *philosophes* in person, she did so vicariously through her personal physician, François Quesnay (1694–1774), who had an apartment adjacent to hers at Versailles. Here, the doctor, also a leading light in the sect of political economists known as Physiocrats, held meetings and dinners at which Pompadour could converse with foremost figures including Diderot, d'Alembert (the illegitimate and abandoned son of Madame de Tencin) and the great natural historian Buffon (to whom she was to bequeath her parrot and other pets). She championed and corresponded with Voltaire, who still felt undervalued and left for the court of the 'philosopher-king', Frederick II of Prussia (1712–1786), when she showed favouritism to his enemy in matters theatrical, Crébillon *père*. She also provided patronage for Duclos (whose comments on Agnes Sorel had perhaps given her some clues to conduct),[21] the fashionable author and critic Jean-François Marmontel (1723–1799), the poet Piron and others. In spirit at least, Voltaire was to judge, in a comment to Diderot, that Pompadour was 'one of us'.[22]

29
Maurice-Quentin de La Tour
Madame de Pompadour, 1755
Pastel on grey blue paper
mounted on canvas,
177.5 × 131 cm
Musée du Louvre, Paris

Patron of the arts, Pompadour also developed her own skills as an artist from around 1750 as part of her wish to be 'one of us' within the cultural world. Her abandonment of the hunt, and her gradual disengagement from amateur dramatics,[23] was combined with a growing interest in more homely artistic pursuits. From 1750, she arranged for the celebrated engraver of gems, Jacques Guay (1715–1787), to give her instruction. With help from Boucher (who had been one of Guay's teachers) and Cochin, she became a proficient engraver, who in 1755 published a book of some fifty-two of her works. She also set up a little printing press in her new apartments at Versailles.

The symbols of cultural patronage and artistic engagement also appear in the portrait Boucher painted of her in 1756, which was shown at the Paris Salon the following year (fig. 30). She has broken off from reading to gaze reflectively into the middle distance. The objects round her feet include sheets of music, a folded map, a portfolio of prints and drawings, etching tools and a couple of pink roses. Imposing theatrical curtains frame this moment of repose, and evoke both her patronage and her performance in drama – as well as the anonymous portrait of Madame de Montespan noted above.[24] Whereas La Tour had been notoriously difficult to work with, Boucher was fast becoming Pompadour's preferred artist, and he proved particularly adept at presenting her in the style and form that she preferred. That Boucher's portraits were collaborative affairs was highlighted by the fact that this portrait travelled from the artist's studio to Versailles and back again so that she could comment on progress and likeness.[25]

In this stunning portrait, the *femme savante* image seems to be eclipsed by the element of glorying in sheer, if still seemly, ostentation. The dress, an emerald-green creation bedecked with ribbons, bows and rosettes, cascading in luxuriant and capacious folds, seems almost to take over the picture. The ornate clock behind her (depicted in reflection) shows a time of 8.20, and it has been suggested that this would indeed have been a time in the evening when Pompadour might well have had a moment to herself following some great ceremonial event.[26]

Pompadour's concern for exactness in the representation of significant detail in this painting leaves one major area of uncertainty: was Pompadour still as beautiful as she was portrayed? In 1751, Kaunitz had adjudged her 'thin rather than fat', while the marquis d'Argenson was gleefully reporting severe weight loss.[27] Yet by the mid to late 1750s court gossip was suggesting that her looks had gone, and implied that her fuller figure rather detracted from her '*air de nymphe*'.[28] Pompadour even described herself as fat in 1757.[29] Boucher, hardly renowned for producing likenesses,

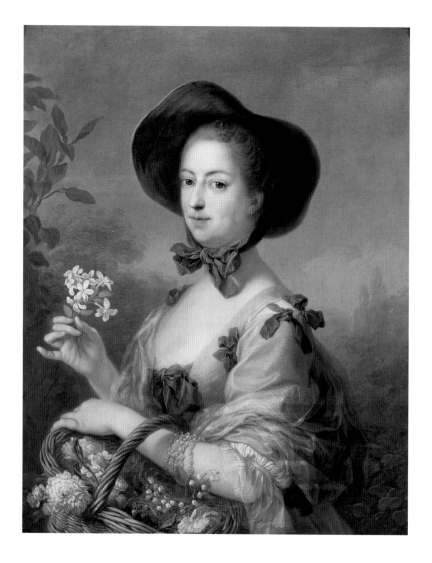

was the perfect portraitist for a woman wishing to hide her advancing years and increasing weight. Pompadour had chosen to multiply representations of herself as a means of compensating for her exile from the king's bed and Boucher's skill ensured that, in his paintings at least, the marquise remained forever young and beautiful.

The extent to which Boucher idealised Pompadour's beauty is strikingly highlighted by comparing his paintings with those of other portraits of the marquise, such as those by Carle Vanloo (1705–1765) and François-Hubert Drouais (1727–1775). It was probably as early as 1754–5 that Carle Vanloo painted '*La belle jardinière*' (fig. 31), highlighting a pastime that she shared with the king. [30] The literary journalist Grimm – who had attacked Boucher's 1756 portrait as 'weighed down

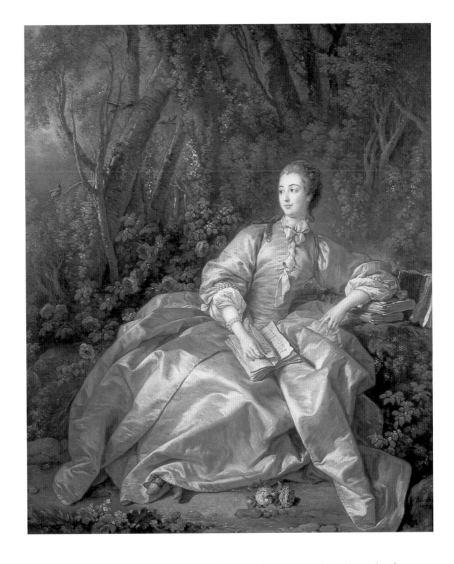

with ornaments, pompons and other frillinesses'[31] – dubbed Vanloo 'the first painter of Europe', and indeed in 1762 Louis XV appointed him *premier peintre*. Pompadour's gardening hat and her flower-strewn pose evoke both her taste for gardening and a love of nature evident in the theatrical pastorals she had produced and starred in at Versailles. But the face is surprisingly full for a woman in her mid thirties renowned for her beauty. A contemporary of Boucher, Vanloo clearly lacked his diplomatic tact.

Sylphlike beauty is very much back in command in Boucher's portrait painted in 1758 – several years after Vanloo. Now located at the Victoria and Albert Museum in London (fig. 32), it shows Pompadour in much the same posture as in the 1756

painting – reclining with a book and roses and showing no sign of embonpoint. As in the Vanloo, there is a natural setting, but the presence of the hefty tomes on which she leans her elbow suggests that she has not totally abandoned culture for nature. 'I pass half my life [in the forest near Compiègne] with great satisfaction', Pompadour told her brother in 1750.[32] 'I saw her, dreaming under the elms', versified the President Hénault, as if writing a caption for the portrait. 'It was there that her voice attracted the birds.'[33] Boucher's well-known mastery over the pastoral idiom showcases the marquise's avowed love for the natural. The woods look as theatrical a setting for Pompadour as the draped curtains of the 1756 portrait. Even when the marquise is lost in the realms of nature, the staging of self is never far away.

Natural surroundings are also the context for Boucher's last portrait of Pompadour, now in the Wallace Collection, London (fig. 33). The pinkness of the rose which had been a topos in all previous paintings here invades the dress. The face, the waist, the hands and the complexion are those of a young woman. This painting, however, has a more studied and complex message than the putative unchangeability of Pompadour's good looks. Inès, one of the marquise's much-beloved dogs, obediently crouches on a garden seat. The presence of a dog in a portrait was a well-established convention to signify obedience and unquestioning devotion. Inès was in fact sometimes called 'Fidelity', while another dog, Mimi, seen elsewhere in Pompadour portraiture, was named 'Constancy'. The marquise lavished great affection on both animals, who besides appearing in paintings of their mistress also had their portraits done by the gifted painter of animals, Jean Baptiste Oudry (1686–1755). These were turned into engravings by Étienne Fessard (1714–1777) and also appeared on Sèvres porcelain panels which were later turned into a snuffbox, which is currently in the collections of Waddesdon Manor (fig. 34).[34]

If the presence of Inès signified a blind devotion to her mistress that paralleled the mistress's unbending commitment to the king, the presence in the portrait of a statue (against which Pompadour is inclining) is even more loaded with meaning. The painting illustrates a work that she had commissioned from the sculptor Jean-Baptiste Pigalle (1714–1785) in 1754, to signify that her relationship with Louis had shifted into non-sexual mode. She had made the first gesture of acknowledgement in this direction as

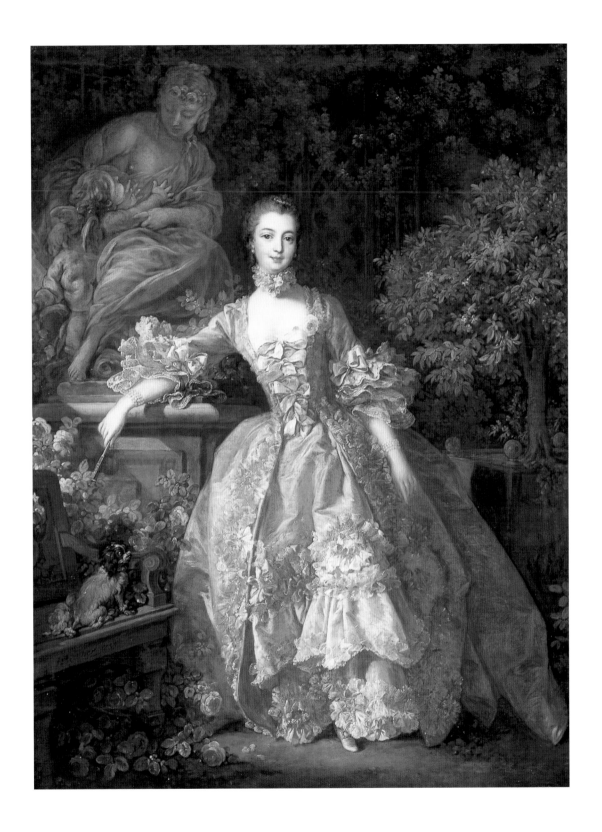

LEFT
35
Jean-Baptiste Pigalle
Love embracing Friendship, 1758
Marble, 142 × 80 cm
Musée du Louvre, Paris

RIGHT
36
After Étienne-Maurice Falconet
Madame de Pompadour as Friendship, 1755
Soft-paste 'biscuit' porcelain,
27 × 14.4 × 8 cm
The Bowes Museum, Barnard Castle,
Co. Durham

early as 1750–1, when she had commissioned the same sculptor to represent her as *Amitié* (Friendship). Her intention was to place this in a clearing in the gardens of her favourite château at Bellevue in a niche formerly occupied by a statue of *Amour*, located opposite a statue of Louis XV. In 1754, this commission was followed up with an order for a statue depicting Love and Friendship (fig. 35). *Amitié* – said to be in Pompadour's image – embraces and consoles a cherubic *Amour*. Friendship is clearly the superior emotion – and would be the topic of further commissions, including Étienne-Maurice Falconet's (1716–1791) porcelain figure, and many subsequent copies (fig. 36).[35]

Another work that also evokes and glorifies Pompadour's change of status is Vanloo's *Madame de Pompadour as a Sultana*, painted in the early 1750s (fig. 37).[36] This was one of three paintings with Turkish content commissioned for Bellevue, and placed in the *'chambre à la turque'* (Turkish bedroom) that she designed for herself. Related paintings show two women working at a tapestry frame (fig. 38) and an odalisque playing some sort of stringed instrument. Since the publication of a highly popular edition of the story series, *A Thousand and One Nights*, by Antoine Galland (1647–1715) and the visit in 1721 of ambassadors from Turkey, Turkish culture had become a component part of French exoticism. The integration of such oriental themes within French culture – under the catch-all title of *chinoiserie* – involved their acclimatisation to French taste. Galland, for example, claimed to

have set out 'to show the Arabs to the French people with all the circumspection required by our language and our times.'[37]

The harem with its themes of male-dominated sexuality and female submission was a prominent area in which Western fantasy prevailed over Eastern verisimilitude. The gender politics in Vanloo's *The Grand Turk giving a Concert to his Mistress*, painted in 1737, are conventionally patriarchal. The body language of the Grand Turk conveys power, that of his mistress and the other denizens of the harem, unqualified fascination and submission (fig. 39). The Pompadour painting, in contrast, is less about male than female power – suggesting an input from the marquise into the content. The marquise-sultana – whose profile is not altogether flattering – is even shown wearing oriental trousers: Pompadour is known to have had these in her wardrobe.[38] The sultan is absent as sultana Pompadour takes her

coffee – another exotic eastern substance which had passed into Western mores by the mid century. She receives it from the hands of a black slave – not an implausible eventuality in the harem, but also an unwitting reminder of the sugar plantation slavery to which European states were subjecting African people. The setting also evoked – to those who knew her – the fact that Pompadour had two black servants on her staff.[39]

Even within the harem, then, Pompadour soars above the abjection of other women, and her own domination is projected outwards onto others. As the sultana, Pompadour is prostrately obedient to her master, but dominates the other women of the harem. The luxuriant setting, with the heavy drapes and cushioned sofa, highlights the special relationship she would have had with the sultan.

The notion of Friendship trumping carnal love was transposed into a very different setting in Drouais and his studio's *Madame de Pompadour as a Vestal* probably

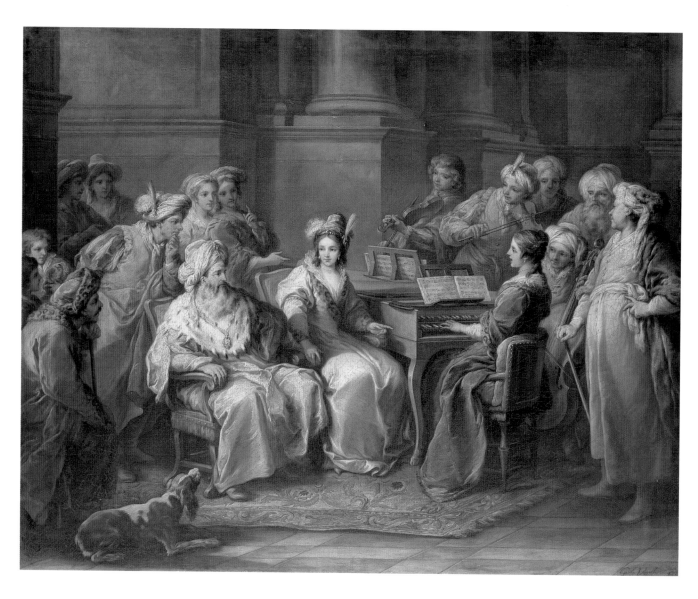

ABOVE 39
Carle Vanloo
The Grand Turk giving a Concert to his Mistress, 1727
Oil on canvas, 72.5 × 91 cm, The Wallace Collection, London

OPPOSITE 40
François-Hubert Drouais and Studio
Madame de Pompadour as a Vestal, probably 1762–3
Oil on canvas, 100 × 81 cm, Stewart Museum at the Fort Île Sainte-Hélène, Montreal, Quebec

painted in the early 1760s (fig. 40).[40] Virginity was not
something that one readily associated with a royal
mistress, but in the context of Pompadour's changed
relationship with Louis over the 1750s, it seems to signify
a chaste fidelity and a superiority over other women
grounded in more than mere beauty. Pompadour –
showing signs of facial embonpoint as in Vanloo's *'La belle
jardinière'* – also represents the vestal, charged with
authority over the other virgins and with a special
responsibility for keeping alight the sacred flame.
Moreover, she holds a weighty tome on the history of the
vestal virgins, as though to underline her intellectuality.[41]

The large number of paintings and sculptures of
Pompadour after 1750 testified to Pompadour's
commitment to multiply and diversify her own image.
Part of Pompadour's charm in the 1740s had been her
infinite diversity – but that diversity was most clearly
manifest in the many theatrical roles she awarded herself.
With her physical relationship with the king at an end,
artists were enlisted to reproduce the physical beauty that
Pompadour was finding difficult to retain in the fraught
atmosphere of the court – a cosmeticising development
in which Boucher, as we have suggested, played a key role.
Where that beauty was not pristine – as in the Vanloo
portrait of her as sultana and Drouais's depiction of her as
a vestal virgin – the content of the picture was framed in
terms that stressed the unique power of the official
mistress in a world of women dominated by men.

A particularly fine example of this modulation in
Pompadour's manipulation of her own image is provided
by Boucher's well-known canvas of her at her morning
toilette (fig. 41). At one level, this is a representation of a
mundane act in which any woman of breeding would
engage: composing her face in the powdered and
berouged style which was the norm at court, and possibly
receiving guests. Pompadour's toilette, however, was

famous and was satirised as such (fig. 42).[42] From the late 1740s, she turned the occasion of her toilette into a power strategy. The circumstance of the toilette meant that the tiresome minutiae of formal court etiquette did not apply, so that clients and guests could converse with their hostess within that ambiance of informality in which Pompadour excelled. Pompadour's toilette became celebrated for the amount of business that the marquise transacted at it. The ambitious courtier, the duc de Croÿ, realised that if he was to stand any chance of preferment, he would need to be an assiduous attendee at Pompadour's toilette. His memoirs also highlight how many of the loftiest courtiers were also by then willing to attend this ritual. These individuals may well have inwardly retained their lip-curling resentment for this bourgeois invader into their world; but they kept such feelings to themselves.

Penetrating recent scholarship by the North American scholars Alden R. Gordon and Teri Hensick has revealed this canvas as literally stitched together over a period of anything up to ten years.[43] They contend that Pompadour's face constitutes, almost in its entirety, the portrait that was sent out to Vandières in Italy in 1750 (rather than any putative 'lost' portrait), and that it thereafter remained in his possession. Forensic study reveals that the dressing table, the mirror and Pompadour's poised hand were added at various stages up until the late 1750s – possibly by artists other than Boucher.

In spite of these important caveats about a work that has attracted a good deal of critical attention, it is difficult to resist the feeling that this witty and ironic painting, in which one instinctively suspects a direct Pompadourian influence, says something important about Pompadour's identity. The work allegorises, in a way that would hold special meaning for the marquise and her intimates, the make-up process by which Jeanne-Antoinette Poisson had made herself up as an individual of quasi-regal proportions. As with Boucher's other portraits, the face is still unchangeably beautiful, and the application of cosmetics a statement that she had acquired this practice as a woman of elevated breeding – an identity further confirmed in her dress and accoutrements. Yet though Pompadour puts on her cosmetic mask to make her – as in Nattier's portraits – almost interchangeable with other women, it was in fact Pompadour's toilette that set her above all others of her gender. This included the queen, for it is relevant to note, in terms of the complicated relations Pompadour sustained with Marie Leszczynska, that almost alone among court women, the queen had abandoned the use of make-up out of religious piety. In this portrait, then, the marquise's glorification of the toilette triumphantly performs the identity of a queenly person she has herself made up.

LEFT

43
Detail of fig. 41

RIGHT

44
Jacques Guay
Louis XV, before 1764
Onyx cameo mounted
in a gold ring set with
diamonds,
1.6 × 1.3 cm (setting)
Bibliothèque Nationale
de France, Paris

Directly below her eyes, moreover, Boucher and/or his aides have placed the image of Louis XV, on a cameo bracelet, almost like a shackle of her own enslavement to him (fig. 43). Yet the self-referentiality about this particular jewel is worth noting: it was carved by gem specialist Guay, whose work Pompadour herself had engraved and published from the 1750s onwards (fig. 44). It has been suggested that the painter copied not Guay's image but Pompadour's representation of it (which was achieved almost certainly with Boucher's help and touching up). To some extent at least, this image of Louis was Pompadour's own work – a satisfying sign of her influence on her master rather than of his power over her, and a statement that in making up her own identity, she was also contributing to the reinvention of the image of the king.

4

Rococo Self-fashioning

Madame de Pompadour's concern to build up a body of images of herself that not only highlighted the diversity but also the permanence of her own beauty was part of a more wide-ranging process of self-making. Her portraits were usually intended for private interiors in which viewing would either be restricted to the king and his commensals or to intimates in her own dwellings. She did not protest against wider public viewing – the La Tour portrait and Vanloo's 'Sultana' were displayed in 1755 at the public showings of the Salon held at the Louvre, which from the late 1730s had become a regular fixture in Parisian cultural life.[1] Then Boucher's great 1756 portrait (see fig. 30) was exhibited at the 1757 Salon. The artist Gabriel de Saint-Aubin (1724–1780) sketched the part of the exhibition in which it was placed: for convenient viewing it was positioned on an easel on top of a kind of dais, which had an almost altar-like appearance (fig. 45). Saint-Aubin also sketched a satirical cartoon of himself – or perhaps of Boucher, who was renowned for his dalliances – as a satyr recording this key moment in Pompadour's public display (fig. 46). The implication that the public showing was a sycophantic charade would have had very serious consequences for Saint-Aubin had his drawing been made public.

Pompadour was not at all opposed to the idea of art having a wider public use, as we shall see.[2] However, her more pressing commitment to the commissioning of art lay in her own more private needs. She used art to embellish her life in ways which affected the identity she presented to king and courtiers. It was not simply her portraits that were part of the process of her self-fashioning. Over the course of her career as official mistress, she purchased every form of artwork and craftsmanship that offered decoration. She bought prodigiously and discarded almost nothing.[3] By the end of her life, several of her numerous properties were little more than junk-rooms in which her cast-offs were stored. After her death the inventory of her effects occupied a team of evaluators for more than a year – and a further year was needed

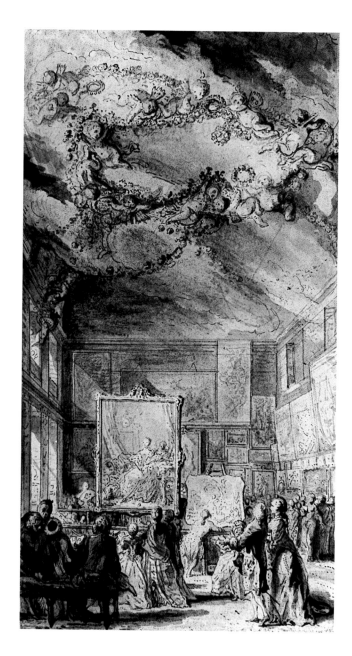

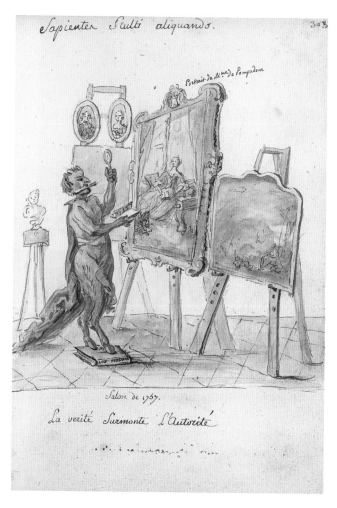

46

Gabriel de Saint-Aubin

The Wise are sometimes Stupid (Sapientes stulti aliquando) from

Livres des caricatures tant bonnes que mauvaises, 1775

Drawing, 18.9 × 13.4 cm, folio 303, inv. 675

Waddesdon, The Rothschild Collection (The National Trust)

45

Gabriel de Saint-Aubin

Boucher's Portrait of Madame de Pompadour at the Salon of 1757

from Du Perron, *Discours sur la peinture et sur l'architecture*, 1758

Drawing, 18.9 × 13.4 cm, inv. B1/8/2

Waddesdon, The Rothschild Collection (The National Trust)

to complete their sale. Two decades after the auction, writer Louis-Sébastien Mercier could still remember 'the admiration mixed with amazement' elicited by browsing amongst Pompadour's prodigious collection of 'objects of luxury, fantasy and magnificence'.[4]

A writer on social mores noted that 'each class is distinguished not only by the degree of power or respect it enjoys, but also by a sort of exterior appearance appropriate to the rank it holds in society'.[5] By this token, Pompadour's amassing of luxury commodities was a statement about her social identity: her constant commissioning reflected her own quest for an identity. The middle decades of the century constituted a period in which notions of connoisseurship among collectors were being refined. Yet even though many parts of her collections were unrivalled in quality, Pompadour was less a collector – a term that denotes choice, selection and discrimination – than a cultural accumulator.[6] Nearly all the canvases in her possession were for decorative purposes. The high quality of so many of the decorative arts in France at the time meant that she could put in an order for work and rely on Tournehem to make an apposite choice of artist. She showed less interest in the making of luxury objects than queen Marie Leszczynska, who scrutinised her commissions as they were being produced.[7] When Pompadour did pick and choose, moreover, she showed some surprising blind spots: she had no old masters in her collection, no work by Jean-Antoine Watteau (1684–1721) and only a couple of canvases by Jean-Siméon Chardin (1699–1779).

A subsequent generation of artists would scornfully characterise the age of Pompadour as a period in which the Rococo style was dominant. The Rococo – a term first used in the late eighteenth century, long after its period of alleged hegemony was at an end – was often thought to be Pompadour's preferred style. The term derived from *rocaille* – the combination of rocks and shell shapes characteristic of grottoes – and came to denote elegant asymmetrical and luxuriant ornamentation, with a content drenched in fantasy and imagination. The Rococo set itself in opposition to many of the artistic norms codified in the age of Louis XIV, notably by *premier peintre* Charles Le Brun (1619–1690). It shunned the grand, the public and the monumental for urbane values and a more domestic scale. Irony and wit were prioritised over pathos and heroism; lightness and fluidity over dignity and energy; pastel tones over chiaroscuro. The struggle to depict strong feelings and to express a moral pedagogy within the traditional aesthetic – which customarily reached its highest pitch in history painting (that is, the depiction of events in myth, ancient and biblical history) – was rejected for a more informal pursuit of the pleasurable.

Although often associated with the marquise, this artistic style – and many of its practitioners, not least Boucher – were already well established long before Pompadour began her patronage of the arts.[8] The royal mistress did not invent Rococo nor give it its first chance. If she accorded the style her approval and imprint, this was more because it already represented what was currently most valued in the world of art. Her accumulative instinct was so catholic that her purchases and commissions included works by the style's foremost practitioners as well as by artists critical of Rococo.[9]

The hegemony of the Rococo in post-Louis XIV society exacerbated a decline in history painting that was traditionally considered the apex of the traditional hierarchy of genres. This was linked to the absence of large-scale commissions after 1715, which reduced the part that history painting played in the work of most artists. The state was drying up as a source for major cultural projects even before the death of Louis XIV, and in the early decades of the reign of his successor the only work of this scale was the ceiling of the Salon of Hercules in Versailles, completed in 1736 by François Lemoyne (1688–1737). There were still churches that required major paintings, although Catholic fervour was beginning to wane and commissions were not numerous. Changes in styles of life among the social elite also affected the nature of demand. 'The public asks us for pleasing subjects' one of Lemoyne's pupils, Charles Natoire (1700–1777), noted in 1747. He added 'ever since I've been in Paris I've never been asked for anything else.'[10] What was 'pleasing' to Natoire's wealthy patrons were works that suited their elegant private *hôtels*. The popularity of sculpted wood panelling, stucco plasterwork, wall-hung mirrors and larger windows left less space for the traditionally outsized history paintings. The preferred artwork tended to be smaller-scale works, overdoors or ceiling panels. 'Everything is white and gold, with mirrors', noted Horace Walpole on his encounters with Parisian society around 1740.[11] Clients with premises designed in the new way sought out hedonistic and materialistic content, nicely exemplified by Boucher's pastoral nymphs and shepherdesses. They shunned the moral content of history painting.

Boucher was the artist who made his way most successfully in this changing world of demand. His possibly autobiographical painting – *Le Déjeuner* – with its combination of ornate, curving decoration and graceful and expensive material objects – is a typical Rococo interior, albeit at a far humbler level than Pompadour's (fig. 47). Son of a master-painter who ran a shop selling engravings, Boucher was a Parisian who rarely strayed far from the banks of the Seine; the pastoral countrysides that he depicted were drawn more from his imagination than from

OPPOSITE

47
François Boucher
Le Déjeuner, 1739
Oil on canvas, 81.5 × 65.5 cm
Musée du Louvre, Paris

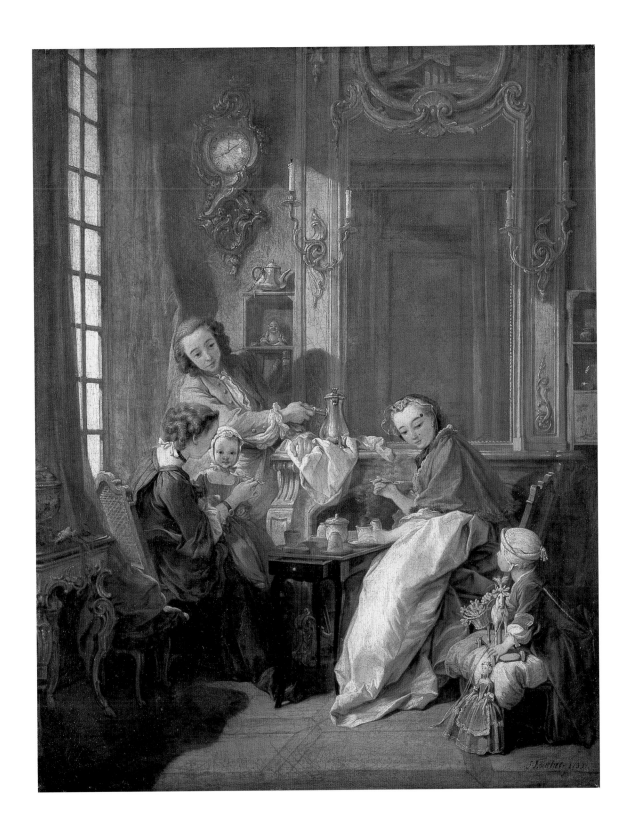

48
François Boucher
Painting and Sculpture, 1746
Oil on canvas, 217 × 77 cm
The Frick Collection, New York

rural life. After the death of Lemoyne in 1737 Boucher became the most sought after painter in France. He accepted occasional commissions for history painting, but generally left religious commissions to others, and concentrated on easel painting and miscellaneous other work. His contributions to the decoration of the fashionable *hôtel* of the prince de Soubise (1715–1717) in the late 1730s established his reputation for this kind of commission, and he was brought in to provide a similar service at Versailles. He also did a good deal of engraving; targeted a popular market with his '*Les Cris de Paris*' ('Paris Cries') series showing street traders; supplied designs for the Beauvais and Gobelins tapestry works; painted stage sets for the theatre; and even decorated Easter eggs for the royal family. Boucher was thus by far the best qualified, most versatile and most highly regarded artist available when Pompadour sought out a cultural factotum.

Pompadour was a model client: she had lots of money. The strength of the king's early infatuation meant that he granted her almost anything she wanted. One early New Year's gift to her comprised diamond-encrusted writing-tablets embossed with the royal arms, with a note for 50,000 livres attached.[12] Furthermore, her political manoeuvrings since becoming royal mistress had given her more influence over state commissioning of the arts than any woman since Louis XIV's grandmother, Marie de Medici, more than a century earlier. Her influence over the *directeur des Bâtiments du Roi* ensured that whatever Pompadour wanted, Pompadour got.

The marquise's demands were many and various, not least because part of her strategy for holding the king's affections and preventing him from brooding at Versailles was to circulate him around a string of palaces and country houses. One of the king's passions was architecture, in which he had developed some expertise from the 1730s onwards, particularly in the extensive redesigning and redecoration of the *Petits Appartements*. Pompadour used to say, according to the marquis d'Argenson, 'that one can only really keep the king amused with architectural drawings'.[13] His mistress now shared his interest and she also involved the king in her own decorative obsessions. Their joint activities, on which *premier architecte* Jacques-Ange Gabriel (1698 –1782) was a major influence, began in earnest at the end of the War of Austrian Succession in 1748. It was Louis's habit to move the court each year for a season to the royal palaces of Marly in the spring, Compiègne in the summer and Fontainebleau in the autumn, and these sites were subject to

49
After Jacques-
François-Joseph Saly
Hebe, before 1783
Marble, 100 × 30 × 20 cm
The Victoria and Albert
Museum, London

extensive remodelling. In both Compiègne and Fontainebleau Pompadour had little hermitages built within the grounds in which she and the king could escape the round of court protocol and indulge their taste for comfort, privacy and seclusion.

In 1749, the marquise accompanied Louis on a visit to the port of Le Havre, and the couple also made several visits to the homes of wealthy courtier friends. The vast majority of their travelling was, however, to royal houses such as the little ex-hunting lodge at La Muette, the château at Choisy-le-Roi and the new Saint-Hubert, near Rambouillet or to properties belonging to Pompadour. In 1746 the king had purchased for her the country house at Crécy, near Dreux in Normandy, which was enlarged by the architect Jean Lassurance, who was to become one of Pompadour's favourites, while the gardens were re-designed by Garnier d'Isle. An enormous amount of energy and expenditure went into furnishing and remodelling Crécy. Ornate panelling was created by the experts Verbreckt and Rousseau and Boucher was awarded the commission of decorating the octagonal study. He painted children representing the arts and sciences and Pompadour's daughter, Alexandrine, posed as model in the painting representing sculpture (fig. 48). The sculptors Vassé, Coustou, Allegrain and Falconet provided one work each for the *'laiterie'*, a kind of Rococo dairy in which Pompadour and her daughter dressed up as milkmaids for the king's delectation.

In time, however, even Crécy would be eclipsed by the house that Pompadour had built overlooking the Seine near Meudon at Bellevue. She chose the site, had the *Bâtiments du Roi* arrange the purchase, and at one stage (even though she regarded it as more of a bourgeois residence than a royal palace) had 800 workers attached to the site. Bellevue's formal opening in November 1750 was a bit of a disaster – the ovens smoked and the party had to be promptly shifted to a little dwelling in the grounds called Brimborion – and to crown matters the king was spotted looking bored. Yet despite this inauspicious beginning, the site evolved into an extraordinary pleasure zone and treasure trove. Statues on display included Falconet's *Music* (whose face was supposed to be modelled on Pompadour) and Saly's *Hebe* (fig. 49), as well as Pigalle's 'Friendship' suite (fig. 35).[14] The mythological theme developed in the sculptures was also evident in the painting, together with gentle rural themes and a diluted exoticism. The *chambre à la turque* highlighted Vanloo's harem scenes,[15] and there was much

chinoiserie to the fore (figs. 50, 51). Boucher's arts and sciences series composed for Crécy were mirrored in the allegorical series that Pompadour commissioned from Vanloo for Bellevue in 1753, using children as models. Vanloo ensured that Pompadour touches abounded: the sculptor chisels away at a bust of Louis XV (and the marquise had indeed commissioned such a work); the architect shows the master builders a front elevation of Bellevue; and a young girl plays music on one of Pompadour's favourite instruments, the harpsichord (figs. 52–55).[16]

Boucher had had to turn down a proposed commission from the Swedish ambassador in 1750 because he was working so hard on house decoration for the king – and for Pompadour. 'M. de Tournehem overwhelms him with orders for all the houses that the king has built or wants to embellish', the Swedish ambassador noted around this time, 'so that he has not a moment to give his private clients.' Boucher confirmed this state of affairs: 'I am still engaged in some of the works for Bellevue for Madame de Pompadour.' As always, he knew how his interests could be best served: 'These are things that one can neither refuse nor neglect, for to do so would be to deprive oneself of all the means of obtaining favours.'[17] For her bathroom, he painted *The Toilet of Venus* (fig. 56) and *The Bath of Venus*. In these works, completed in 1751, eroticism blends with mild prudery, and some personal touches – the vases depicted, for example, are likely to be exact copies of ones in Pompadour's possession. Some critics have detected the features of Pompadour in *The Toilet of Venus*. This seems far-fetched, though the toilette was of course one of Pompadour's sites of power at court, and it is also the case that she played the title role in *La Toilette de Vénus, ou le Matin*, a ballet by Lanjon performed at Versailles in 1750. 'Has one rivals to fear', Mars asks Venus/Pompadour in the piece,

52–53
Carle Vanloo
Painting, 1752/3 (LEFT)
Sculpture, 1752/3 (RIGHT)
Oil on canvas, 87.5 × 84 cm
Mildred Anna Williams
Collection, Fine Arts Museums
of San Francisco, CA

54–55
Carle Vanloo
Architecture, 1752/3 (LEFT)
Music, 1752/3 (RIGHT)
Oil on canvas, 87.5 × 84 cm
Mildred Anna Williams
Collection, Fine Arts Museums
of San Francisco, CA

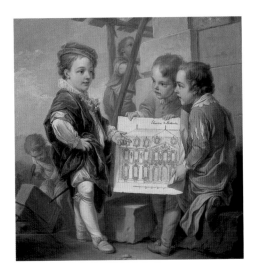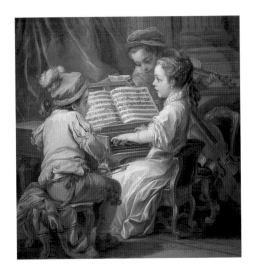

'When one has the allurements of Venus?'[18] Interestingly, the striped drapery encompassing the goddess in the painting bears comparison with that which was normally shown adorning vestal virgins in eighteenth-century paintings – and which Drouais depicted in his 1760 portrait of the marquise.[19] It stands as a quiet homage to Pompadour's fidelity to the flame above all other women.

The theme of the very special status of Pompadour is also evident in Boucher's two massive works, *The Rising of the Sun* and *The Setting of the Sun*, which were widely praised when shown at the 1753 Salon. The association of the sun with the French king and the daily rituals of the royal *lever* and *coucher* made the monarchical allegory

56

François Boucher

The Toilet of Venus, 1751

Oil on canvas, 108.3 × 85.1 cm

Bequest of William K.
Vanderbilt, 1920, inv. 20.155.9

The Metropolitan Museum of
Art, New York

OPPOSITE

57

François Boucher

The Setting of the Sun, 1752

Oil on canvas, 318 × 261.cm

The Wallace Collection,
London

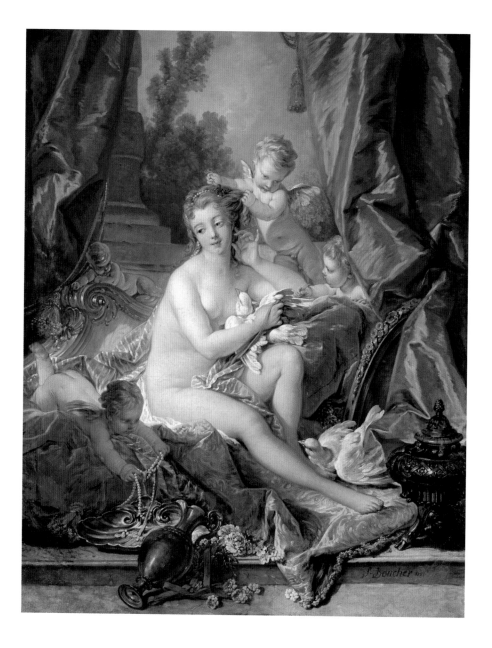

implicit in these works clear. What is particularly striking about the latter work (fig. 57) is the way that one chief nymph, Tethys, is singled out from the ranks of female mythic entities to welcome Apollo back beneath the waves following his passage across the sky. The painting allegorises and re-enacts the gender politics of the sultana and vestal virgin paintings of Vanloo and Drouais.[20]

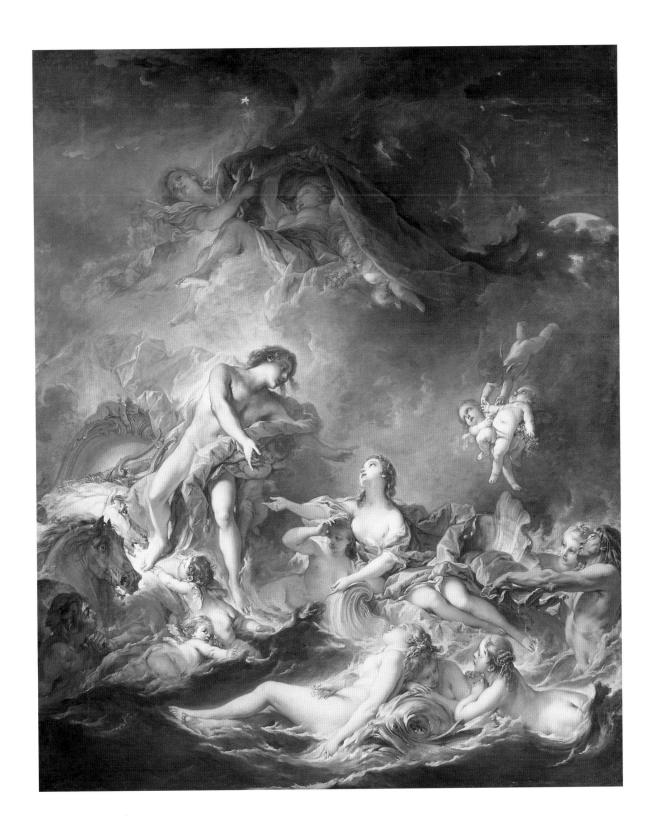

For a short time, Bellevue was Pompadour's showcase, a temple to her glorification, in which she and her roles as source of beauty, royal helpmate and patron of the arts were endlessly celebrated in a whirl of references, homages and artistic quotations. This was a fantastic confection which was not on view to all – any more than was a harem or the temple of the vestals, other dreamworlds in which Pompadour imagined herself. Exclusivity of access was the point of Bellevue. Like much of Pompadour's art, the house was intended only for Louis XV and the happy few privileged enough to be in their entourage. Indeed, as with attendance at her theatrical presentations, the marquise utilised invitation as a political stratagem designed to build and maintain her patronage network.

Central to the Bellevue experience was Pompadour's own presence – both in person and in artistic representations. When her friends and clients were physically unable to witness her image in a luxurious and royal milieu, those images had to be brought to them. Thus she had nineteen table-top copies made of Falconet's *Amitié* (bedecked with her own face) for presentation as gifts to intimates. Similarly, she had a three-sided cachet fashioned that contained images based on engravings by Guay: *Love Consoling Friendship*, *Love and Friendship*, and *The Temple of Love*.[21] These images are also found in her own book of engravings and the cachet itself is evident in Boucher's 1756 portrait (see fig. 30). With that cachet she sealed her letters: the image of Pompadour circulated with her post.

In 1757, Pompadour sold Bellevue to the king and though she still visited it frequently with him, she moved many of the most striking works of art into her other residences. Following this sale, she bought a country house at Champs from the duc de La Vallière, and soon afterwards a property at Saint-Ouen from the duc de Gesvres. It is difficult to tell whether she was seeking new sites for cultural display – or merely speculating in property. She may well have been doing both. Her dealings in real estate were shrewd and increased her wealth considerably. Although she received a monthly allowance from the king, plus occasional gifts, she also depended on the sale of jewels and winning at court gambling parties to raise cash. The purchase of the house at Champs on the Loire – some distance from Versailles – may have been intended for her retirement, although she was not to have time to develop it for this role. More directly of use was her purchase from the comte d'Evreux of his elegant private *hôtel* – the present-day Élysée palace – which abutted on to the Champs-Élysées, and which she equipped in great luxury and at considerable expense. Falconet's statue of Cupid originally destined for Bellevue, found its way to the *hôtel* in the late 1750s (fig. 58). The statue, sometimes referred to

as *Threatening Love*, has a slightly ambiguous feel to it. Atop a cloud, trailing roses, the god of love puts his finger to his lips in a way that enjoins secrecy. The figure illustrates the twin Pompadourian themes of discretion and fidelity that lay at the origins of her relationship with the king.[22]

A particular advantage of the Hôtel d'Évreux for Pompadour was its closeness to the Rue Saint-Honoré, which had become the centre of the flourishing trade in fashionable goods. A leading figure in this respect was Edmé-François Gersaint, supplier of high art to the rich and famous but also dealer in luxury items of every description. Watteau's *L'Enseigne de Gersaint* (*Gersaint's Shop Sign*) shows the interior of his shop hung with fashionable paintings (as well as some less fashionable, such as a portrait of the deceased Louis XIV, shown being put into store), while wealthy ladies consider their choice (fig. 59).[23] In 1740, Gersaint changed his shop title from *Au Grand Monarque* to *A la Pagode*. He arranged for Boucher to design a trade card for him, highlighting the *chinoiserie* in which (as the pagoda reference in the shop's title suggests) he specialised (fig. 60). He still relied on pedlars and commercial travellers of the kind shown in Boucher's *The Dressmaker*, who brought showroom samples into many a bourgeois domestic interior (fig. 61). But he also began a series of entrepreneurial initiatives to expand his trade – he advertised in the newspapers, organised public auctions with well-trumpeted advance showings, and published sales catalogues.

Figures like Gersaint were crucial in lubricating the burgeoning market for luxury goods in eighteenth-century Paris, providing new lines, importing foreign goods (and encouraging import substitution), yoking together new teams of workers and bringing into contact wholesaler and retailer, customers and producers. Another such dealer was Lazare Duvaux, proprietor of *Au Chagrin de Turquie*, whose surviving order book from 1748

59

Jean-Antoine Watteau

Gersaint's Shop Sign, 1720

Oil on canvas, 163 × 308 cm

Schloss Charlottenburg,

Berlin-Brandenburg

to 1758 gives details of his wealthy clientele, including Madame de Pompadour, his very best customer.[24] It was from Duvaux that Pompadour acquired the essentials for the decoration of her residences. She made over a dozen purchases in October 1752 for Crécy alone and nearly twenty in October 1758 for her house at Champs. Plus there were treats for herself and for others. Chinese and Japanese lacquer, crystal chandeliers, and porcelain were her main loves. She also purchased the equipment for making coffee (such as cafetières and spirit lamps) and gold-plated dog collars for Mimi and Inès embossed with her coat of arms (her expenditure of 530 livres on the collars in the course of 1755 alone was markedly more than the annual wages of a Parisian stonemason). Duvaux was also one of her suppliers of jewellery. Much of this was donated to the state in 1759,[25] but even so by her death less than five years later she had still amassed a cache of diamonds worth nearly two million livres, engraved jewels estimated at 400,000 livres and sizeable collections of antique lacquer and gold and silver plate.[26]

Pompadour's portraits linger over the extravagant commodities that surround her (not least those voluminous cascades of high-quality fabric) and reflect an ideal to which her life at court and in her private residences also aspired. The decorative value of her paintings was thus reinforced by all the accoutrements of daily living, for which she could draw, through the *Bâtiments du Roi*, on the finest artists working in the decorative arts in Paris. It was as much by immersing herself, and her royal friend, in a world of beautiful objects as in her obsessive portraiture that Pompadour fashioned her identity in the canons of the Rococo.

5 Patriotism and Piety

Popularity was not Pompadour's strong suit. She spent so much energy on keeping the king's affections, maintaining her balance in the treacherous world of court faction and circulating her image amongst the happy few of her friendship network, that she had little time to develop a strong identity beyond that. As we have seen, rather than shower compliments on the official mistress, Parisians – prompted by malicious denizens of Versailles such as Maurepas – saw her as an expensive distraction for the king, keeping him away from his duties and emptying the royal purse. Though the Parisian songsters had welcomed Pompadour in 1745 as 'less ambitious and more beautiful/ Than Diane [de Poitiers] and Gabrielle [d'Estrées]'[1], this sentiment was soon forgotten in a host of sniping satires and ditties, which did not dry up after Maurepas's departure.[2] Indeed, hostility towards Louis – and Pompadour – flared up even more spectacularly in 1750 in the shape of a sudden and almost inexplicably violent outburst in Paris: the affair of the vanishing children.

Following the Treaty of Aix-la-Chapelle in 1748, military demobilisation and high bread prices had caused a great deal of population movement, vagrancy and petty crime. In 1749, the Paris police authorities began to arrest the homeless, with the aim of returning them to their native villages. The round-up extended to children who were found in the streets, and a rumour started that the government was secretly aiming to people French colonies in America with Parisian children. Riots broke out in April, with crowds hunting down the Paris Police Lieutenant, Berryer, and even murdering several suspected child kidnappers. They came close to assailing Pompadour, who was out shopping in the city. She was, it was melodramatically reported, 'only one street away' from being 'torn apart by the rebels'.[3] The movement was put down effectively with a few token executions. However the outburst

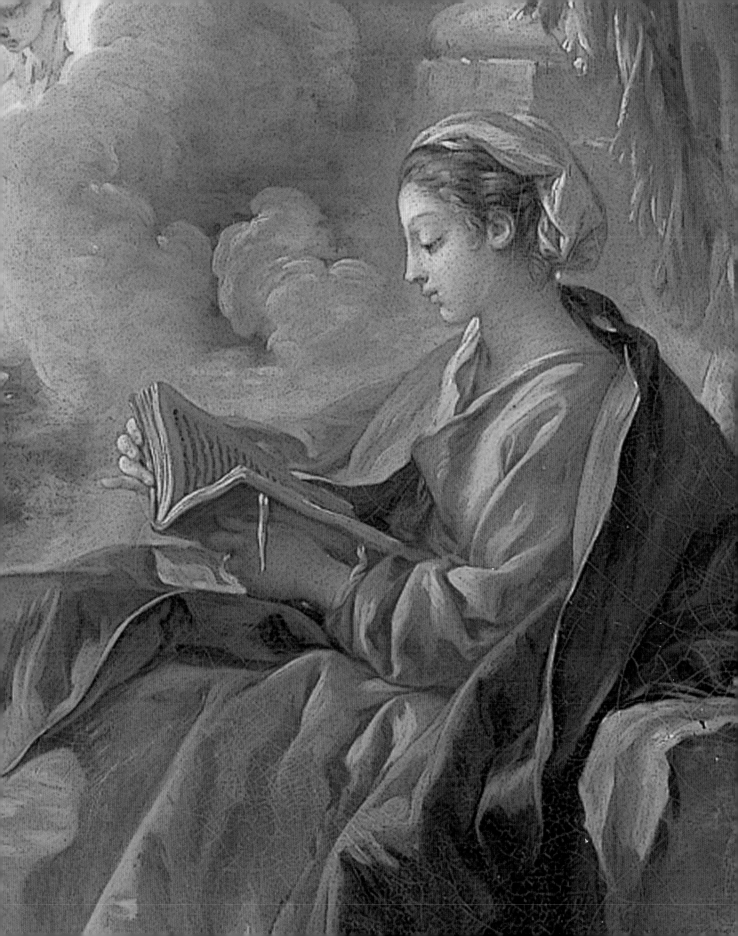

highlighted, and almost certainly exacerbated, the hostility of Paris towards the royal court. The Parisian barrister Barbier recorded in his journal that:

…people have been saying that the object of these child-kidnappings is that there is a leprous prince who needs baths of human blood for his cure, and as there is no purer blood than that of children, they have been taken and bled from all extremities and sacrificed.[4]

When informed of this rumour, the king said, with a reference to the Massacre of the Innocents, 'they are treating me as Herod'. He was profoundly depressed by the idea that his sobriquet, *le Bien-Aimé* was becoming *le Bien-Haï* ('the Well-Hated').[5]

Although the birth of a son, the duc de Bourgogne, to the Dauphin in 1751, caused a mild flutter of popularity for the king, it did not last. The monarch had reacted imperiously to the vanishing children episode. He pointedly refused to pass through Paris on his way from Versailles to Compiègne. He visited his capital less and less and from the 1740s never spent a night in the city. He used the road via Saint-Denis, now the chemin de la révolte, so that he could avoid it while travelling between his residences. Choiseul was exaggerating both wildly and perfidiously when he wrote that, Nero-like, Louis XV would have been 'delighted to see Paris burn from Bellevue (though he would have lacked the courage to give the order)'.[6] But henceforth the king would drift between cool contempt and mild disinterest in all his dealings with his capital city.

Pompadour was also disdainful towards the 'follies of the Parisians'. Her own childhood had not been without its problems, particularly when her father was disgraced and abandoned her mother in some material difficulty, yet she had no real sense of the kind of anxieties and distrust of authority bred by poverty. She can have had no real knowledge of what most Parisians thought and felt. Her spending on Crécy, Bellevue and her other homes was taking place just as the government was trying to increase taxes to recover financially from the War of Austrian Succession. Yet the marquise showed no awareness of how her prodigality would be perceived by the nation's tax payers. She had climbed the social ladder – and pulled the ladder up after her. 'I don't think there is anything so silly as to believe that people want to bleed their children for a leper-king to bathe in. I shamefully confess that I thought them less imbecilic.'[7] She did accept the king's desire for economies to pre-empt the need for higher taxes on a population already suffering economic hardship: she cut the theatrical troupe at Versailles (though she temporarily reconstituted it in Bellevue). But this was hardly destined to eradicate her reputation for prodigal spending.

Although Pompadour had proved utterly relentless in tapping the services of the *Bâtiments du Roi* for her own uses and private pleasures, she was also aware of the need for developments that served public utility and royal popularity more manifestly, and also made her seem less like materialistic *fermier-général* stock. (Her support for the *philosophes* had a similar inspiration.) Here again, she looked back to the reign of Louis XIV for models, her inspiration coming less from the king's mistresses than from his ministerial and policy aide, Colbert, whose portfolio of responsibilities had included the *Bâtiments du Roi*, and whose altruistic commitment to state service was legendary.

There were two aspects of 'neo-Colbertianism' associated with Pompadour's period as mistress. The first was the quest, initiated by her allies (and relatives) Tournehem, then Vandières (soon to be known as the marquis de Marigny), to revitalise the quality, training and public *éclat* of French artists. The despatch of Vandières to Italy in 1749 deliberately echoed Colbert's sending his own son, Colbert de Seignelay, to the peninsula as part of his education for royal service. Tournehem, realising his own limitations in a field that was new to him, had Charles-Antoine Coypel (1694–1752) appointed by the king as *premier peintre* (an office which had lain vacant), for advice on commissions and choice of artists, and took as artistic consultants Vandières's friends, the abbé Leblanc and Cochin. The wish to restore history painting to the glory days of Louis XIV and his *premier peintre* Charles Le Brun led Tournehem to establish a competition in 1747 to renew interest in the genre, and also to create in 1749 the École royale des élèves protégés. This would be a kind of prep school for young artists, who were to be taught, alongside their technical training, 'a sufficient tincture of history, fable, geography and other forms of knowledge' to rekindle their interest in history painting.[8] The official price roster was altered, with prices for portraits being reduced to the benefit of history painting.

Tournehem and his successor also sought to encourage the growing interest of the public in matters artistic. The transient activity of the Paris Salon was from 1750 complemented by permanent exhibitions of pictures from the royal collections in the Luxembourg palace on the Left Bank of the Seine. The *Bâtiments du Roi* also showed interest in major projects of urban embellishment in Paris. Work was begun on refurbishing the Louvre, which was in some disrepair. In addition, support was given to the Paris municipality's plans for a large city square to honour the king following the Treaty of Aix-la-Chapelle of 1748. Tournehem invited plans to be submitted for a commission based around a statue of the king to be located in the Place Louis XV (now the Place de la Concorde). Plans were also started on the

building of a church dedicated to Sainte Geneviève, in fulfilment of a vow made in 1744 at the time of the Metz incident. For this project, which led to the building of the Sainte-Geneviève church (now known as the Panthéon), Pompadour supplied the architect. Overcoming the assumption that *premier architecte*, Gabriel, would provide the plans, she handed the whole business over to Marigny's friend, the architect Jacques-Germain Soufflot (1713–1780) who was to turn it into a Neoclassical temple.[9]

A further initiative with public scope was the establishment of a military academy – a measure that would be especially popular amongst the noble elite. France somewhat lagged behind other European powers in this respect: the regent had not listened to representations from Antoine Pâris after the death of Louis XIV concerning the need for a training school for officers. The plan had been passed around government offices ever since, but it came back onto the agenda once the Pâris brothers' protégée had achieved a position of influence at the heart of government.

Pompadour later claimed to be largely responsible for the École militaire, which was founded in January 1751. This was an exaggeration, and her adoption of the project owed much to her sense of how her association with it dovetailed with her political ambitions. She appears to have viewed it as a homologue to the school of Saint-Cyr founded in 1686 by Madame de Maintenon, for poor girls from the ancient nobility. The new military academy was planned to receive some 500 sons of old noble families whose fathers had fought in the army or fallen in battle. The king was soon won over to the idea, though he wanted a proper endowment for the institution to be established before it was announced publicly. Throughout 1750, he and Pompadour worked on the plan alongside her old backers – Pâris-Duverney, Pâris-Montmartel, Tournehem – and the architect Gabriel. In September 1750, she visited Saint-Cyr: 'they all came up to me to say that they wanted a similar institution created for men', she recounted to Duverney, 'which made me want to laugh, since when our business is done they will think it was they who gave me the idea!'[10] It was to Duverney that she looked 'to make sure that all the world knows about it', so it could accrue to the king's glory.[11]

In the event, the École militaire's foundation document of January 1751 failed even to mention her name – although the lengthy article on the new institution written in the *Encyclopédie* was more generous.[12] She paid workers out of her own pocket when the building was having cash flow problems, not wishing to hold up progress on an institution that in her eyes was aimed 'to immortalise the king, rejoice his nobility and make known to posterity my own attachment for the state and for the person of His Majesty'. Her words recalled the advice about the need for political selflessness

that she had been given in 1745.[13] In the event, the institution was too slow in the building to accrue very much to her own glory. The war minister, the comte d'Argenson, attracted the plaudits for setting up the École in temporary quarters and making sure it actually functioned, and the buildings with which Pompadour was associated were only completed after her death (fig. 62).[14]

The second neo-Colbertian element in Pompadour's artistic policy was in regard to industry. Colbert had sought to sponsor state manufactures that would supply the needs of the state and of the social elite and also create commodities that would be exported, reducing France's dependence on imports and attracting foreign currency into the country. The producers of luxury goods had benefited from France's fashionable status across Europe in building up a 'fashion cycle', particularly evident in the garment trades. From the late seventeenth century, for example, Lyon silk manufacturers launched new lines at high prices, waited until rival producers in other countries started copying the styles at competitive prices, then dumped their stock and launched a new style. To some degree, Pompadour found herself taken up

in this cunning mechanism: the portraits of her that were most intended for public consumption (such as the La Tour pastel, shown in the 1755 Salon, and the 1756 portrait by Boucher) were both examples of current dress styles.[15] With Pompadour enlisted as mannequin for the Paris garment industry, Versailles was increasingly bowing the knee, at least in regard to female fashions, to the capital.

If wearing fashionable clothes by French couturiers was a way of showing one's dedication to the national interest, championing French porcelain was another. Here, Pompadour was more than willing to play the part, as she put it, of 'good citizen'.[16] The arrival of Chinese and Japanese porcelain in the late seventeenth and early eighteenth centuries had set European manufacturers on an emulative quest. Very few localities, however, had access to deposits of kaolin necessary for the manufacture of the hard paste porcelain characteristic of the East. One of these locations was Saxony and the porcelain ware coming out of Meissen had become Europe's product champion, combining technical artistry with sometimes-questionable taste (fig. 63). Pompadour herself bought from this source, sometimes via Lazare Duvaux, particularly objects in keeping with the oriental themes she showcased at Bellevue. But she was also aware of the qualities of the French ware

64 French console table,
about 1750
Carved and gilded oak topped
with marble, 88.5 × 116 × 40 cm
Musée National des Châteaux
de Versailles et de Trianon

65 Sèvres inkstand, probably
1758–9, painted by Jean-
Baptiste Tandart the Elder
Soft-paste porcelain,
5.5 × 30.1 × 19.2 cm
Gift of J. Pierpont Morgan
The Wadsworth Atheneum
Museum of Art, Hartford, CT

produced at Vincennes, Rouen, Lille, Chantilly and Saint-Cloud. At her death she owned 475 items from Meissen, but four times as many French-produced items.[17] From early on Vincennes was her particular favourite, especially for the porcelain flowers in which it specialised. Prudently, Duvaux visited the works weekly to scrutinise and give advice on what came off the production line. In 1745, the crown gave the company established in the château at Vincennes a twenty-year monopoly of French production of porcelain *façon de Saxe*. Pompadour's interest seems to have determined Louis's decision, when the company struggled in the early 1750s, to shift production from Vincennes to Sèvres, which was very close to his mistress' beloved Bellevue (and where she owned a bottle factory). The king increased state aid and in 1759 purchased the factory outright.

Pompadour's voracious buying habits included the full range of the decorative arts. Her taste for lacquerware, marquetry, tapestries and other luxurious commodities set many Parisian workshops running (figs. 64, 65). But it was with Sèvres that her name was enduringly associated. Her well-known link with the *Manufacture royale de Sèvres* was a productive one for the fledgling company – even though the clear definition of a 'Pompadour style' is difficult to pin down, and despite the fact that the company's distinctive pink, *rose Pompadour*, seems only to have gained that name after her death. Most of the porcelain designed in her life time or purchased by her was in a variety of blues and a good deal in fact was white – the so-called 'biscuit' developed by the company. Nearly all the Sèvres statuettes in Pompadour's possession were in the latter medium. The quality of painting on the coloured ware was very high, with first Bachelier, then Falconet leading a team of specialists on each type of subject (such as animals, children or landscapes). Falconet was also responsible for using designs by Boucher, whose child and animal figures were also copied for the statuettes. Falconet was resentful of being obliged to rely on his fellow artist in this way, but later sighed, 'Boucher was Boucher, and the orders

66

Pair of Sèvres vase candelabra, 1760, painted by Charles-Nicolas Dodin
Soft-paste porcelain, 43.5 × 26 × 18.5 cm
Acquired by Mrs Henry Walters, The Walters Art Museum, Baltimore, MD

67

Pair of Chinese Kangxi vases, about 1685–1720, on French mounts 1740–1750
Hard-paste celadon porcelain with gilt-bronze mounts, 30 × 15.5 × 11 cm
The Victoria and Albert Museum, London

68 Vincennes pot-pourri
Pompadour, about 1751
Soft-paste porcelain, with a
later gilt-bronze stand
45.7 × 24.2 cm
Private collection, courtesy of
Christie's, London

69 Sèvres gondola pot-pourri,
1756–7, painting attributed to
Charles-Nicolas Dodin
Soft-paste porcelain,
35.9 × 36.8 × 20.3 cm
Gift of the Samuel H. Kress
Foundation, 1958, inv. 58 75.88
a-c, The Metropolitan Museum
of Art, New York

were quite clear'.[18] The many practical objects that Pompadour purchased from Sèvres included the famous elephant vases (fig. 66). The kinds of Pompadourian intertextuality that the marquise practised as regards her own image also found an echo here: there were vases, for example, making play with her maiden name of 'Poisson' (fig. 67).[19] She also owned no fewer than twenty-eight pot-pourri holders, one style of which came to be known as a 'pot-pourri Pompadour'. Olfactory bombardment from flower vases, pots-pourri and exotic perfumes was part of the multi-sensory Rococo experience that Pompadour fashioned for herself and her intimates (figs. 68, 69).[20]

Besides these objects purchased for private use, Pompadour often utilised Sèvres (often purchased through Duvaux) for the diplomatic gifts that she and the king made to foreign rulers and their ambassadors – the duke of Zweibrugge (1754), the duchesse of Strozzi (1755), and empress Maria-Theresa of Austria (1758), for example. The king was also a keen collector of porcelain. In 1754, Croÿ records him getting his courtiers to help him unpack:

…the beautiful, blue, white and gold Vincennes[21] service, that had been sent from Paris, where it had been exhibited to connoisseurs. It is one of the first masterpieces of the new porcelain manufactory, which hopes to surpass and bring down Meissen.[22]

The king purchased around 25,000 livres worth of Sèvres each year, on top of Pompadour's purchases. From 1758, the two of them organised annual sales of new lines from Sèvres aimed at courtiers, which brought in anything between 80 and 100,000 livres. A special shop was opened up on the rue de la Monnaie off fashionable rue Saint-Honoré as a 'dépôt royal des porcelaines de Sèvres' so as to encourage Parisians to emulate royal taste. Pompadour berated those courtiers who failed to support local produce: 'the marquise says not to buy as much of this porcelain as one can afford', the marquis d'Argenson recorded, 'is simply not to be a good citizen.'[23]

Pompadour's continuing collaboration with the king on matters of cultural policy was not enough to prevent her giving in to bad feelings at times. 'Except for the happiness of being loved by the one one loves', she opined, 'a solitary and less brilliant life' would have been preferable to her current lot.[24] The discordant notes that Pompadour had struck earlier in the relationship continued. Her health was never strong, and she was put to the test by the fact that from 1750 Louis began to have affairs with other women.

Initially, Pompadour may well have winked at this development. Indeed, it was claimed that one of the first of king's mistresses following their rift was Mademoiselle de Trusson, one of Pompadour's former acting troupe, whom the marquise was said to have almost pushed into the arms of the king.[25] Rumour had it that she continued to act as procuress, finding a string of lovers for royal consumption. The Hungarian nobleman, count Joseph Teleki, who visited Versailles in 1760 was certainly given to understand this was the case. Pompadour had, he confided, 'a certain illness which prevents the king from sleeping with her'. Instead, 'he sleeps with the women selected by her'.[26] Yet there seems little hard evidence that Pompadour acted as high-class procuress for the king over the long term. That role seems to have been taken again by *premier valet de chambre* Le Bel, who had much experience in the kind of discreet communication and cover needed to keep such things firmly under wraps – as seemed to be the king's wish, as well as Pompadour's.

For the king to acknowledge a new mistress publicly would inevitably have placed great strain on Pompadour's position, and probably have ended it altogether. To stay in place, she needed to prevent any woman of rank developing a relationship with

the king. This point was brought home to her in 1751–2, when the king started writing gallant letters to the comtesse de Choiseul-Beaupré, newly arrived at court. War minister the comte d'Argenson and his lover, Pompadour's 'friend', the comtesse d'Estrades, saw this as an opportunity for the removal of the marquise and the promotion of their own candidate to official mistress. They threw their support behind what soon became Choiseul-Beaupré's bid for mistresshood. However, the comte de Stainville was the woman's cousin and, feeling that her becoming the lover of the king blighted the family escutcheon, he inveigled the king's letters from her, and took them to Pompadour. The marquise showed them to the king, who reacted by withdrawing embarrassedly from the relationship and banishing the poor countess from court. The royal banishment of the perfidious d'Estrades took a little longer, but Pompadour managed to obtain it in 1755.

Pompadour came out of the affair well, and the remorseful monarch even conferred ducal honours on her (although she continued to use the title of marquise). Yet her vulnerability to being ousted from favour by factional intrigue had been starkly highlighted. Thereafter she worked hard to keep such women away from the king, possibly even encouraging Le Bel to provide a series of willing young women from a background she adjudged too lowly to provide real rivalry. The most striking early case of such a woman was the beautiful Mary-Louise O'Murphy, daughter of a wayward Irish exile and a mother keen to sell her and her sisters to the highest bidder. 'Morphise' may have been Boucher's model for *Odalisque* (fig. 70). Even if she was not – and the likelihood seems against it[27] – the painting still gives a sense of what Pompadour was now up against.

Mademoiselle O'Murphy may have been the first *petite maîtresse* to be set up in the private house in Versailles known as the Parc-aux-Cerfs. This discreetly-run institution was the subject of much fabulation. The duc de Croÿ estimated that the king had housed nearly one hundred women there, nearly ten times more than was the case. The young women were paid for by a 'Polish nobleman' whom only Mademoiselle O'Murphy (after consulting a banknote to compare likenesses) recognised as the king of France. Louis found the young women husbands, and settled money upon the children they bore him. Louis XIV had legitimised several of his bastards and sought to put them in line for the throne. This had caused too much political turbulence for Louis XV to want to repeat the experiment. Though he did in fact legitimise their births discreetly, the children were not presented at court.

On learning of the king's first *petites maîtresses* in the early 1750s, many courtiers cheerfully predicted the worst for Pompadour. After all, sexual continence was the

70

François Boucher

Odalisque, 1743

Oil on canvas, 59 × 73 cm

Alte Pinakothek, Bayerische

Staatsgemäldesammlungen,

Munich

shortest chapter in the annals of official royal mistresses. However, the end proved not to be nigh, and the sexual outlet that these women provided the king, who was able to keep them sealed off from affairs of state and court intrigue, seems to have strengthened rather than weakened Pompadour's position. Croÿ, attending her toilette after the news of the resumption of the *passades* was first out, adjudged her 'more in credit than ever and still just as pretty', while Luynes also noted that she 'was more powerful than ever'.[28] As we have seen, several of Pompadour's portraits – notably Vanloo's portrait of Pompadour as a sultana and Drouais's vestal portrait – even seemed to acknowledge these new sexual arrangements, and stressed the marquise's dominant position over the other women in the king's life.

What became increasingly clear in the early 1750s was that Pompadour probably had less to fear from the king's sexual drives than from his spiritual remorse. Despite his carnal sins, Louis was too firm a believer to accede to the hypocrisy of taking communion or performing the touching for the King's Evil. There was also a custom of moralising sermons in Lent in the presence of the king, so that each spring the *dévot* faction at court joined with ecclesiastical dignitaries to bring the king under pressure. 1751 was a jubilee year in the church, and the *dévot* faction organised a religious campaign urging Louis to return to the path of spiritual and marital righteousness. He resisted, but Pompadour suffered some worrying alarums. The sudden death of his daughter Henriette in February 1752 was followed by the illness of the dauphin from smallpox in September. Had the dauphin died, as at one moment seemed likely, the king would almost certainly have seen it as a punishment from God and banished Pompadour from court. The dauphin lived and the marquise survived.

Pompadour's thoughts seem to have been straying more and more towards devotion. It is impossible to get a clear idea of Pompadour's inner spiritual life, given the degree to which she fashioned her identity by projecting idealised images of herself.[29] Although she commissioned Joseph-Marie Vien (1716–1809) to provide paintings for the hospital that she founded at the village of Crécy[30], adjacent to one of her favourite residences (fig. 71), Boucher was again her favoured artist in matters spiritual. Outside his relations with the marquise, Boucher was no more a religious painter than he was a portraitist; but she seemed to bring out the best of him. His *Adoration of the Shepherds* (fig. 72) was commissioned for the chapel at Bellevue around 1750. The painting was subsequently turned into a very popular engraving by Étienne Fessard (1714–1777), known as *The Light of the World*.[31] Boucher uses the infant Jesus almost as a light source to illuminate a picture whose tranquil stillness allays a

71
Joseph-Marie Vien
The Visitation, 1752–3
Oil on canvas, 35 × 22 cm
Musée des Beaux-Arts, Rouen

OPPOSITE
72
François Boucher
The Adoration of the Shepherds,
1750
Oil on canvas, 175 × 130 cm
Musée des Beaux Arts de Lyon

73

François Boucher

The Infant Christ blessing

Saint John, 1758

Oil on canvas, 50 × 44 cm

Galleria degli Uffizi, Florence

OPPOSITE

74

François Boucher

Saint John the Baptist,

about 1757

Oil on canvas,

163.8 × 115.6 cm

The Putnam Dana

McMillan Fund,

Minneapolis Institute

of Art

somewhat cloying sentimentality. Much the same can be said for Boucher's other religious works, nearly all of which were associated with Pompadour. This included his putti-like *The Infant Christ blessing Saint John,* (fig. 73) and a number of other paintings with biblical themes (figs. 74, 75) as well as etchings he made for Pompadour's prayer book.[32]

Boucher's religious commissions provide far less insight into Pompadour's character than his other work for her, and it is necessary to look elsewhere for the motivation behind her growing interest in religion. The marquise's personal

75 François Boucher

The Flight into Egypt, 1757

Oil on canvas, 139.5 × 148.5 cm

The State Hermitage Museum, Saint Petersburg

76
Louis-François Aubert after François Boucher
Alexandrine Lenormant d'Étiolles, 1751
Enamel on metal in a copper frame, 2.8 × 2.4 cm
Musée Lambinet, Versailles

circumstances and the intimations of mortality gained by simply getting older should not be discounted in any change of attitude she showed. Many of the individuals who had shaped the early part of her career were dying. Tournehem passed away in 1751, while the death of Madame de Tencin in 1749 was followed by her brother, now cardinal de Tencin, moving away from Paris. Then, within a matter of months in early 1754, her father and her daughter Alexandrine (fig. 76) both died suddenly. Pompadour had been in closer contact with the church as a result of visiting her daughter at the convent of the Assumption in Paris. She had even arranged for Alexandrine to be betrothed to the young duc de Pecquigny, son of the august duc de Chaulnes. The death of the child was a heavy blow. 'All satisfaction for me', the marquise wrote, 'died with my daughter.'[33]

The impact of these deaths should not be underestimated in shaping Pompadour's interior life. All the same, it was less the personal tragedies than the sense that her further advancement would be favoured by a move towards devotion which appears to have been most influential in her conduct. She was not alone in believing that the king, who was spasmodically wracked by spiritual guilt, would eventually succumb to piety. From the early years of his reign courtiers had said that 'the king fears hell and that sooner or later he will pass from his pleasures to the

most excessive devotion'.[34] In 1750, the prince de Kaunitz, evoked 'these returns to devotion [by the king] which are very frequent and make the marquise tremble'. 'It is not merely to hazard a conjecture', he believed, 'to maintain that [her] plan is formed on the model of Madame de Maintenon. If the queen were to disappear, one would soon see [Pompadour] a *dévote*.'[35] The influence of the Sun King's mistresses had already been apparent in Pompadour's development as patron of the arts and of men of letters. Her move away from sexual relations with the king seemed to echo the case of the prudish Maintenon who was not believed to have continued sexual relations with him in their later years. (In fact, Maintenon was well into her seventies when she sought spiritual guidance from the church over whether she was duty bound to submit to sexual congress with Louis twice daily!)[36]. Were the queen to die – she was nearly twenty years older than Pompadour – then a morganatic marriage *à la Maintenon* was not out of the question. She certainly reflected on such matters: 'I would have preferred the big niche', she wrote to the duc d'Aiguillon in the late 1750s, 'and I'm sorry to have to content myself with the small one; it doesn't suit me at all.'[37]

If there was a case for Pompadour pre-emptively striking out towards piety, the course of public affairs in the early 1750s was also driving her towards the *dévot* camp. From the late 1740s, a major religio-political dispute arose over Jansenism, an Augustinian form of Catholicism stressing human sinfulness, which had developed over the seventeenth century and the alleged precepts of which had been formally declared heretical by the Unigenitus papal bull of 1713. The Jansenist movement had, however, developed a popular following, and had supporters within the church and the state. In particular, the Paris *Parlement* – a high court of law that also had the right to protest against royal legislation which could be claimed to be unconstitutional – had become a strong defender of Jansenism. The *Parlementaires* were formally opposed to the ruling of the archbishop of Paris, Christophe de Beaumont (1703–1781), a virulent anti-Jansenist, that only individuals who were able to produce a *billet de confession* (confession certificate) from their parish priests (who had to have sworn obedience to the Unigenitus bull) were to be given the last rites. There was a running battle between the *Parlement* and de Beaumont and the *dévots* (including the queen, whose pro-papalism was such that she was dubbed 'Unigenita')[38] throughout the 1750s. On several occasions the magistrates went on judicial strike and threatened to close down the operation of justice within the realm.

The king and government sought desperately to find a way out of a hopelessly polarised situation. Pompadour's apprenticeship amongst members of the *philosophe* movement had left a deep enough mark for her to feel uncomfortable with the

religious intolerance exhibited by the *dévots*. 'Your *billets de confession* are an excellent thing', she wrote to de Beaumont, 'but charity would be even better.'[39] Yet her hostility towards the magistrates of the *Parlement* was even more extreme: they were 'plebeians' (something of which she herself was often accused), 'petty republicans', 'lunatics and bad citizens'[40] who ought to learn that their first duty was obedience to the wishes of the king. More curial than most courtiers, in political matters Pompadour was more royalist than the king.

In the midst of these political struggles, Pompadour's allies suggested that if she could regulate her relationship with the church she could be awarded a position in the ceremonial household of the queen, which would solidify her position at court. From late 1755, therefore, she entered into lengthy conversations with the Jesuit father, de Sacy. He urged her to return to her husband – an outcome which seemed unlikely at best, given that the latter had just taken up with a dancer in the opera. Sacy then demanded that she take a formal position at court so that she would not be seen simply to be living in circumstances of scandal. The king asked the queen for this favour, and she could not refuse. On 7 February 1756, the marquise was finally formally accepted into court hierarchy as lady-in-waiting to the queen – a pure sinecure, which she was possibly celebrating in Boucher's great 1756 portrait.[41]

The court was astonished to see Pompadour seriously moving towards a piety that all had assumed was a Tartuffian ruse to improve her position at court. Though her Jesuit confessor allowed her to continue to use rouge, she gave up going to the theatre, fasted on the right days, and was observed reading religious works and promptly attending early morning mass. Her employment of art dealer Lazare Duvaux now concentrated on gemmed crucifixes and other objects of piety. She would, moreover, do one additional good turn for the *dévot* cause. Since the early seventeenth century, *dévot* groupings within France had been against the prevalent foreign policy of the Bourbon dynasty, which was based upon systematic hostility towards the fellow Catholic nation, Austria, and involved French alliance with Protestant powers such as Prussia. Pompadour was involved in the reversal of this system of alliances and the creation of a Catholic bloc of powers centred on France.

The 'Diplomatic Revolution' or 'Reversal of Alliances' was brokered by Pompadour, who gained enormously in prestige as a result. Some historians have highlighted the king's attraction to the idea of closer links with Austria long before 1755 and have suggested that he utilised his mistress as a front to achieve his own ends. Louis certainly knew how to be machiavellian; but Pompadour does appear to have played a significant part in forging the new alliance. It was she that prince von

77
Jacques Guay
The Alliance of France and Austria,
1756
Onyx cameo, 3.5 × 2.9 cm
Bibliothèque Nationale de
France, Paris

Kaunitz, former Austrian ambassador in Paris and now one of Maria-Theresa of Austria's most trusted advisers, secretly approached in the autumn of 1755 to negotiate a possible rapprochement. The approach was opportune, in that French relations with England were deteriorating fast over the expansion of both powers in the Americas, and a war between the two countries seemed quite likely. This would therefore be a good moment for France to bolster its position against England. For its part, Austria – against which France had spent most of the previous two centuries fighting – had been disappointed with the outcome of the War of Austrian Succession and was seeking a more reliable ally than England. Negotiations were conducted around Pompadour's beloved Bellevue – and notably in the summer house of Brimborion – and involved the Austrian envoy, the count of Starhemberg, and, on the French side, the abbé de Bernis, who was in Paris in transit between diplomatic postings. On 1 May 1756, the first Treaty of Versailles was signed between France and Austria – leaving the Protestant powers, England and Prussia, to seek an alliance. This 'masterpiece of political wisdom', as Bernis put it,[42] was generally seen as owing much to Pompadour. Some saw this positively, as was highlighted by Guay's cameo in the alliance's honour (fig. 77) – but also negatively, as in Saint-Aubin's private sketch (fig. 78). The marquise was, noted Starhemberg, 'enchanted with the conclusion of something she regards as her own work'. 'We owe her everything we can expect in the future', was Kaunitz's view. 'She seeks esteem and she does indeed deserve it.'[43]

The Treaty of Versailles would prove to be based on a massive misunderstanding. France expected the treaty to bring peace on the continent so that it could concentrate on its global struggle against England; Austria saw it as a launching pad for attacking Prussia and winning back the province of Silesia, which it had lost in the War of Austrian Succession. War proved unavoidable and the next few years would bring problems arising from the war crashing around the ears of Pompadour and the king, testing both their piety and their patriotism.

L'alliance de faitte en may 1756. par L'abbé de Bernis
Alliance de M.me de Pompadour et de M.r de Stahremberg pour la
France et l'Autriche

78
Gabriel de Saint-Aubin
Pompadour and Starhemberg from
Livres des caricatures tant bonnes
que mauvaises, 1775
Drawing, 18.9 × 13.4 cm,
folio 285, inv. 675
Waddesdon, The Rothschild
Collection (The National Trust)

6 A Mistress goes to War

In 1756, France would be drawn into a war that was, for the first time effectively, more than European in scale. The Seven Years War (1756–63) was a truly global conflict against Prussia and England, the latter fast becoming Europe's greatest colonial and commercial state.[1] France was now allied with Austria, and, from 1761, with fellow Bourbon and Catholic power, Spain. The state was obliged to maintain a massive army in Europe as well as to fight England on the world stage with arms which, it soon became clear, were unequal. Though the war started well for France, it developed into one of the most humiliating in the recent history of the French monarchy. Strain without was matched by strain within as there were severe political crises inside France in 1756–7 that conspired seriously to tarnish Pompadour's image and that of the king.

Part of the legend of Louis XIV's greatness had been that he had chosen to rule without a principal minister, conducting business directly with the secretaries of state of each of the principal ministries. This was a system that Louis XV chose as his ideal, but until the 1740s found impossible to implement. In 1726, aged sixteen, he expressed the wish to rule in exactly the same way as his great-grandfather – but in practice the king was totally dependant upon Fleury. Although the latter never received the title of principal minister, he had an extremely wide range of positions of patronage, supervised the work of other ministers and adroitly balanced competing claims for advancement. There were many courtiers who felt that this was too much power for a single individual, and increasingly they included Louis himself. After Fleury's death in 1743, Louis inaugurated a system derived from his great-grandfather in which he dealt individually with each minister rather than rely on a ministerial coordinator like Fleury.

To some degree, Pompadour moved into the space vacated by Fleury. By the early 1750s she had become, as Prussian envoy the baron Le Chambrier testified, 'all-powerful in regards to what are known as grace and favour decisions, in military and

OPPOSITE
Detail of fig. 86

court posts, and in general for everything concerning the interior of the kingdom'. Her influence over patronage was extremely extensive: 'all the high nobles make their court to her whenever they need something.'[2] Other court observers concurred with this assessment of Pompadour's powers. Kaunitz was quite categorical: 'she governs despotically. The ministers forewarn her of everything they have to say to the king. He himself requires them to.'[3] 'The ministers are sure to speak to her [about state policy]' noted the marquis d'Argenson. 'They are obliged to do so, under pain of disfavour.' People were saying, he recorded, that the marquise was 'Fleury and a half'.[4]

Pompadour certainly had extensive influence over much domestic business, helped partly by her political closeness to the most important domestic minister, *contrôleur-général des Finances* Machault d'Arnouville (who was widely believed to owe her his post).[5] Unlike Fleury, however Pompadour was unable to dominate foreign and international policy. This was not through lack of interest on her part. Her correspondence with Louis when he was at the front in 1745 during the War of Austrian Succession gave her a taste for military affairs. Until the Treaty of Aix-la-Chapelle she kept up a steady correspondence with a number of field commanders: notably the effective generalissimo of French forces, maréchal de Saxe, whom the marquise referred to as 'my marshal'; the prince de Soubise, who became one of her most devoted friends; the comte de Clermont; and the maréchal de Luxembourg. Her very active part in negotiating the marriage of the Dauphin to Marie-Josèphe of Saxony in 1747 showed that her influence extended to international relations as well as military affairs, even before the end of the War of Austrian Succession.

The marquis d'Argenson testified to the marquise's avidity for involvement in the international and military aspects of rule. In 1751 he noted that she had started reading foreign state papers, with the clear intention, he surmised, 'of becoming *savant* in politics. She wants to govern the state increasingly as prime minister'.[6] It would appear that Louis did not want his mistress to be involved in this area and limited her prime ministerial ambitions. The king made a few concessions; in 1751, for example, she was granted permission to sit in on the king's *travail* with Puisieulx, the foreign minister. Yet Louis looked elsewhere for counsel and advice on non-domestic issues. He spent much time with the highly experienced war minister, the comte d'Argenson (whose *dévot* links contrasted with Pompadour's faction). The king also worked closely with his cousin, the prince de Conti, whom, as we have seen, was no friend of Pompadour's.

The king, noted Prussian envoy Le Chambrier, 'is impenetrable as regards secrets, [and] he has shown that he can carry dissimulation to the point of excess when he

79
Sèvres bust of Louis XV, 1760
Soft-paste 'biscuit' porcelain,
height 37 cm
Private collection

regards it as necessary' (fig. 79).[7] The secretive side of Louis's nature stood in the way of Pompadour becoming another Fleury. She could cover the king's inadequacies, support his decisions and supply a willing and sympathetic ear. But such was Louis's character, that there would always be something that escaped her. It may have been as early as 1740–1 that Conti and the king began a secret rapport over foreign policy that no one at court knew anything about (save only that the two men spent hours closeted together in the king's private rooms). Conti had been approached by Polish noblemen to see if he would be willing to be elected to the throne of Poland. From this began a clandestine parallel diplomacy centred on the prince, which aimed to maintain links with France's traditional allies (Poland, Turkey, Sweden), whatever the current complexion of official foreign policy was. The 'Secret du Roi' ('King's Secret'), as it was later known, gave the king diplomatic options – even though it achieved very little, and may have made the work of France's official ambassadors more difficult. Conti was a difficult man. Dufort de Cheverny noted that he had 'a great deal of character' but added that he also possessed 'no judgement at all, which comes from always wanting to shine'.[8] Conti had been distinctly anti-Pompadour ever since her presentation at court. The fact that Louis never gave him an official position in government suggests the king had no more and no less trust in him than in his official diplomats. Yet the secrecy of his relations with the king was a rebuff to the marquise's wider political aspirations.

Despite the appearance of omnipotence which some court observers attributed to Pompadour, high politics was highly divided and factionalised in the early and mid 1750s, with the king (rather than Pompadour), as Bernis later noted, 'keeping the balance between [the] divisions'.[9] The breakdown of Fleury's political system, and Pompadour's disregard for dividing and ruling between Robe and Sword nobles,[10] had exacerbated divisions and worsened the unruliness of factional disputes. The

French government, Kaunitz shrewdly observed, was rather like 'a badly yoked-together cart, where most things are done through intrigues and cabals'. He actually thought it a good thing that Pompadour was not more aristocratic. If she had been she would have been pressing the war minister for jobs and opportunities for glory for her relatives. As things were, she preferred peace and sided with *contrôleur-général des Finances* Machault who controlled the state's purse strings and allowed her to indulge her cultural projects.[11] Against this background, the Diplomatic Revolution of 1756 – and Pompadour's part in it – had aggravated the situation. By raising Pompadour's prestige and projecting her into the foreign policy arena, it presaged a period of worsening factional instability.

Pompadour's forceful incursion into foreign policy issues brought her into conflict with Conti. The reversal of alliances ran diametrically counter to Conti's diplomatic plans. When war broke out in early 1756 against Prussia and England, Conti stepped forward to receive a high military command – only to be rebuffed on (he thought) Pompadour's instruction. Feeling slighted, he promptly withdrew from the *Secret du Roi*. Very much a loose cannon, the prince acted sympathetically towards the Paris *Parlement* over the persistent Jansenist revolt. Here too he ran athwart Pompadour, since she had taken responsibility for negotiating with Pope Benedict XIV a way out of the *billets de confession* imbroglio through the French envoy in Rome, Stainville. Furthermore, Pompadour had heard from intelligence sources that Conti had established links with Protestant leaders in the west and south of France and was exploring with them the possibility of a concerted revolt against Catholic hegemony.[12] The appearances were that Conti, acting out of spite towards Pompadour, was rashly putting himself outside the charmed circle of government, and using extra-political pressure as a means of forcing himself into the administration.

The war against England and Prussia started surprisingly well for the French. There were early campaign successes both in Germany and overseas in Canada and India. England's plans to invade western France came to nothing and in May 1756 French forces under Richelieu produced a stunning manoeuvre, to capture Minorca from the English – a success which Pompadour celebrated in style with a special fête in honour of 'her Minorquin', as she now fondly called Richelieu (fig. 80).[13] Yet appearances would flatter to deceive. Pompadour had joined Louis in going to war in a military situation in which, despite their complacency, French forces were not well placed to succeed. More pressing, however, was the fact that Pompadour also found herself battling not just with Conti but also with the comte d'Argenson and

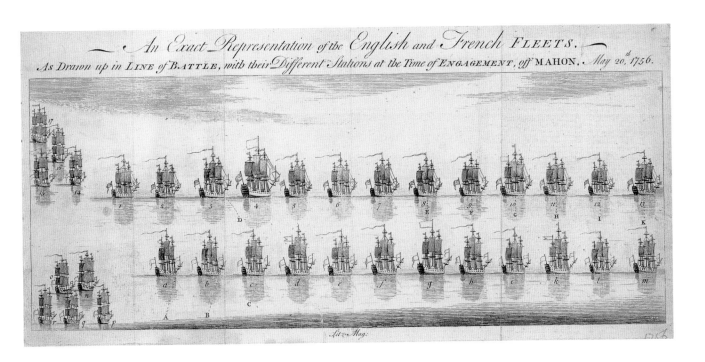

An Exact Representation of the English and French FLEETS.

As Drawn up in LINE of BATTLE, with their Different Stations at the Time of ENGAGEMENT, off MAHON, May 20th 1756.

80
British, 1756
…[T]he English and French Fleets
…at the Time of Engagement off
Mahon, May 20th 1756
Engraving, 18.5 × 38.6 cm
National Maritime Museum,
London

with the Paris *Parlement*. And she was also confronted by the sudden and real possibility of her expulsion from court, following an assassination attempt on the life of the king.

Louis's would-be assassin was Robert François Damiens (1714–1757), an unemployed servant, who in January 1757 stepped forward as the king was leaving the palace at Versailles, and delivered a penknife blow to his side. Damiens was a disturbed individual with religious preoccupations who had worked as a servant for magistrates in the Paris *Parlement*. The dispute between pro-Jansenist *parlementaires* and *dévots* in the church and state was still continuing, and Damiens had received a garbled sense of the Jansenist case from his parliamentary masters (who counter-claimed that he had been goaded into action by their long-term enemies, the Jesuits). He would be tried by the *Parlement* and executed in a spectacular manner aimed to recall the punishment meted out to the assassin of Henry IV in 1610, climaxing in his being torn apart by four horses charging towards the four cardinal points. There was no grimmer reminder of what lay under the veneer of Enlightenment civility and Rococo decorativeness (fig. 81).

Although there was a faint chance that Damiens's knife had been poisoned, it soon became apparent that the king's wound was not life-threatening. Yet even

81

French, 1757

The Execution of Damiens from

Portrait et souffrances de R. F.

Damiens

Engraving, 26 × 18.5 cm

Bibliothèque Nationale de

France, Paris

PORTRAIS·DES·SOUFRANCE·DE·R·F·DAMIEN·ATTANTATEUR·DE·LAS
PERSONNES·SACRE·DUROV·LOUIS·XV·LE·5·JEANVIER···1757

before this became clear, the political impact fast made itself felt and nowhere more pertinently than in the mind of the king. The assassination attempt troubled the king deeply. Louis did not need his priests to suggest that maybe this was a warning from God to amend his ways. His underlying sense of guilt, exacerbated by the death of his daughter and the smallpox of the dauphin in the early 1750s, was already leading him to that conclusion. Pompadour had nothing to do with the Damiens incident; but she risked losing everything because of the spiritual crisis it caused in the king. The opposition of the *dévots* to Pompadour had been temporarily dissipated by her turn to piety, while the Diplomatic Revolution in which she had played a part had delivered them alliance with fellow-Catholic Austria. They remained, however, fundamentally antagonistic to her. Now, with the royal family preventing the ailing monarch (who was still skulking behind his bed curtains) from seeing the marquise, the comte d'Argenson, her longstanding enemy, emerged as the leading political actor. The *dévot* faction began to anticipate a wholesale reversal in state policy, with a spiritually cleansed monarch removing the harlot Pompadour from his side and following pro-Catholic policies under d'Argenson's tutelage.

Pompadour was well aware of the *dévots'* hopes. 'Imagine the second volume of the Metz affair [of 1744], with the exception of [the threat of withholding from the king]

the sacraments, that he wasn't in a state to receive', Pompadour told Stainville.[14] Kept away from the king's side by the queen and dauphin, the marquise was powerless to shape her fate and expected banishment from court on the lines of the duchesse de Châteauroux at Metz in 1744. Her bags were indeed packed in readiness for departure, when her friends, Bernis, Soubise and Gontaut persuaded her to stay. She did so, even outfacing an attempt to get her to leave by her erstwhile ministerial ally, Machault, who, seeming to realise which way the wind was blowing, had promptly become a *dévot*.

Eventually, more than a week after the assassination attempt, Louis dared go down the stairs to visit Pompadour. He came back a changed man, resolute and cheerful. Those who had encircled the king, opined Dufort de Cheverny in his memoirs:

…had been endeavouring to prove to him that the assassination attempt had been aimed at him personally, and that it constituted a hatred, a conspiracy… which by his very indifference he had been fomenting. Madame de Pompadour made him see the opposite. Damiens was a knave, a fool and a dangerous lunatic and he had no accomplices.[15]

Although the king was still riven with spasmodic depressions, Pompadour had re-cast her spell over him. Indeed, there were even court rumours, probably unfounded, that she had started sleeping with him again.[16] After certainly the most serious threat ever to her power over Louis, the marquise was back at his side.

Pompadour's rehabilitation definitively closed the door to Conti's links with the king. The *dévots* too had time to rue her return. Although in late January, the king took decisive action to crush the political ambition of the *Parlement* over the Jansenist issue he accompanied this on 1 February 1757 with the summary dismissal of his long-serving ministers, the comte d'Argenson and Machault. There were extraneous reasons for these reversals which had been weighing on the mind of the king: d'Argenson had been opposed to the Diplomatic Revolution, on the basis of which the war was taking place, while Machault's political effectiveness had been questionable of late. Nevertheless, courtiers were under no illusions that the contrasting shadows of Damiens and Pompadour hung over the dismissals. Within a matter of months the marquise had experienced the biggest political fright of her life yet managed to despatch all the main rivals and opponents to her influence within the administration and to open up a pathway towards direct and unmediated influence on all aspects of royal policy.

82

Gabriel de Saint-Aubin

Bernis and 'Poisson' from *Livres*

des caricatures tant bonnes que

mauvaises, 1775

Drawing, 18.9 × 13.4 cm,

folio 254, inv. 675

Waddesdon, The Rothschild

Collection (The National Trust)

The marquise was at the zenith of her power, with her factional rivals out of the way. She publicly celebrated her political success by the ostentatious exhibition of her great Boucher portrait in the 1757 Salon (see fig. 30). War cost money, and the needs of the state treasury were such that all major cultural projects were put on hold. Though she did bear some responsibility for commissioning from Joseph Vernet a series of canvases of the French ports – stressing the country's naval and commercial strength – other portrait commissions of her would be for her own and the king's delectation rather than for public consumption.

The new ministry was to all intents and purposes a Pompadour ministry. Most of the new ministers were nonentities – and not very competent nonentities at that.

Gabriel de Saint-Aubin

Opérations de la campagne de 1757
from *Livres des caricatures tant
bonnes que mauvaises*, 1775
Drawing, 18.9 × 13.4 cm, folio
288, inv. 675
Waddesdon, The Rothschild
Collection (The National Trust)

The most influential figures were the venerable military veteran, the maréchal de Belle-Isle, who in 1758 was made war minister (yet left all tasks of substance to his officials) and Bernis, whose loyalty to Pompadour was rewarded with his appointment as foreign minister (fig. 82). Bernis also acted as ministerial go-between in negotiating a truce with the Paris *Parlement*. Pompadour's truce with the pro-Jansenist magistracy more or less put an end to her *dévot* connections. Her shows of piety had been becoming less evident when their political point seemed redundant. She dropped de Sacy as her spiritual advisor after he steadfastly refused to allow her absolution even after her appointment as lady-in-waiting to the queen.

Pompadour's new influence in affairs of state meant that she would be particularly targeted if business went badly. The Provençal nobleman, the comte de Sade (father of the more infamous marquis) wrote to her at around this time, 'As long as MM. d'Argenson and Machault were in place, the public blamed only them for the state's misfortunes. Their exile leaves the king exposed – and you also, Madame'.[17] The writer Marmontel, one of her *philosophe* clients, gave her much the same warning:

Now that the ministers have been dismissed and that the men who have replaced them have no ascendancy or influence, bear in mind, Madame, that all eyes are on you, and that in future all blame and grievances will be placed at your door.[18]

The words were to prove prophetic, as the war became disastrous for the French, bringing opprobrium on the heads of Pompadour, the king and the government. In November 1757, Frederick II of Prussia dealt out one of the worst defeats in French military history in the battle of Rossbach. At a single blow, it called into question the bravery of French troops, the competence and intelligence of their officers (most notably their commander, Pompadour's friend, Soubise), and the effectiveness of the state's administration and strategy (fig. 83). The losses at Rossbach led many Frenchmen to suggest suing for peace forthwith, though France was too deeply involved to make that a viable option. The war went badly for France outside Europe too. In North America, a combination of English colonists, regular troops and the Royal Navy chipped away at French possessions, taking the key port of Louisbourg in 1758 and then following up with the seizure of Quebec in 1759 (fig. 84). French attempts to mythologise the gallant marquis de Montcalm (fig. 85), commander at Quebec, were outmatched by the English. The death of General Wolfe would be memorialised in print and paint for many years to come, making the victor of

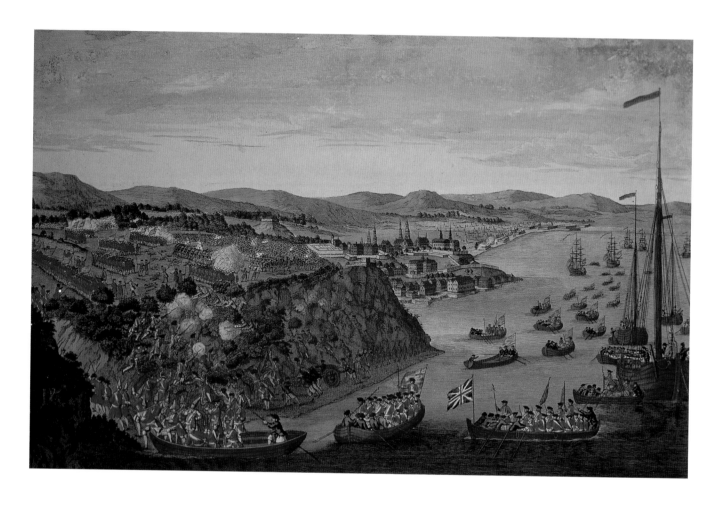

84
British, 1797
A View of the Taking of Quebec,
September 13th 1759
Coloured line engraving,
34.2 × 49.2 cm
National Army Museum,
London

Quebec an iconic figure of nascent English nationalism (fig. 86). The Royal Navy ruled the waves (fig. 87) and French overseas possessions in the Caribbean (fig. 88), Africa, and India were soon under English control. Pompadour was an easy target for an English cartoonist rejoicing in the discomfiture of the French government (fig. 89).[19]

In France too, responsibility for this depressing catalogue of disasters was increasingly ascribed to the marquise, who was now playing a large part in decisions relating to military operations. When her old benefactor, Pâris-Duverney, 'the Flour General',[20] who was in charge of provisioning the army in Germany, fell out with local commanders, she rallied strongly to his aid, alienating many of the generals. She also was so determined to secure a marshal's baton for her client and friend, Soubise, despite the Rossbach catastrophe, that her sense of judgement of military operations and personnel deserted her. Commanders tired of receiving maps from

85
Juste Chevillet after
François Watteau
The Death of the Marquis de Montcalm-Gozon, 1783
Etching and engraving,
49.6 × 61.4 cm
National Army Museum,
London

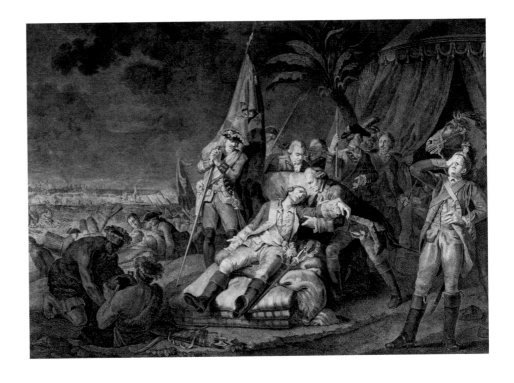

86
Edward Penny
The Death of General Wolfe, 1763
Oil on canvas, 102 × 127 cm
Visitors of the Ashmolean
Museum, transferred from the
Bodleian 1845
Ashmolean Museum, Oxford

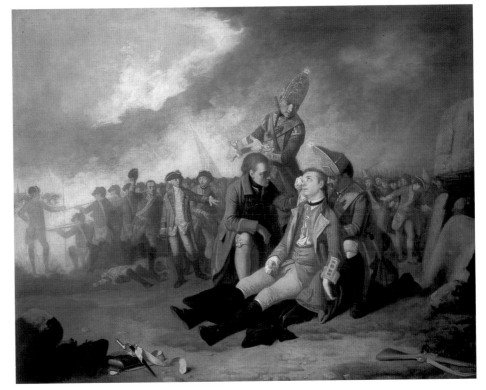

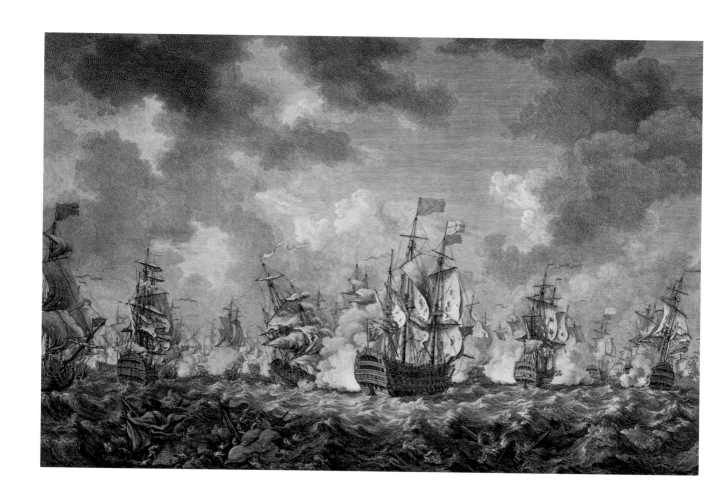

Pompadour with various suggested troop movements indicated by the careful location of her beauty spots. She obviously resented the bad news about troop morale that the comte de Clermont informed her of on joining the German front in 1758, and urged him to take to the offensive in a way which he adjudged imprudent: 'one does not move an army, Madame,' he wrote firmly, 'as easily as the way that you move your fingers over the map.' [21]

The chivalrous code of conduct, the bright uniforms and the gentlemanly nonchalance of generals in these so-called 'petticoat wars' of the eighteenth century had initially cocooned Pompadour from the bloody, dangerous and destructive character of war which at least the king had seen at first hand. French defeats were sufficiently serious to bring any minister under extreme pressure, and the constant stream of bad news took a toll on her nerves. She was unable to sleep without sedatives and composed her last will and testament a matter of days after hearing

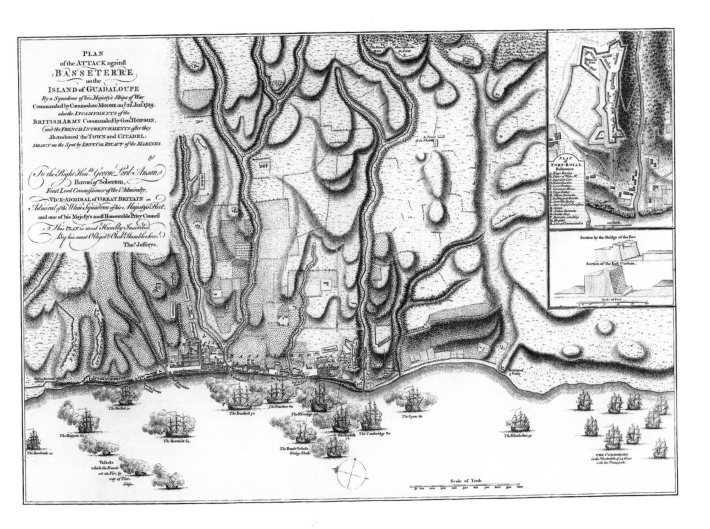

88

British, 1760, after Thomas
Jefferys and Paul Rycaut
*Plan of the Attack against
Basseterre on the Island of
Guadeloupe...22ᵈ Jany 1759*
Engraving with etching,
40.2 × 55.5 cm
National Maritime Museum,
London

about Rossbach. The probably apocryphal phrase that she is alleged to have uttered in response to the circumstances in which she and the king found themselves – '*après nous, le déluge*' ('after us, the deluge') – is usually dated precisely to this time.

Foreign Minister Bernis, who was becoming increasingly pessimistic about France's chances in the war, urged a much more circumscribed strategy. Bernis was also well placed to see the weaknesses of the way in which the government was conducting its business. The king's individual *travail* with each minister left each not knowing exactly what the others were doing, nor necessarily comprehending the scale of the crisis facing the state. Despite the whispers that Pompadour was effectively principal minister, she did not provide the coordination needed, and seemed wedded to, a strategy that Bernis encapsulated as 'perishing without glory in

89
British, 1759
The French King in a Sweat or the Paris Coiners
Etching with a few burin retouches, 19.7 × 34.2 cm
The British Museum, London

the service of the Empress [Maria Theresa of Austria]'.²² Indeed, Bernis was beginning to think that the marquise – who, he confided to Stainville, 'sees affairs of state like a child'²³ – was part of the problem rather than its solution. He began to call for a principal minister to be appointed, an eventuality which neither the king nor Pompadour would countenance, not least because it would affect their own spheres of influence, prestige and *modus operandi*.

In the event, the move towards a minister with a degree of coordinating ability and a character to develop a general strategy happened in an unanticipated fashion. Bernis was made cardinal in return for his past labours. He now looked to move sideways within the ministry, opening up a niche for his ally and Pompadour's friend, the comte de Stainville (fig. 90). Following a spell as ambassador in Rome in 1755–7, Stainville had been appointed France's Austrian ambassador, but he was now brought back to Versailles as foreign minister. Bernis's attempts to enlist him as an ally in his plans to have a principal minister appointed blew up in the face of the new cardinal. In October, Bernis was dismissed, leaving Stainville – raised to the peerage

as duc de Choiseul – as by far the most forceful and most dominant figure in the ministry.

Choiseul was far too powerful a personality to be Madame de Pompadour's poodle. Like Bernis, he had his doubts about what France could achieve in the war, but worked hard to make the best of a bad situation. He was able to draw Spain into the conflict on France's side in 1761–2. Although the Spanish suffered defeats – losing Havana to English bombardment in 1762, for example (fig. 91) – the alliance with them helped improve France's fate in the peace, which by 1762 all parties were accepting as inevitable. By then, Choiseul had added to his foreign affairs portfolio the navy and war ministries, which he would head until 1766 and 1770 respectively. This pluralism was a passable substitute for better interministerial coordination at the heart of government.

The Treaty of Paris of 1763 was appalling for France and might have been even worse without the Choiseul-led recovery in the final years of the war. France lost much of its overseas colonial empire, made no gains at all in Europe, and faced financial ruin. Considerable energy and commitment would be needed to bring the country out of this trough in its fortunes. Neither quality, however, characterised the marquise de Pompadour. She had in particular found it difficult to resist the gradual take-over of the war effort by her protégé, Choiseul, who proved a wily operator at court as well as a shrewd minister. He was quite willing to work alongside other Pompadour protégés, such as former Paris Police Lieutenant Berryer who, navy minister from 1758, was appointed keeper of the seals in 1761, and Bertin, contrôleur-général des Finances from 1759 to 1763. He came to dominate them all, especially after 1761, when he brought in his brother, the duc de Choiseul-Praslin, to run the foreign ministry. Choiseul also controlled Pompadour's growing fury with the Paris Parlement – the parlementaires were, in her view, 'unworthy citizens and far worse enemies of the state than the king of Prussia and the English'24 – and continued Bernis's strategy of accommodating the institution so as to secure relative tranquillity on the home front while the country was at war. He also inveigled himself into Pompadour's circle of intimates at court. He, his vivacious wife and his sister-in-law, the duchesse

90

After Louis-Michel Vanloo
Étienne-François, Duc de Choiseul-Stainville, eighteenth century.
Oil on canvas, 80 × 64 cm
Musée National des Châteaux
de Versailles et de Trianon

91
French, eighteenth century
The Taking of the Forts and Town of Havana by the English in 1762
Hand-coloured etching and engraving, 30.3 × 46 cm
National Maritime Museum, London

de Gramont, were amongst the most frequent attendees of the *petits soupers*. Indeed, partly because of deaths and personal circumstances, the numbers at these events fell from the usual twenty guests to half that number and Choiseul proved adept at imprinting his influence and views upon them.

Choiseul's Trojan horse strategy, designed to insert himself at the heart of Pompadour's power nexus, was also enacted in a way that did not attract him as much odium as he might have suffered. Indeed, as Sade and Marmontel had warned, it was Pompadour who was subject to the attacks. 'Paris hates her and blames her for everything', Bernis told Choiseul in 1758.[25] She began receiving poison-pen letters, and the scurrilous ditties resumed in earnest, associating the king with Pompadour's unpopularity:

> As long as Beaumont heads the church;
> As long as Bourbon fucks the marquise;
> As long as the army fights under Soubise;
> Then we'll be forced to stagger and lurch.[26]

That this disfavour towards king and mistress outlasted the war was displayed in Parisians's attitude towards the new statue of Louis XV planned for the new urban

square, the Place Louis XV (today the Place de la Concorde), immediately after the war was over (fig. 92). The idea had originated as a thanks-offering for Louis's part in the 1748 Treaty of Aix-la-Chapelle. Criticisms of royal policy over that treaty were as nothing compared to the hostility over the recently-signed Treaty of Paris, so the timing of the inauguration was singularly inept. The sculptor commissioned for the equestrian statue of Louis XV, Edmé Bouchardon (1698–1762), had approached the project with extraordinary commitment and punctilious concern for exactitude, devoting the last six years of his life to it, only to die before it was complete. Pigalle was called in to finish it. The statue was destroyed in the French Revolution, though a reduced size bronze by Vassé and sundry engravings allow us to grasp the nature of Bouchardon's achievement (figs. 93, 94).[27] Louis is dressed as a Roman emperor – a fashionably Neoclassical touch – and is escorted by four statues representing Virtue, Prudence, Peace and Justice. Extensive celebrations were laid on for the inauguration. If one reads the official accounts, joy was unconfined. In fact, the festivities were ruined by heavy showers of rain and by the subversive comments of Parisians present. Graffiti were drawn on the base of the statue:

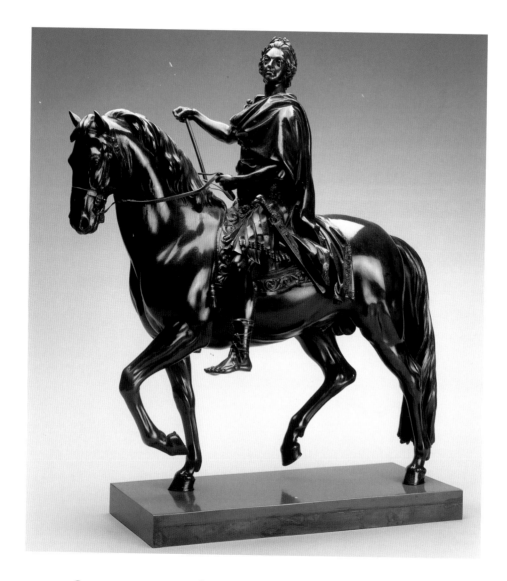

LEFT
93
Louis-Claude Vassé after Edmé
Bouchardon
Louis XV on Horseback, after 1761
Bronze, 67 × 60 cm
The Royal Collection,
Buckingham Palace, London

RIGHT
94
Sèvres vase with a concealed
statue of Louis XV, about 1763
Soft-paste porcelain, gilt
bronze, silver and gold,
27.6 × 18.2 × 15.1 cm closed
30.2 × 18.2 × 15.1 cm open
Gift of J. Pierpont Morgan, The
Wadsworth Atheneum
Museum of Art, Hartford, CT

FAR RIGHT
95
Louis-Jacques Cathelin after
Jean-Michel Moreau
The Equestrian Statue of Louis XV,
probably 1763
Etching and engraving,
68.6 × 50.8 cm
The Victoria and Albert
Museum, London

> Grotesque monument, infamous pedestal
> The Virtues are on foot, and Vice in the saddle.

And:

> He's the same here as at Versailles:
> No heart, no guts.

Unlike in the War of Austrian Succession, Louis had not left his mistress's side
during the Seven Years War, and his most bellicose act had been the massacring of
game in his endless hunting pursuits. With the ink on the ignominious Treaty of

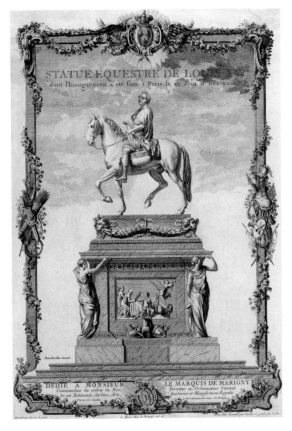

Paris scarcely dry, the martial and equestrian aspects of the statue (fig. 95) were too much for many Parisians to stomach, and they proffered ribald comments about Louis being gently held up by four *grues* (cranes – but also whores, itemised as Mailly, Vintimille, Châteauroux and Pompadour).[28]

Yet the attacks on Pompadour missed the mark. For the truth was, that by the end of the Seven Years War, her powers had been eclipsed by Choiseul, and she would play no part in post-war reconstruction. The strains of office at time of war had proved too severe for her rather fragile constitution. A heart condition was diagnosed. Her breathing was severely affected. The marquise was dying.

7 Scheherazade Pompadour?

In the cycle of Arabian folktales, *A Thousand and One Nights*, beautiful young Scheherazade avoids execution by devising new and ever more fascinating stories for her sultan master. In the end, the master falls in love with her and they live happily ever after. Pompadour had a copy of the translation by Antoine Galland in her library. Its Turkish theme resonated with the oriental leitmotifs she featured in her decoration of Bellevue.[1] Scheherazade's profile accorded surprisingly closely to the image that the marquise projected: she was, Galland tells us, a kind of Arabian *femme savante*, who had read widely in history and the arts and combined 'excellent beauty' with 'unbreakable virtue'.[2]

It is impossible to know whether Pompadour in any way identified with Scheherazade. She probably never thought about it. Yet it is difficult not to be struck by the similarity between the beautiful story-teller's relationship with the sultan and the way in which Pompadour span a web of entrancement over the king, making herself a fixture in his life by catering to his needs and fantasies. The quest for continued royal favour through an alluring image was the quest for her continued existence at court. Pompadour had neither the gender nor the class background normally required for high position in the state, and was utterly dependent on the whim of one man for her continuation at court. Initially, she satisfied Louis's needs sexually, but she remained in position more than twice as long as the king's friend. The royal needs to which she catered most enduringly were less to do with the king's sexuality. The images of herself that she sought to place continually before his eyes were intended to make him feel good about himself – as well as about her. Beneath Pompadour's astonishingly self-centred, narcissistic display of her own image in all artistic media, and her profligate spending on herself and her ambiance, there was a core of humble self-abasement. She was as faithful and obedient to the king as she expected her dogs Mimi and Inès to be to her. Her motto to the last was discretion and fidelity.[3]

OPPOSITE

96

François-Hubert Drouais
Madame de Pompadour at her Tambour Frame, 1763–4
Oil on canvas, 217 × 156.8 cm
National Gallery, London

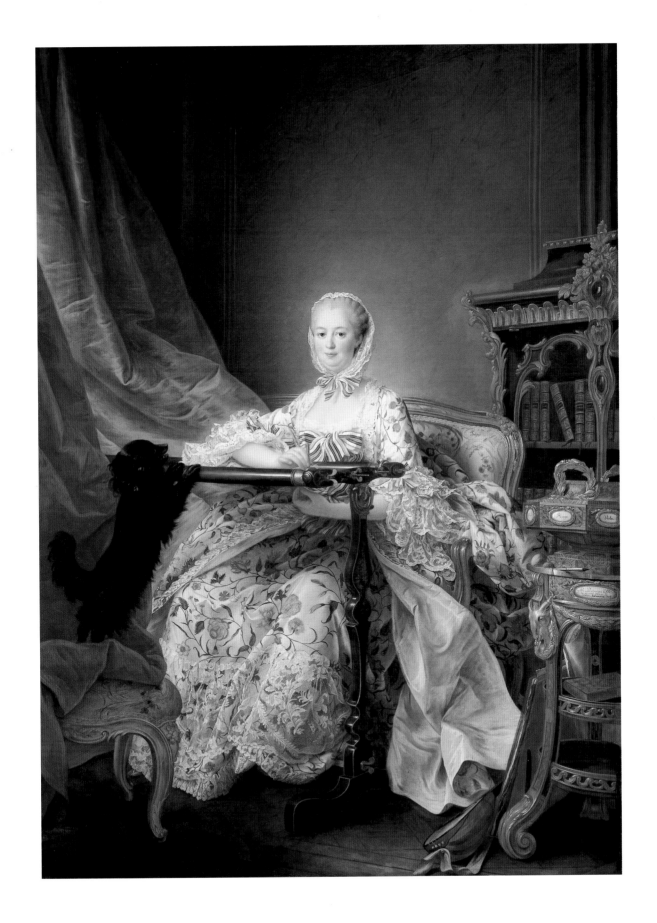

In her way, she had sought to follow the description of royal mistress Agnes Sorel as loving the king – according to the marquise's client-*philosophe*, Duclos – 'solely for himself and never [having] any other aim in her conduct than the glory of her lover and the happiness of the state'.[4] This was a difficult assignment, given the character of the king, whose 'cruellest enemy', as Kaunitz noted, was boredom. Pompadour was thus fortunate to have 'the great skill', as Dufort de Cheverny recorded, 'of entertaining the most difficult man in the kingdom to amuse'.[5] That she filled this role effectively was demonstrated not simply by the durability of her relationship with the king, but also by being more associated with the inception and early, disastrous conduct of the Seven Years War than any individual and yet retaining royal favour. It is difficult to imagine any other minister or courtier during Louis XV's long reign (save arguably cardinal Fleury) surviving this kind of record.

As had been the case with Fleury, the more Pompadour became a fixture in the king's life, the less likely she was to be dislodged. By his own admission, Louis was someone, who 'when [he] loves, loves well'.[6] Sheer habit, Croÿ believed, 'was what attached the king to her'.[7] Just being around the king, the duchesse de Brancas told Pompadour, would have an effect: 'the chains of habit will attach him to you forever.'[8] The maréchale de Mirepoix was of much the same advice. The king was:

…a creature of habit. [His] love for you is the same as for the staircase that leads to your apartment… You are made to his measure; you are receptive to his stories; he is not embarrassed with you; and he doesn't worry about boring you.[9]

Pompadour had become a permanent fixture in the life of the king, even as her political influence was being eclipsed by Choiseul. She seemed increasingly out of the information loop, even though she was less vulnerable than at any time in her career.

Pompadour's impact on cultural policy was also much diminished by the early 1760s. The return of peace had not allowed a revival in major cultural commissions, for the state was facing

bankruptcy. In 1759, Pompadour even sent most of her plate and part of her jewellery to the royal treasury as a patriotic gesture in straitened times. The marquise's biggest influence over cultural policy had been in the late 1740s and early to mid 1750s, largely through offices of the *Bâtiments du Roi* held by Tournehem and her brother Marigny. By the 1760s, there were signs appearing of tastes and outlooks that made the Rococo style, which Pompadour was held to champion, look increasingly old fashioned.

Burgeoning hostility towards the kind of decorative art and Rococo values which were associated with Pompadour and the artist most closely associated with her, Boucher, was foregrounded in newly-emergent art criticism, originating in published responses to the Paris Salon. From the 1740s, the writer La Font de Saint-Yenne led the charge followed by the *philosophe* Diderot. The paintings of Boucher, whose technical artistry Diderot could not fault, had in them 'everything except the truth'. 'Where has one ever seen shepherds dressed with such luxury and elegance?'[10] Diderot was especially harsh towards the 'made-up seductiveness' of Boucher's work, and lambasted his prevalent pink tones that seemed as cosmetically applied to the cheeks of his subjects as to the bottoms of his nymphs and shepherdesses.[11] Diderot was the author of pornographic writing – his banned *Les Bijoux indiscrets* (*Indiscreet Jewels*), a kind of erotic *A Thousand and One Nights*, found its way into Pompadour's library[12] – yet he got on a moral high horse to attack the prevalent nudity in many of the canvases of Boucher and his ilk. They threatened to pollute the seemly *pudeur* of public life: most women with even the vestiges of modesty refused to allow their children to see his canvases.[13] The depravation of Boucher's morals was to blame for 'the degradation of taste, colour composition, characters, expression [and] design' evident in his work and those he influenced.[14]

These rebukes stung the artists involved. The frontispiece of a riposte to the critics by the abbé Leblanc in 1747, based on a Boucher drawing, was an etching showing *Painting mocked by Envy, Stupidity and Drunkenness*, while the frontispiece to Jacques Lacombe's *Le Salon* in 1753 showed a poor artist receiving a merciless tirade from a provincial pedant (figs. 97, 98). Yet the criticisms were not simply the outpourings of out-of-touch intellectuals as their targets sought to portray them. They also reflected a change occurring in the taste of the public. Chardin's thoughtful canvases, which were far removed from Boucher's lightness of touch, were increasingly in favour (fig. 99). The triumph of the 1761 Salon was Jean-Baptiste Greuze's (1725–1805) *The Village Bride* (*L'Accordée de village*), a highly-wrought composition depicting a domestic drama in a way that allows psychological insight and characterisation. Greuze offers a kind

of domesticated history painting, which transposes the values championed by Le Brun into the bourgeois household (fig. 100). The emotional pathos in his paintings of children – as in *Simplicity* (fig. 101) – are very different from Boucher's fattened putti or 'the bastard progeny of Bacchus and Silenus' as Diderot described them.[15]

Given these changes to the character of artistic production in the 1750s and early 1760s, it is intriguing to speculate on the last great painting of Madame de Pompadour. It was by François-Hubert Drouais, who was

99
Jean-Siméon Chardin
The Kitchen Boy, about 1736–8
Oil on canvas, 46 × 38 cm
Private collection

LEFT
100
Jean-Baptiste Greuze
The Village Bride, 1761
Oil on canvas, 92 × 117 cm
Musée du Louvre, Paris

RIGHT
101
Jean-Baptiste Greuze
Simplicity, probably 1759
Oil on canvas, 71.1 × 59.7 cm
Kimbell Art Museum,
Fort Worth, TS

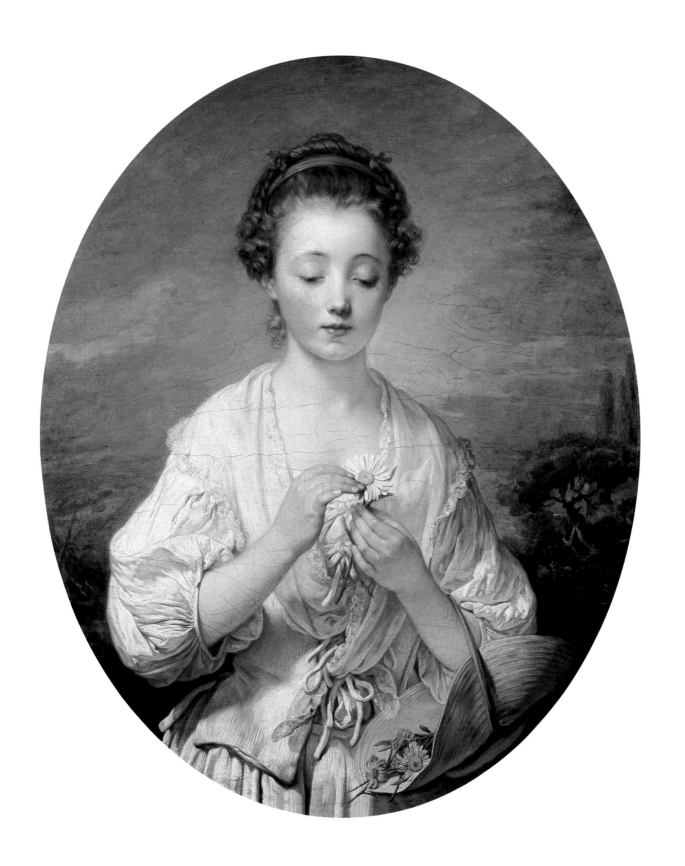

fast overtaking Nattier as the preferred portraitist of royalty and court society (fig. 96). This was a painting of size and éclat – more in the style of Boucher's portrait exhibited at the 1757 Salon than his other, more personalised productions of the late 1750s. Like the 1767 portrait, it was given a public showing – although only after her death. For by the time that Drouais painted her, in April 1763, Pompadour was very ill. She would die before it was even finished. The canvas on which he painted the marquise's head was sewn into the larger canvas containing her clothing and the background in spring 1764. The face was utilised again in Drouais's less celebrated canvas of the marquise with a muff (fig. 102).[16]

In Drouais's classic portrait, it is difficult to resist the implication that the arch image-maker was putting down a marker for posterity. All the themes of her earlier portraits are evoked: the books and bookcase, the portfolio of engravings, the pencil-holder, and the skeins of wool for her tapestry all mark her out as the patron and practitioner of the arts and sciences. She looks down with some hauteur on the viewer, her head bathed in a whiteness that evokes her place in the Enlightenment.[17] Her opulent dress displays the highest-quality French garment production, and sets off the luxuriant curtain drape. The colour of the skeins on the beautifully rendered ornamental woolstand are the same as those of her dress. Her dog again evokes her mistress's fidelity and obedience to her master.

There is also some significant innovation. The background is far less fussy and ornate than in her other portraits, and presages the austere settings of Neoclassical portraits, while there is also a Neoclassical edge to some of the furnishings. In addition, the unchangeability of her beauty, which had been such a powerful feature of her self-presentation in the 1750s, has now been sacrificed. Although the hair is swept back and the complexion is clear, this is a slightly portly woman at the *quarantaine* (her fortieth birthday had been two years previous). Her appearance chimes with the description given by a recent visitor at court: 'she is of average height and corpulence…She seems beautiful, but not of the greatest beauty.'[18] Drouais had achieved, as even critics of her earlier portraits agreed, 'the most striking of resemblances'.[19] The marquise seemed finally to be embracing verisimilitude, even in her own depiction.

After her dabbling with devotion in the mid 1750s, the marquise appears to have given up receiving visitors at her toilette, and switched to a tapestry frame. It is noticeable that the number of these frames in her possession far outnumbered the prayer-stools of this fair-weather *dévot*.[20] Drouais's is therefore again a portrait in power, where the work of tapestry is a pretext for the bigger work of patronage and

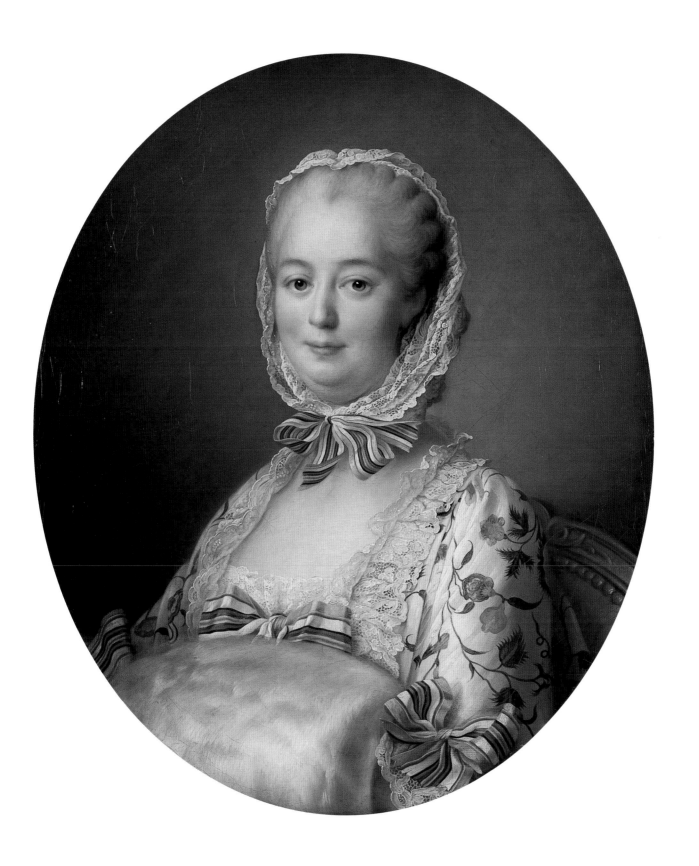

149

politicking. The lace cap is an interesting touch too. This is *habit de ville* of the kind that queen Marie Leszczynska had commanded Nattier in 1748 to portray her in. It was as though by making a concession to bourgeois dress, Pompadour was paradoxically highlighting her queenly attributes.[21] As always, Pompadour's images are as much about fantasy as reality.

This, however, was to be the final fantasy. Early in the new year of 1764, the marquise received a visit from her long-term friend the marquise de La Ferté-Imbault, Madame Geoffrin's daughter. The latter's record of the meeting highlighted Pompadour's torment over the state of the kingdom, the king's sexual affairs and her own health. As throughout her career, she volunteered the wish to leave the court – she was only staying out of loyalty to the king's orders that she remain.[22] Her health was taking a sudden turn for the worse. She rallied – enough indeed for Vanloo to volunteer a depiction of *The Arts imploring the Fates to spare Madame de Pompadour*, (fig. 103) and for Cochin to engrave a little allegory about her convalescence. But on 15 April 1764, she died, rather heroically and in a piety which impressed even the queen and her daughters. She had a private funeral, over which the king wept only private tears.

In political circles, there was certainly no huge sigh of relief nor outpouring of grief at Pompadour's passing. It was recognised that her functions were covered in other ways. The king's sexual servicing was now responsibility of others, while the royal need for a Fleury figure had, since around 1760, been met by Choiseul, who was also building up an impressive patronage network partly deriving from that of Pompadour. The marquise had made a half-hearted attempt in 1763 to boost the new *contrôleur-général des Finances*, Laverdy, as a counterweight to Choiseul, but it was ineffectual. There was no sign of a lurch in government policy after her death.

With the marquise in her grave, the field was free for her image to be made and remade by others with no prompting or interference from herself. Pompadour as a politically redundant fixture in Louis XV's life was only one posthumous image of Pompadour. In 1815 the English connoisseur William Beckford would laud her as the exquisite acme of civilised good taste: 'No lady of the old or new world has ever been a better judge of the rare, the beautiful and the fine than Madame de Pompadour.'[23] By that time in fact, the 'Pompadour style' had become an acknowledged way of talking about all the art of the reign of Louis XV. This inflated posthumous reputation for cultural distinction and influence was not particularly well deserved.[24] Pompadour was more accumulator than collector or connoisseur, and was merely fortunate to have the cultural capital and the financial means to profit from the high quality of the artistic field on which she drew.

OPPOSITE
103
Carle Vanloo
The Arts imploring the Fates to spare Madame de Pompadour, 1764
Oil on canvas, 80.6 × 67.5 cm
The Frick Art and Historical Center, Pittsburgh, PA

At the end of the nineteenth century, the Goncourt brothers saluted the marquise as 'the godmother and queen of Rococo', but this too rather missed the mark. In fact Pompadour had never staked body and soul on the Rococo. She endorsed a style that predated her, and was not as totally in thrall to it as the Goncourts's label suggests. Her support for the initiatives of her uncle and brother as successive *directeurs des Bâtiments du Roi* showed an openness to more public, morally uplifting art than the private fancies indulged by the Rococo. It had been Tournehem, after all, who had launched the call for a revival in history painting from the late 1740s. And she herself nurtured many of the new trends and modes of thinking. Many of the artists she patronised were already working in new styles: she owned a number of Greuzes, including *La Simplicité*, which Marigny commissioned for her; patronised Vien; sponsored antiquophile Soufflot as architect for the Paris Sainte-Geneviève church; applauded Bouchardon's Roman-imperial statue of Louis XV; and owned a good number of *commodes à la grecque* which prefigured Neoclassical furniture styles. Although she had intended the visit of her brother to Italy as much to make him a gentleman as an art aficionado, that visit did help to infuse the cultural establishment with a new spirit of excitement by the Antique and a wish to explore its heritage which was blossoming even before her death. Marigny's companions on the Italian trip – particularly Soufflot and Cochin – were in the vanguard of the Neoclassical revival from the late 1750s onwards. Ironically, given her later image, Pompadour planted the seeds of Rococo's destruction. Fittingly, her final portrait by Drouais showed a Pompadour seemingly comfortable with the winds of stylistic change. [25]

The artists and writers whom she had supported proved lukewarm towards her passing, despite the sycophantic outbursts occasioned by her seeming convalescence. Any regret which writers and artists expressed was influenced by the fear of her place being taken by someone less publicly well-disposed towards them as a group. Falconet's back-handed compliment of an epitaph was balanced, but dismissive: 'she loved the arts which she had neither the time nor the talent to cultivate. But she paid well.'[26] She was 'one of us', Voltaire regretfully commented. But d'Alembert thought 'she didn't like the *philosophes*', and Diderot was cuttingly astringent:

What has remained of this woman, who has wasted so many men and so much of our money, left us without honour and without energy, and who has overturned Europe's political system? The treaty of Versailles which will last what may be; Bouchardon's Amour that will

always be admired; some engraved gems by Gai [Guay], which will astonish antiquarians in ages to come; a good little painting by Van Loo that will be looked at now and again; and a smidgeon of ashes.[27]

The stress placed by Diderot on the political as well as the cultural upshot of Pompadour's influence was echoed by the dramatist Charles Collé (1709–1783). The latter fulminated that 'since the establishment of the monarchy no royal mistress has ever caused as much harm to the kingdom'.[28] 'All public misfortunes and the contempt into which our nation has fallen in Europe' were her responsibility. Collé also highlighted her role in having incapable and venal ministers appointed, in conniving in a bad selection of generals, in worsening relations with the *Parlement*, and in allying France with Austria rather than 'our natural ally', the king of Prussia. She had been responsible for the depravation of aristocratic values of honour by financial considerations. Pompadour 'had infused the court with a materialistic spirit'. 'Individuals of the highest rank have not disdained having financial business interests, and do not regard this as low behaviour.' 'Nothing is given freely; most things are bought and sold.' 'Frightful greed has spread among all estates and money alone seems to bring esteem.'[29] Collé's only surprise was that there had not been more than a handful of epigrams and ditties celebrating her departure.

That literary figures were drawing on moral and political arguments in order to scapegoat the marquise was symptomatic of the times, for it was on a literary terrain that many of the political battles of the late Enlightenment would be fought. The public sphere was now more difficult to dominate with *lettres de cachet*. Authors found it easier to circumvent censorship regulations, and found a public more than ready to listen to them. That public rubbed shoulders not only in the Salon but also in the various institutions of bourgeois sociability (coffee-houses, masonic lodges, public gardens, for example) and kept abreast of news and views in a much expanded network of pamphlets, newspapers and periodicals.[30] Social energies now derived from Paris, not Versailles. Pompadour had herself registered this development in regard to her choice of clothes and cultural artefacts and by her consumerist habits. She shopped on the rue Saint-Honoré, and spurred the court to follow city fashion, rather than rely on the city aping the court.

Far more extensive than the court-based clienteles, which were the audience for Pompadour's cultural production, the new public looked to Paris rather than Versailles to inform its tastes. Writer Louis-Sébastien Mercier would highlight the primordial force of the capital's energies, by characterising Versailles as a 'satellite'

round a [Parisian] 'whirlwind'.[31] The public was increasingly looked upon as a kind of 'tribunal' that judged the moral value and social utility of works of art and literature. It thus became the custom to regard public opinion as a source of political and moral legitimacy. This was a move which was extended so as to justify attacks on the immoral materialism and corruption associated with the court as well as the degraded artistic taste supposedly sponsored by courtiers.

The moralising discourses that had invaded art criticism were thus also increasingly visible with regard to the role of Versailles in political and social life. A taste for court gossip was gratified by scandal sheets, which became ever more numerous and scurrilous as the century progressed. Louis XV's Parc-aux-Cerfs was now demonised, in the words of one such text, as:

…an abyss for innocence and simplicity, which swallowed up throngs of victims and then spat them back out into society, into which they carried the corruption and the taste for debauchery and vices, which necessarily infected them in such a place.[32]

Although the king was ascribed ultimate responsibility for such corruption and debauchery, the role of women in pandering to his taste and in influencing state policy was also highlighted. If Louis's *petites maîtresses* were viewed more as victims than propagators of vice, the scandalmongers aimed their prurient venom at the *maîtresse en titre*. Pompadour was perhaps spared the most violently unpleasant attacks, which focused instead on her successor in this role, Madame du Barry (1743–1793) (fig. 104). Her entry into the king's private life in 1768 was arranged through the continuing services of *valet de chambre* Le Bel. An illegitimate daughter of a wandering monk, with a career of colourful *galanterie* behind her before in 1768 she was to tumble into the king's bed, *La du Barry* made Pompadour look positively saintly and aristocratic in comparison.

Royal favourites, opined the editors of the much-reprinted work on courtly lore, the *Science des personnes de la cour* (which Pompadour had in her library), had political uses. Most notably:

…they are a shield against hatred. It is necessary to have a tough-skinned individual as a target against whom all attacks and reproaches can be turned for all faults and weaknesses.[33]

By this standard, Pompadour must be accounted a failure. Perhaps because as mistress she was tied so closely to the person and reputation of her royal master, her alleged faults were held to apply to him as well. Far from being a lightning rod, diverting criticism away from Louis, she and her successors seem to have worsened

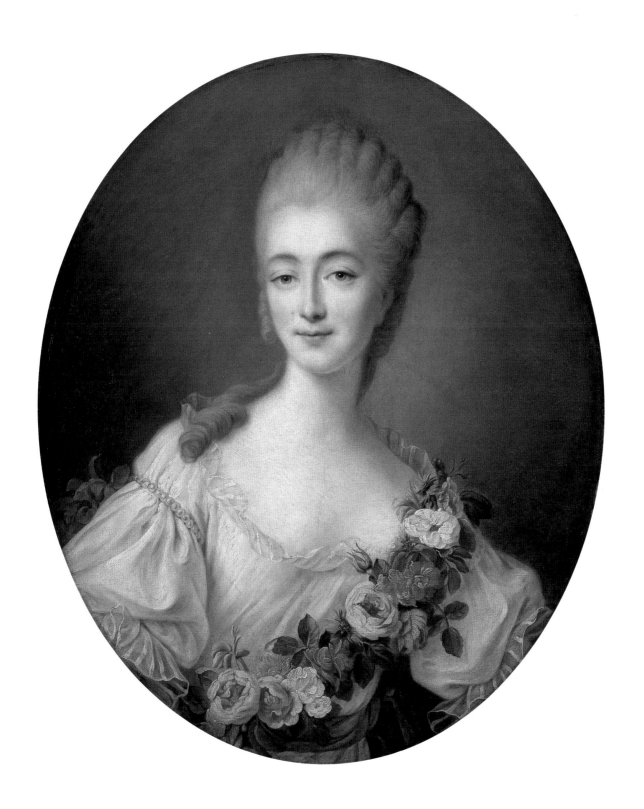

the esteem in which he was held. Political discourse in the latter half of the century stressed that manly political virtues could only be kept intact through the systematic exclusion of women in public life. From this angle of vision, Pompadour and the other mistresses had prevented Louis XV from being a man, and robbed public life of a needed virility – which helped explain France's lack of military success. The 'feminisation' of public life over which she had presided had brought political corruption and impotence in its train. As France's arch-enemy, Frederick II of Prussia had asserted, Louis was pathetic for being 'Pompadour's plaything'.[34] In cultural policy too, support for painters like Boucher had risked choking the development of a public art that stressed high moral values, and that valorised new notions of stoical masculinity.

Throughout her career in the royal court, Madame de Pompadour's existential dilemma and her Scheherazade-like quest had been to find means of keeping the affection and favour of the king – a task requiring a firm sense of balance, an endless capacity for adjustment, and a bottomless supply of discretion and fidelity. She did indeed manage this task brilliantly, not least through the dedicated cultivation of her own image, or images. The price of such single-minded devotion, however, was that the marquise was astonishingly out of touch with much that was taking place within French society as a whole. Her manipulation of image was so focused on the sensibility of one man that she simply did not look outside the immediate ambiance of the royal court. Even though she had a troubled childhood she knew Paris through her shopping trips rather than through acquaintance with the poverty and the popular resentments which had triggered the affair of the vanishing children in 1749–50. Her spending on Crécy and her beloved Bellevue were at their most insensitively prodigal whilst most of the population was opposing the state's plans to introduce higher taxes. She showed a thorough lack of awareness of the violence that lay beneath the surface of the Bourbon state, whether this was the vicious torture and punishment of criminals such as Damiens or the collective violence of warfare. Her cultivation of image muddied the wider society's view of her; but it also muddied her view of the wider society.

Her limitations were cruelly exposed in the Seven Years War, when she finally beat off the challenges of her rivals and secured an unchallengeable position in the king's counsels. Yet she was perhaps too easy a scapegoat. It was her friend and lover who was in command, not she. It would thus be unfair to lay the blame for the disasters of the Seven Years War at her door: they had been prepared before her time and in ways which were outside her competence. In the event her moment at the

helm soon passed. Once Conti, Machault and the comte d'Argenson had been expelled from court, her own bad health and the subtle wiles of Choiseul removed her from a position of dominance. She enjoyed power (in both senses of enjoyment) less than court gossip would suggest.

Even in her own lifetime, the marquise was finding herself increasingly unable to control the reception of those images on the growing public sphere, and her death was followed by the systematic denigration both of herself and of the images she had projected. No one sprang to Pompadour's defence. Attitudes towards her sketched out after her death would be endorsed by the Revolutionaries of 1789. Her name was viewed not as a marker of cultural refinement, but as a symptom of decay – a decay that Madame du Barry worsened and that culminated in Louis XVI's queen, Marie-Antoinette, who was routinely ascribed all the moral vices and every sexual perversion imaginable.[35]

The moralism might have dissipated, but more recent political and social historians have also tended to endorse the criticisms of her made in the years following her death. The widely believed, but almost certainly apocryphal phrase associated with her name – *après nous, le déluge* – has been largely viewed as a prophetic acceptance of the inevitable collapse of the Bourbon state, and she has been invariably written off as a corrupt symptom of an intrinsically rotten 'Old Régime'. Ironically, the image of herself that the marquise worked so tirelessly to construct has fallen an easy victim to the constructions of those who have come after her.

Notes

INTRODUCTION

1 A.W. von Kaunitz, *Correspondance secrète entre A.W. von Kaunitz-Rietberg et le baron Ignaz de Koch, 1750–2*, ed. H. Schlitter, Paris 1899, p. 167: '*la façon de penser de la maîtresse du Roy est une affaire très sérieuse dans ce pays-ci*'.

2 [Chevigni], *La Science des personnes de la cour, d'épée et de robe*, new edn., 8 vols., Paris 1752, VIII, p. 399: '[*un*] *bouclier contre la haine*'.

3 This phrase was coined and popularised in the late nineteenth century by the Goncourts: E. & J. Goncourt, *Madame de Pompadour*, Paris 1899.

4 P. Burke, *The Fabrication of Louis XIV*, New Haven, CT 1992.

5 E. Goodman, *The Portraits of Madame de Pompadour: Celebrating the Femme Savante*, Berkeley, CA 2000. See also *Madame de Pompadour et les arts*, ed. Xavier Salmon, Paris 2002.

6 For an outline of the range of new approaches see C. Jones, *The Great Nation: France from Louis XV to Napoleon (New Penguin History of Modern France. Vol. I)*, Harmondsworth 2002.

7 See *Louis XV: un moment de perfection de l'art français*, Paris 1974.

CHAPTER ONE

1 Dufort de Cheverny, *Mémoires*, ed. P.A. Weber, 2 vols., Paris 1969, p. 89: '[*une femme que*] *tout homme aurait voulu avoir pour maîtresse – elle avait le visage rond, tous les traits réguliers, un teint magnifique, la main et le bras superbes, des yeux plus jolis que grands, mais d'un feu, d'un spirituel, d'un brillant, que je n'ai vu à aucune femme.*' There are two very good source-based general biographies of Madame de Pompadour: Danielle Gallet, *Madame de Pompadour et le pouvoir féminin*, Paris 1985 and Evelyne Lever, *Madame de Pompadour*, Paris 2000. In English, the best biography remains Nancy Mitford, *Madame de Pompadour*, London 1954. Most biographical treatments in English – such as Margaret Crosland, *Madame de Pompadour: Sex, Culture and Power*, London 2000 – invariably do little more than mine the Mitford work. There is no scholarly edition of Pompadour's correspondence. The core of what is in print is contained in *Correspondance de Madame de Pompadour*, ed. M.A.P. Malassis, Paris 1888. There are some important previously unpublished letters in the appendices of Lever, *Madame de Pompadour*.

2 Hénault to Madame du Deffand, in Mme du Deffand, *Correspondance complète*, ed. M. de Lescure, 2 vols., Paris 1867, I, p. 70: '*une des plus jolies femmes que j'aie jamais vues; elle sait la musique parfaitement, elle chante avec toute la gaieté et tout le goût possibles, sait cent chansons* [*et*] *joue la comédie* [*à Étiolles*]'.

3 'Mémoire sur la cour de France', cited in *Les Français vus par eux-mêmes. Le XVIIIe siècle*, eds., A. de Maurepas & F. Brayard, Paris 1996, p. 917: René-Louis de Voyer de Paulmy, marquis d'Argenson, *Journal et mémoires*, ed. J.B.F. Rathery, 9 vols., Paris 1859–67, V, p. 308: '*la plus charmante femme qu'il y eût en France*'.

4 See e.g., *Histoire des femmes. III. XVIe-XVIIIe siècles*, eds. G. Duby & M. Perrot, Paris 1991; S. Hanley, 'Engendering the state: family formation and state building in early modern France', *French Historical Studies*, 16, 1989; *Femmes et pouvoirs sous l'Ancien Régime*, eds. D. Haase-Dubosc & E. Viennot, Paris 1991; L. Steinbrügger, *The Moral Sex. Women's Nature in the French Enlightenment*, New York 1995; J. Landes, *Women and the Public Sphere in the Age of the French Revolution*, Ithaca, NY 1988.

5 See below pp. 66–71, 88, 111.

6 *Œuvres complètes de Pierre de Bourdeille, seigneur de Brantôme*, 9 vols., Paris 1864–82, IX, p. 393: '*un astrologue lui avait prédit qu'elle serait aimée et servie de l'un des plus vaillants et courageux rois de la chrétienté*'.

7 J.A. Leroy, 'Relevé des dépenses de Madame de Pompadour depuis la première année de sa faveur jusqu' à sa mort', *Mémoires de la Société des sciences morales, des lettres et des arts de Seine-et-Oise*, III, 1853, p. 144: '*pour lui avoir prédit, à l'âge de neuf ans, qu'elle serait un jour la maîtresse de Louis XV*'; P. de Nolhac, *Louis XV et Madame de Pompadour*, 2 vols., Paris 1903, p. 21.

8 Lever, *Madame de Pompadour*, pp. 22, 39. For the pre-planned aspect of the seduction see also [Feydeau de Marville], *Lettres de M. de Marville au ministre Maurepas*, ed. A. de Boislisle, 3 vols., Paris 1896, II, p. 71–2.

9 *Nouveaux Mémoires du maréchal duc de Richelieu, 1696–1788*, ed. M. de Lescure, 3 vols., Paris 1863, III, p. 97: '*n'était pas seulement une femme, c'était un parti et elle marchait au premier rendez-vous accompagnée d'un groupe de clients pour lesquels le signal de l'amour était aussi celui du crédit*'. The woman in question was Madame de la Tournelle later the duchesse de Châteauroux. See also below p. 27.

10 *Mémoires du duc de Choiseul*, eds. J.P. Guicciardi & P. Bonnet, Paris 1987, pp. 192–3: '*il parle continuellement d'enterrements, de maladies, de morts, d'opérations de chirurgie*'.

11 Emmanuel, duc de Croÿ, *Journal inédit*, eds. vicomte de Grouchy & P. Cottin, 4 vols., Paris 1906–07, II, p. 513: '*un être isolé au milieu de la foule et pour qui la foule n'est personne*'.

12 Fleury never officially received the title 'principal minister'. See below, p. 122.

13 Letter to Richelieu, cited in extenso by Lever, *Madame de Pompadour*, p. 380: '*quand j'aime une fois, j'aime bien*'.

14 See M. Bloch, *The Royal Touch: Sacred Monarchy and Scrofula in England and France*, London 1974. This thaumaturgic power was also claimed by the kings of England.

15 There were strong constitutional grounds for Louis's XIV's grandson, King Philip V of Spain, acceding to the throne if Louis XV died childless. However in the Treaty of Utrecht in 1713, which ended the cycle of Louis XIV's foreign wars, Philip had renounced this right. This clash between national conventions and international law guaranteed a major political crisis were Louis XV to die young.

16 According to the duc de Bourbon: M. Antoine, *Louis XV*, Paris 1989, p. 158.

17 P. Narbonne, *Journal des règnes de Louis XIV et Louis XV (de l'année 1701 à l'année 1744)*, Paris 1866, p. 509: '*fort aimable le verre à la main*'.

18 She was marquise de Nesle when the liaison with the king started in 1738, marrying the marquis de Vintimille the following year, but continuing her relationship with the king.

19 See above, p. 22.

20 François-Joachim de Pierre, Cardinal de Bernis, *Mémoires*, eds. J.M. Rouart & P. Bonnet, Paris 1986, p. 132: '*le peuple, tout corrompu qu'il est, veut que les princes aiment leurs femmes*'.

21 On this episode, see T. Kaiser, 'Louis the *Bien-Aimé* and the rhetoric of the royal body' in *From the Royal to the Republican Body: Incorporating the Political in Seventeenth- and Eighteenth-Century France*, eds. S.E. Melzer & K. Norberg, Berkeley, CA 1998. More generally on Madame de

Pompadour see also idem, 'Madame de Pompadour and the theatres of power', *French Historical Studies*, 9, 1996.

22 R. Butler, *Choiseul, Father and Son*, Oxford 1980, p. 567.

23 Marville, *Lettres*, II, p. 73: '*le bruit court que Madame d'Étiolles ne sera plus longtemps en place et l'on dit que c'est une assez belle bête… Elle n'est ni baronne, ni comtesse, ni marquise. Elle n'a rapporté, dit-on, de la cour que beaucoup de regrets de toutes les folles démarches qu'elle a faites.*'

CHAPTER TWO

1 Charles-Philippe Albert, duc de Luynes, *Mémoires sur la cour de Louis XV (1718-63)*, eds. L. Dussieux & E. Soulié, 17 vols., Paris 1860–5, VII, p. 55.

2 See successive annual editions of the *Almanach royal*. Pompadour is only listed from 1757 in the role of lady-in-waiting in the queen's household.

3 The *mot* was Madame de La Fayette's: cited in Kaiser, 'Louis the *Bien-Aimé*', p. 148.

4 See the discussion in E. Goodman, *The Portraits of Madame de Pompadour: Celebrating the Femme Savante*, Berkeley, CA 2000, pp. 60–61. Goodman's study complements the work of Gallet and Lever, who accord only a limited amount of space to Pompadour's portraits and cultural interests. The study highlights the portraits rather than Pompadour's wider cultural role.

5 Maintenon's bourgeois origins made her closest to Pompadour in this respect. However, she had come within the compass of Louis XIV after she had entered the court entourage and had become accepted enough to be offered marriage to a duke prior to her relationship with the king.

6 See above, p. 27.

7 Voltaire to Hénault in Voltaire, *Correspondance*, ed. T. Besterman, 51 vols., Oxford 1968–77, XIV, p. 216, letter 2961, 25 August 1745: '*elle a plus lu à son âge qu'aucune vieille dame du pays où elle va régner*'.

8 See *Catalogue des livres de la Bibliothèque de feue madame la marquise de Pompadour*, Paris 1765, item 2690.

9 Cited in G. Chaussinand-Nogaret, *La Vie quotidienne des femmes du Roi*, Paris 1990, p. 42: '*rare exemple pour celles qui jouissent de la même faveur, elle aima Charles uniquement pour lui même, et n'eut autre objet dans sa conduite que la gloire de son amant et le bonheur de l'état*'.

10 Bernis, *Mémoires*, p. 154.

11 Ibid., pp. 153–4: : '*je lui conseillai de protéger les gens de lettres; ce furent eux qui donnèrent le nom de Grand à Louis XIV*'; cf. Luynes, *Mémoires*, VII, p. 111.

12 Marville, *Lettres*, II, p.104: '*c'est lui qui apporte à Madame d'Étiolles la façon d'écrire…et à faire des réponses convenables*'.

13 Butler, *Choiseul*, p. 628: '*remplie de faux airs. Elle avait un ton de mauvaise compagnie insupportable.*'

14 cf. J.F. Solnon, *La Cour de France*, Paris 1987, p. 504.

15 Choiseul, *Mémoires*, p. 63: '*paraissait monstrueuse, car il semblait que l'on violait toutes les règles de la police, de la justice et de l'étiquette*'.

16 See below, pp. 124–6.

17 Vandières was sometimes referred to as 'Monsieur Avant-Hier' ('Mister Day Before Yesterday'). See Marville, *Lettres*, II, p. 179. In 1754, following his father's death, Vandières became marquis de Marigny.

18 Choiseul, *Mémoires*, p. 112.

19 The maréchal de Saxe, cited in *Madame de Pompadour et la floraison des arts*, Musée D.M. Stewart, Montreal 1981, p. 48: '*ce sont deux personnes qui ne veulent pas paraître et qui dans le fond sont fort considérables dans ce pays-ci, parce qu'ils font mouvoir toute la machine*'.

20 See below chapter 6.

21 D'Argenson, *Journal et mémoires*, IV, p. 168: '*fécondité, piété, douceur, humilité et surtout grande incapacité aux affaires*'.

22 The death of the elective king of Poland in 1733 led France to try to put the queen's father, ex-king Stanislas Leszczynski, back on the Polish throne. French efforts were thwarted by a joint Austro-Russian alliance in the War of Polish Succession (1733–5). The French were obliged to accept the Austro-Russian candidate, the Elector of Saxony (Marie-Josèphe's father), as the new ruler.

23 Marville, *Lettres*, II, p. 190: '*ne prend pas… à tâcher de mettre le trouble et divorce dans le ménage et on lui en sait gré*'.

24 E.J.F. Barbier, *Journal historique et anecdotique du règne de Louis XV*, ed. A. de La Villegille, 4 vols., Paris 1857–64, III, p. 123: '*le roi a une grande disposition à s'ennuyer partout, et c'est le grand art de madame de Pompadour de chercher à le dissiper*'.

25 See above, p. 34.

26 Croÿ, *Journal inédit*, I, p. 72: '*Le Roi était gai, libre, mais toujours avec une grandeur qui ne laissait pas oublier… Il paraissait fort amoureux de Madame de Pompadour, sans se*

contraindre à cet égard, ayant toute honte secouée, soit qu'il s'étourdit ou autrement, et paraissait avoir pris son parti*'.

27 Ibid., II, p. 264. I am assuming that this is the bird in question.

28 See X. Salmon, catalogue entry, *Madame de Pompadour et les arts*, pp. 196–8.

29 See below, pp. 88–9, for architecture; and for state affairs, pp. 122–41.

30 D'Argenson, *Journal et mémoires*, VI, p. 146: '*la marquise amuse le Roi tant qu'il n'a pas un moment à réfléchir*'.

31 See above, p. 14.

32 The latter performance was in fact at Pompadour's residence at Bellevue: see below, p. 89.

33 Pompadour to her brother, March 1750: Malassis, *Correspondance*, p. 37: '*Nous avons joué hier pour la première fois la tragédie, c'était Alzire. On prétend que j'ai été étonnante*'. For Pompadour's theatre, the fundamental source is A. Jullien, *La Comédie à la cour: les théâtres de société royale pendant le dernier siècle*, Paris 1883.

34 Cited in Butler, *Choiseul*, p. 720. See ibid. p. 704, for the eunuch jibe.

35 There is a dispute on this identification: see *François Boucher, 1703–72*, 1986, pp. 251–2; and H. Siefert, catalogue entry, *Madame de Pompadour et les arts*, pp. 154–5.

CHAPTER THREE

1 See below, pp. 89, 94.

2 Malassis, *Correspondance*, pp. 102–3: '*nous sommes toujours en chemin*', '*la vie que je mène est terrible; à peine ai-je une minute à moi; répétitions et représentations et deux fois la semaine voyages continuels*'.

3 Previously unpublished correspondence between Pompadour and Richelieu in Lever, *Madame de Pompadour*, p. 349: '*plus j'y vis et plus je le déteste et le méprise*'.

4 Malassis, *Correspondance*, p. 54: '*Excepté le bonheur d'être avec le Roy … le reste n'est qu'un tissu de méchancetés, de platitudes enfin de toutes les misères dont les pauvres hommes sont capables*'.

5 d'Argenson, *Journal et mémoires*, IV, p. 135: '*trop grande, trop arrondie et trop bien située pour le commerce, pour préférer encore les acquisitions à la bonne réputation*'.

6 Antoine, *Louis XV*, p. 400: '*non en marchand mais en roi*'.

7 Recueil Clairambault-Maurepas, *Chansonnier historique du XVIIIe siècle*, VII, p. 144: *Lâche dissipateur des biens de tes sujets,/ Toi qui comptes tes jours par les maux que tu fais,/ Esclave d'un ministre et d'une femme avare,/ Louis, apprends le sort que le*

ciel te prépare./ Qui pourra désormais reconnaître son Roi?/ Tes trésors sont ouverts à leurs folles dépenses, /Ils pillent ses sujets, épuisent tes finances…'

8 Ibid., pp. 135–6: *'Les grands seigneurs s'avilissent,/ Les financiers s'enrichissent,/ Tous les Poissons s'agrandissent,/ C'est le règne des vauriens…/ Une petite bourgeoise,/ Élevée à la grivoise,/ Mesurant tout à sa toise,/ Fait de la cour un taudis,/ Cette catin subalterne/ Insolemment le gouverne/ Et c'est elle qui décerne/ Les honneurs à prix d'argent.*

9 Pompadour to comte d'Argenson, cited in Marquis d'Argenson, *Autour d'un ministre de Louis XV. Lettres intimes inédites*, Paris 1923, p. 266: *'ces maudites chansons'*.

10 *Recueil Clairambault-Maurepas*, VII, p.182: *'Fille d'une sangsue, et sangsue elle-même,/ Poisson dans le palais, d'une arrogance extrême,/ Fait afficher partout, sans honte et sans effroi/ Les dépouilles du peuple et l'opprobre du Roi'.* cf. C. Quetel, *La Bastille. Histoire vraie d'une prison légendaire*, Paris 1989, p. 170. Quite a few of these satires made fun of Pompadour's family name, Poisson, which means fish.

11 D'Argenson, *Journal et mémoires*, V, pp. 469–70: Par vos façons nobles et franches,/ Iris, vous enchantez nos coeurs;/ Sur vos pas vous semez des fleurs,/ Mais ce sont des fleurs blanches.

12 Madame du Hausset, *Mémoires sur Louis XV et Madame de Pompadour*, Paris 1985, pp. 58–60 for this conversation: *'un tempérament très froid… une macreuse … dégoûté d'elle, n'en prend une autre'*. For the miscarriages, at least until 1747, see Marville, *Lettres, passim*. For the allegations of sexual problems see du Hausset, *Mémoires*, pp. 58–60. Recent work by Alden Gordon has argued that they were a hoax and should be discounted as a valid source: A.R. Gordon, 'The Longest Enduring Pompadour Hoax: Sénac de Millhan and the *Journal de Madame du Hausset*' in *Art and Culture in the Eighteenth Century: New Dimensions and Multiple Perspectives*, ed. E.Goodman, Newark, Delaware & London 2001. The view therein expounded that many of the stories in du Hausset were *ex post facto* inventions perhaps underestimates the extent to which – as Professor Gordon notes (p. 34) – they accorded with stories circulating at the time of the Seven Years War. Similarly, as he also notes (p. 33), there is a good deal of corroboration as regards Pompadour's sexual problems. Scholars will be awaiting with interest Professor Gordon's

forthcoming book entitled *The Creation of the Myth of Madame de Pompadour*.

13 du Hausset, *Mémoires*, p. 167: *'froide à l'excès pour l'amour'*.

14 See below, pp. 101, 152.

15 Malassis, *Correspondance*, p. 50: *'elle ressemble beaucoup à l'original, peu à moi'*.

16 *Madame de Pompadour et les arts*, pp. 144–7. The widely accepted view of Alastair Laing that these two portraits were sketches for the portrait sent out to Vandières has recently been strongly contested by Alden Gordon, who argues that the Vandières portrait was in fact the central part of the painting known as *Madame de Pompadour at her Dressing Table* (fig 41): see the discussion below p. 80 n. 43

17 Goodman, *The Portraits of Madame de Pompadour*, 19, pp. 39–40.

18 See below, pp. 86–90.

19 Visible on the table is a signed engraving from P.J. Mariette's *Traité des pierres gravées*, 1750.

20 Goodman, *Portraits of Madame de Pompadour*, p. 122 (citing the duchesse d'Imbault-Ferté).

21 See above, p. 21.

22 Voltaire, *Correspondance*, LV, p. 19, letter 11026, 8 May 1764.

23 After closing in Versailles in 1750, there were a couple of seasons at Bellevue, but the passion had gone out of the exercise and there were no more performances after 1753.

24 See above, p. 38 fig. 13.

25 *Livre-Journal de Lazare Duvaux, marchand bijoutier extraordinaire du roi, 1748–58*, ed. L. Courajoud, Paris 1873, pp. 294, 297.

26 Goodman, *The Portraits of Madame de Pompadour*, pp. 23–4. See also below, p. 119.

27 Kaunitz, 'Mémoire sur la cour de France', p. 917: *'plutôt grande que petite, plutôt maigre que grasse'*; d'Argenson, *Journal et mémoires*, VI, pp. 25, 229.

28 Ibid., VI, p. 370.

29 Pompadour to Richelieu, 8 December (probably 1757 or 1758). Cited in Lever, *Madame de Pompadour*, p. 378: *'Je suis aussi grosse que quand vous m'avez quittée'*.

30 H. Wine, catalogue entry, *Madame de Pompadour et les arts*, pp. 158–60

31 Friedrich Melchior Grimm, *Correspondance littéraire, philosophique et critique par Grimm, Diderot, Raynal, Meister, etc*, ed. M. Tourneux, 16 vols., Paris 1878, III, p. 433: *'surchargée d'ornements, de pompons et de toutes sortes de fanfreluches'*. But for a more praising voice, see *Mercure de France*, as cited in J.G. von

Hohenzollern, 'Die Porträts der Marquise de Baglion und der Marquise de Pompadour', *Pantheon*, 4, 1972, p. 307.

32 Malassis, *Correspondance*, p. 57: *'J'y passe la moitié de ma vie avec grande satisfaction'*.

33 Cited in Goodman, *The Portraits of Madame de Pompadour*, pp. 27, 148, n. 54.

34 As was the Versailles pheasant: see above, p. 51.

35 See generally K.K. Gordon, 'Madame de Pompadour, Pigalle and the iconography of friendship', *Art Bulletin*, 50, 1968; and G. Scherf, catalogue entries, *Madame de Pompadour et les arts*, 2002, pp. 298–302.

36 See esp. P. Stein, 'Madame de Pompadour and the harem imagery at Bellevue', *Gazette des Beaux-Arts*, 123, 1994.

37 *Les Mille et Une Nuits*, 11 vols., Paris 1704–17. I have used the 1727 edition: *Avertissement*, p. xii: *'à faire voir les Arabes aux Français avec toute la circonspection que demandent la délicatesse de notre langue et notre temps'*.

38 H. Siefert, catalogue entries, *Madame de Pompadour et les arts*, 2002, p. 179

39 Le Roy, 'Relevé des dépenses', p. 144.

40 This painting has formerly been attributed to Carle Vanloo's nephew, Louis-Michel. See now, H. Wine, catalogue entry, *Madame de Pompadour et les arts*, pp. 164–6. See also K. Nicholson, 'The ideology of female 'virtue': the vestal virgin in French eighteenth-century allegorical portraiture', in *Portraiture: Facing the Subject* ed. J. Woodall, Manchester 1997.

41 As Nicholson points out, there is an implicit allusion to Pompadour's religious phase, which is discussed below, pp. 111–119.

42 The Saint-Aubin drawings at Waddesdon (figs 45, 46, 78, 82, 83) were brought to my attention by Humphrey Wine, to whose attention they were brought by Katie Scott. I am grateful to both scholars.

43 Alden R. Gordon & Teri Hensick, 'The picture within the picture: Boucher's 1750 portrait of Madame de Pompadour identified', *Apollo*, February 2002, pp. 21–30. Despite the cogency of many of the arguments made by Gordon and Hensick, other analyses of the paintings retain much of their interpretative force. See esp. M. Hyde, 'The Make-Up of the Marquise: Boucher's portrait of Pompadour at her toilette', *Art Bulletin*, 82, 2000 and E. Lajer-Burcharth, 'Pompadour's Touch: Difference in representation', *Representations*, 73, 2001.

CHAPTER FOUR

1 The Salon dated back to the seventeenth century, but had been relaunched after 1737 at first as an annual and then from 1751 as a biennial public exhibition of art. See T.E. Crow, *Painters and Public Life in Eighteenth-Century Paris*, New Haven, CT 1985.

2 See below, pp. 101–3, 152.

3 The only real exception appears to be some items of jewellery which she sold so as to maintain her own cash flow: Le Roy, 'Relevé des dépenses', 128 ff.

4 L.S. Mercier, *Tableau de Paris*, 12 vols., Amsterdam 1782–8, ch. DCXXIV: '*les objets de luxe, de fantaisie et de magnificence… avec admiration mêlée d'étonnement*'.

5 As cited in K Scott, *The Rococo Interior*, London 2000, p. 7.

6 This is the argument of D. Posner, 'Madame de Pompadour as patron of the visual arts', *Art Bulletin*, 82, 1990. See also *Madame de Pompadour et les arts*, p. 137.

7 This emerges in *Correspondance de M. de Marigny avec Coypel, Lépicié et Cochin*, ed. M. Furcy-Raynaud, *Nouvelles Archives de l'art français*, XIX, XX, Paris 1903–04, e.g. 11 and (for Marie Lezszcynska) 31. Pompadour seems to have left a similar amount of artistic discretion to her art dealer, Lazare Duvaux: *Livre-journal*, *passim*. The exception to the rule appears to have been in the portraits she commissioned of herself from about 1750 onwards, in which she was highly interventionist: see above, p. 66.

8 For Pompadour's work on her residences, see C. Baulez et al., catalogue entries *Madame de Pompadour et les arts*, pp. 64–133.

9 See below, p. 152.

10 Cited in C. Michel, 'Le Conflit entre les artistes et le public des salons dans la France de Louis XV', *Traditions et innovations dans la société française du XVIIIe siècle*, Paris 1995, p. 153: '*le public nous demande des sujets agréables, et depuis que je suis à Paris on ne m'a jamais demandé autre chose*'.

11 Cited in A. Chastel, *L'Art français. Ancien Régime, 1620–1775*, Paris 1995, p. 281.

12 Marville, *Lettres*, III, pp. 136, 1747.

13 D'Argenson, *Journal et mémoires*, VII, p. 299: '*qu'on ne peut amuser le Roi absolument que de dessins d'architecture*'.

14 See above, pp. 71–3. See also Bent Sørenson, catalogue entries, *Madame de Pompadour et les arts*, pp. 304–5.

15 See above, pp. 74–6.

16 See H. Siefert, catalogue entries, *Madame de Pompadour et les Arts*, pp. 182–3

17 G. Brunel, *Boucher*, London 1986, p. 240; *François Boucher*, p. 78.

18 *François Boucher*, p. 258. See also H. Wine, catalogue entry, *Madame de Pompadour et les arts*, pp. 182–3.

19 See above, pp. 77–8.

20 See above, pp. 73–80.

21 See M. Avisseau-Broustet, catalogue entry, *Madame de Pompadour et les arts*, p. 267.

22 See above, p. 34. See also G. Scherf, catalogue entry, *Madame de Pompadour et les arts*, pp. 311–3.

23 See A. McClellan, 'Watteau's Dealer: Gersaint and the marketing of art in eighteenth-century Paris', *Art Bulletin*, p. 78, 1996.

24 See the Introduction to *Livre-journal*.

25 See below, p. 144–5.

26 Le Roy, 'Relevé des dépenses', 136 ff.

CHAPTER FIVE

1 Kaiser, 'Madame de Pompadour and the Theaters of Power', p. 1026.

2 On this point, see R. Darnton, 'An early information society: news and the media in eighteenth-century Paris', *American Historical Review*, 2000, p. 105.

3 D'Argenson, *Journal et mémoires*, VI, p. 212: '*a pensé être déchirée par les révoltés; on ne l'a manqué que d'une rue*'.

4 Barbier, *Journal historique*, III, p. 125: '*il s'est débité que l'objet de ces enlèvements d'enfants étant qu'il y avait un prince ladre pour la guérison duquel il fallait un bain ou des bains de sang, et que n'y en ayant point de plus pur que celui des enfants, on en prenait pour les saigner des quatre membres et pour les sacrifier*'. cf. d'Argenson, *Journal et mémoires*, VI, p. 296. More generally on the incident, see A. Farge & J. Revel, *The Vanishing Children of Paris. Rumor and Politics before the French Revolution*, Cambridge, MA 1991.

5 D'Argenson, *Journal et mémoires*, VI, p. 219: '*ce vilain peuple qui dit que je suis Hérode!*'

6 Choiseul, *Mémoires*, p. 192: '*il aurait, comme Néron, été enchanté de voir brûler Paris de Bellevue, mais il n'aurait pas eu le courage d'en donner l'ordre…*'

7 Malassis, *Correspondance*, p. 55: '*Je ne crois pas qu'il n'y ait rien d'aussi bête que de croire qu'on veut saigner leurs enfants pour baigner un prince ladre. J'avoue à ma honte que je les croyais moins imbéciles*'.

8 M. Levey, *Painting and Sculpture in France, 1700–89*, London 1993, p. 159.

9 A.R. Gordon, 'L'Influence du marquis de Marigny sur Madame de Pompdour' in *Madame de Pompadour et les arts*, pp. 51–63

10 Malassis, *Correspondance*, p. 124: '*ils sont tous venus me dire qu'il faudrait en faire un pareil pour les hommes. Cela m'a donné envie à rire, car ils croiront, quand notre affaire sera sue, que c'est eux qui ont donné l'idée*'.

11 Ibid., p. 129: '*pour que l'univers en soit bientôt instruit*'.

12 *Encyclopédie, ou Dictionnaire raisonné des sciences des arts et des métiers, par une société de gens de lettres*, eds. D. Diderot & J. d'Alembert, Paris, 1751–72, V, p. 302: '*C'est par ses soins généraux que l'école militaire doit son existence*'.

13 Malassis, *Correspondance*, p. 130, *un établissement qui doit immortaliser le Roy, rendre heureuse sa noblesse, et faire connaître à la postérité mon attachement pour l'état et pour la personne de S.M.*, cf. above, p. 39.

14 See esp. R.M. Laulan, 'La Fondation de l'École militaire et Madame de Pompadour', *Revue d'histoire moderne et contemporaine*, 19, 1974; and Y. Combeau, *Le Comte d'Argenson, ministre de Louis XV*, Paris 1999, esp. 332 ff.

15 The other dress of this sort was the 1764 portrait by Drouais: see below, p. 148–50. cf. Goodman, *The Portraits of Madame de Pompadour*, p. 152, n. 85. The latter reference suggests that the dresses shown in the other Boucher paintings were for private viewing and took a more idealised form. For the 1757 Salon viewing, see above, p. 82. For the fashion cycle, see M. Sonenscher, 'Fashion's Empire: trade and power in early eighteenth-century France', in *Luxury Trades and Consumerism in Ancien Régime Paris: Studies in the History of the Skilled Workforce*, eds. R. Fox & A. Turner, Aldershot 1998; and M. Berg, 'French fancy and cool Britannia: the fashion markets of early modern Europe', *Proceedings of the Istituto internazionale di storia economica F. Datini*, Prato 2001.

16 cf. d'Argenson, *Journal et mémoires*, VII, p. 408.

17 J. Terrasson, *Madame de Pompadour et la création de la 'porcelaine de France'*, Paris 1969, p. 37 – and *passim* for this section. Of around 2000 French-manufactured objects in Pompadour's possession, 220 were from Saint-Cloud, 7 from Chantilly and the remainder were either Vincennes or Sèvres ware.

18 Cited in Terrasson, *Madame de Pompadour*, p. 104: '*C'est que Boucher était*

Boucher, et les ordres formels.

19 For satirical use of surname cf. p. 59.
20 M.L. de Rochebrune 'La passion de Madame de Pompadour pour la porcelaine', R. Savill 'Les porcelaines de Sèvres de Madame de Pompadour dans les collections anglaises et américaines' and catalogue entries in *Madame de Pompadour et les arts*, p. 407 ff. For the pots-pourri see Terrasson, *Madame de Pompadour*, p. 39.
21 The company had not at that time (February 1754) yet relocated to Sèvres.
22 Croÿ, *Journal inédit*, I, p. 230: '[son] beau service bleu, blanc et or de Vincennes, que l'on venait de renvoyer de Paris l'avait étalé aux yeux des connaisseurs. C'était un des premiers chefs-d'œuvre de cette nouvelle manufacture de porcelaines qui prétendait surpasser et faire tomber celle de Saxe'.
23 d'Argenson, *Journal et mémoires*, VIII, p. 212: 'la marquise dit que ce n'est pas d'être citoyen de ne pas acheter de cette porcelaine autant qu'on a de l'argent'.
24 Letter to her brother, cited in Malassis, *Correspondance*, p. 47: 'Excepté le bonheur d'être aimé de ce qu'on aime … une vie solitaire et peu brillante'.
25 cf. d'Argenson, *Journal et mémoires*, VII, p. 408.
26 Teleki, *La Cour de Louis XV*, pp. 58, 83: 'elle a une certaine maladie qui empêche le Roi de coucher avec elle… il vit avec les filles choisies par elle'.
27 See the discussion by Alastair Laing in *François Boucher*, pp. 259–64.
28 Croÿ, *Journal inédite*, I, p. 189: 'plus en crédit que jamais et toujours fort jolie'; Luynes, *Mémoires*, XIII, p. 436. 'plus puissante que jamais'. cf. d'Argenson, *Journal et mémoires*, VII, p. 449.
29 The nearest Pompadour got to a personal statement on her spiritual aims in moving towards devotion is contained in ambiguous remarks to Stainville (later duc de Choiseul) in January 1756. As the latter was in Rome negotiating with the Pope at the time, it seems quite possible that the marquise thought that her comments might go further, and dosed them accordingly. See *Lettres de Madame de Pompadour à Choiseul, ambassadeur à Rome (1754–7)* ed. de Piépape, Versailles 1917, p. 20.
30 See H. Wine, catalogue entry, *Madame de Pompadour et les arts*, pp. 209–10.
31 See the discussion by A. Laing in *François Boucher*, pp. 245–9.
32 For the religious works see J. Vittet, H. Siefert, X. Salmon and H. Wine, catalogue entries *Madame de Pompadour*

et les arts, pp. 200–13
33 De Piépape, *Lettres de Madame de Pompadour*, p. 11: 'toute satisfaction est morte pour moi avec ma fille'. The author of Madame de Hausset's memoirs concurred on this point: Du Hausset, *Mémoires*, p. 65.
34 'Journal de police sous Louis XV (1742–3)', in E.F.J. Barbier, *Chronique de la Régence et du règne de Louis XV (1718–63)*, 8 vols., 1857–66, vol. VIII, p. 301: 'le Roi craint l'enfer et […] tôt ou tard ce monarque passera des plaisirs à la dévotion la plus outrée'.
35 Kaunitz, *Correspondance secrète*, p. 327; 'Mémoire sur la cour de France', p. 922: 'ces retours à la dévotion qui sont très fréquents font trembler la marquise. Ce n'est point hasarder une conjecture que d'assurer que le plan de la marquise est formé sur celui de madame de Maintenon. Si la reine venait à manquer, on la verrait bientôt dévote'.
36 Nancy Mitford *The Sun King*, New York 1966, p.210; For the reply *Correspondance générale de Madame de Maintenon*, ed. T Lavallée, 5 vols., Paris 1865–7, V, pp. 411–2
37 Malassis, *Correspondance*, p. 137: 'j'aurais préféré la grande niche et je suis fâchée d'être obligée de me contenter de la petite; elle ne convient pas du tout à mon humeur'.
38 M. Marais, *Journal et mémoires sur la Régence et le règne de Louis XV (1715–32)*, 4 vols., Paris 1863–8, III, p. 205.
39 Cited in Gallet, *Madame de Pompadour*, p. 161: 'vos billets de confession sont une chose excellente, mais la charité vaut encore mieux'.
40 P. de Nolhac, *Madame de Pompadour et la politique*, Paris 1928, p. 318: 'plébéiens'; Piépape, *Lettres de Madame de Pompadour*, p. 19: 'de petits républicains'; Malassis, *Correspondance*, p. 113: 'des fous et des mauvais citoyens'.
41 See above, p. 66.
42 Bernis, *Mémoires*, p. 304.
43 Cited in Lever, *Madame de Pompadour*, p. 255: 'C'est à elle que nous devons tout attendre dans l'avenir. Elle veut que l'on l'estime et elle le mérite en effet'.

CHAPTER SIX

1 There had been fighting and conflict outside Europe in the Wars of Spanish and Austrian Succession (1701–13, 1741–8), but the Seven Years War was the first in which such conflict was far more than a sideshow.
2 Cited in J. de Flammermont, *Les Correspondances des agents diplomatiques*

étrangers en France avant la Révolution, Paris 1894, pp. 17–18: 'toute puissante pour ce qui s'appelle grâces et bienfaits, en argent, en charges, tant militaires que de la cour… et en général pour tout ce qui regarde l'intérieur du Royaume… Tous les grands lui font la cour, dès qu'ils désirent obtenir quelque chose'.
3 Kaunitz, 'Mémoire sur la cour de France', p. 917: 'elle gouverne despotiquement; les ministres la préviennent sur tout ce qu'ils ont à dire au Roi, c'est lui-même qui l'exige'.
4 D'Argenson, *Journal et mémoires*, VII, pp. 64, 282: 'les ministres ne manquent pas de lui en parler, étant obligés sous peine de défaveur', 'le Cardinal de Fleury et demi'.
5 See above pp. 43–4. Prussian envoy Le Chambrier was particularly emphatic about the lack of Pompadour's grip on foreign policy.
6 D'Argenson, *Journal et mémoires*, VII, p. 74: 'faisant la savante en politique… elle compte de gouverner l'état de plus en plus comme principal ministre'.
7 Flammermont, *Les Correspondances des agents diplomatiques étrangers*, p. 26: 'il est … impénétrable sur ses secrets et il a montré qu'il sait pousser la dissimulation jusqu'à l'excès quand il le croit nécessaire'.
8 Dufort de Cheverny, *Mémoires*, p. 313: '[il] avait beaucoup de caractère… le jugement le plus faux, ce qu'il devait à ce qu'il voulait briller'.
9 Bernis, *Mémoires*, p. 236: 'le Roi tenait la balance au milieu de ces divisions'.
10 See above, p. 44.
11 Kaunitz, *Correspondance secrète*, pp. 50, 167: 'une charrue assez mal attelée et la plupart des choses ne se font que par intrigues et cabales'.
12 On this unusual episode, see J.D. Woodbridge, *Revolt in Pre-Revolutionary France. The Prince de Conti's Conspiracy against Louis XV, 1755–7*, Baltimore, Maryland 1995. On the *Secret du Roi*, see esp. M. Antoine, *Correspondance secrète du comte de Broglie avec Louis XV (1756–74)*, eds. D. Ozanam & M. Antoine, 2 vols., Paris 1956–61.
13 I am grateful to Caroline Campbell for finding the visual material used here in the National Army Museum and the National Maritime Museum.
14 Piépape, *Lettres de Madame de Pompadour*, p. 37: 'représentez-vous le second tome de Metz à l'exception des sacrements qu'il n'a pas été dans le cas de recevoir'.
15 Dufort de Cheverny, *Mémoires*, p. 219: 'on s'était attaché … à lui prouver que c'était à lui personellement qu'on en voulait, que c'était peut-être une haine, une conspiration… qu'il

fomentait par son indifférence. Madame de Pompadour avait fait tout le contraire: elle lui avait montré que Damiens était un scélérat, un fou et enragé et qu'il n'y avait aucune conspiration.'

16 Flammermont, *Correspondances des agents diplomatiques étrangers*, p. 176. (My thanks to Humphrey Wine for reminding me of this reference.)

17 Cited in Lever, *Madame de Pompadour*, p. 278. 'Tant que MM. d'Argenson et de Machault ont été en place, le public n'a accusé qu'eux des malheurs de l'État. Leur exil met le Roi à découvert, et vous aussi, Madame.'

18 ibid., pp. 279–80: 'A présent que les ministres sont renvoyés et que les hommes qui les remplacent n'ont aucun ascendant, ni aucune influence, songez, Madame, que c'est sur vous qu'on a les yeux et que c'est à vous désormais que s'adresseront les reproches, les plaintes…'

19 This print was found by Humphrey Wine who kindly brought it to my attention.

20 du Hausset, *Mémoires*, p. 138.

21 Nolhac, *Madame de Pompadour et la politique*, pp. 252–3: 'une armée ne se mène pas comme on promène son doigt sur une carte.'

22 Cited in Lever, *Madame de Pompadour*, p. 312: 'périr sans gloire pour le service de l'impératrice'.

23 Nolhac, *Madame de Pompadour et la politique*, p. 245: 'elle [voit] en enfant les affaires de l'état'

24 Lever, *Madame de Pompadour*, p. 327: 'indignes citoyens et beaucoup plus ennemis de l'état que le roi de Prusse et les Anglais'.

25 *Mémoires et lettres de François-Joachim de Pierre, Cardinal de Bernis*, ed. F. Masson, 2 vols., Paris 1878, II, p. 247: 'Paris la déteste et l'accuse de tout'.

26 E. Dziembowski, *Un Nouveau patriotisme français, 1750–70. La France face à la puissance anglaise à l'époque de la guerre de Sept Ans*, Oxford 1998, p. 427: 'Tant que Beaumont sera chef de l'église/ Tant que Bourbon baisera la marquise/ Tant que l'armée guerroiera par Soubise/ Nous serons fichus du vent de bise'.

27 See G. Scherf, catalogue entry, *Madame de Pompadour et les arts*, pp. 293–5.

28 H. Barbier, *Journal historique*, IV, pp. 447, 460, etc. See also A. McClellan, 'The life and death of a royal monument: Bouchardon's 'Louis XV', *Oxford Art Journal*, p. 23, 2000 and *Madame de Pompadour et les arts*, pp. 193–5.

1 See above, pp. 73–8. cf. *Catalogue des Livres*, item 2147.

2 Galland, *Les Mille et Une Nuits*, p. 33: 'femme savante… beauté excellente… vertu très-solide'.

3 See above, p. 34.

4 See above, p. 39.

5 Kaunitz, 'Mémoire sur la cour de France', p. 883: 'l'ennemi le plus cruel qu'ait ce prince'; Dufort de Cheverny, *Mémoires*, p. 342: 'elle avait le grand art de distraire l'homme du royaume le plus difficile à amuser'.

6 See above, p. 24.

7 Croÿ, *Mémoires*, I, p. 173.

8 Du Hausset, *Mémoires*, p. 59: 'les chaines de l'habitude vous l'attacheront pour toujours [les princes sont avant tout] des gens d'habitude; l'amitié du Roi pour vous est la même que pour votre appartement, vos entours; vous êtes faite à ses manières, à ses histoires; il ne se gêne pas, ne craint pas de vous ennuyer'.

9 Cited in E. Campardon, *Madame de Pompadour et la cour de Louis XV*, Paris 1867, p. 173.

10 Diderot, *Salons*, eds. J. Seznec & J. Adhémar, 2nd edn., 3 vols., Oxford 1975–83, I, p. 112.

11 See Hyde, 'The 'Make-up' of the marquise', p. 456. 'Fard séduisant' was actually a term of criticism originating in the seventeenth century and used by La Font de Saint-Yenne.

12 *Catalogue des livres*, item 2147. (Alongside a translation of John Cleland's *Fanny Hill*).

13 cf. the discussion in T. Crow, 'La Critique des Lumières dans l'art sur XVIIIe siècle', *Revue de l'art*, p. 73, 1986.

14 *Salons*, II, p. 75.

15 *Salons*, II, p. 76: 'de petits bâtards de Bacchus et Silène'

16 See H. Wine's discussion of these two Drouais works in *Madame de Pompadour et les arts*, pp. 160–4.

17 It has also been suggested that the different tonality around the head may result from its separate composition.

18 Teleki, *La Cour de Louis XV*, p. 83: 'Elle est d'une corpulence et d'une taille moyennes…Elle semble belle, mais pas de la plus grande beauté'.

19 [Louis Petit de Bachaumont], *Mémoires secrets pour servir à l'histoire de la République des Lettres en France*, 36 vols., London 1762–89, II, p. 79 'la ressemblance des plus frappantes'. Bachaumont had, in contrast, attacked Boucher's 1756 portrait of the marquise when it was exhibited at the 1757 Salon.

20 Terrasson, *Madame de Pompadour*, p. 132.

21 See above, pp. 45, 47. cf. too Aved's portrait of Madame Crozat (fig. 21).

22 Lever, *Madame de Pompadour*, pp. 338–9.

23 Cited in F.J.B. Watson, 'Beckford, Madame de Pompadour, the duc de Bouillon and the taste for Japanese lacquer in eighteenth-century France', *Gazette des Beaux-Arts*, 111, 1963, 108.

24 See p. 85

25 See B. Rondot, 'De la rocaille au goût grec' in *Madame de Pompadour et les arts*, pp. 315–25.

26 Cited by Posner, 'Madame de Pompadour', p. 74.

27 *Salons*, II, p. 29. For d'Alembert, cf. Voltaire, *Correspondance*, LV, p. 156 (letter 1141).

28 *Journal et mémoires de Charles Collé*, ed. H. Bonhomme, 3 vols., Paris 1868, II, p. 350: 'depuis l'établissement de la monarchie jamais maîtresse du roi a fait autant de mal à ce royaume'.

29 ibid., p. 349: '[elle avait] rendu toute la cour financière','les gens de la plus grande qualité n'ont point dédaigné, n'ont pas regardé comme une bassesse des intérêts des affaires' 'Tout ne se donnait pas; la plupart des choses se vendaient ou s'achetaient; l'argent paraît seul aujourd'hui donner de la considération.'

30 cf. C. Jones, *The Great Nation: France from Louis XV to Napoleon, 1715–99*, Harmondsworth 2002, esp. ch. 5.

31 Mercier, *Tableau de Paris*, 12 vols., Amsterdam 1787–8, vol. IV, ch. CCCXLVI, p. 346: 'Versailles se trouvant dans le tourbillon de la capitale obéira toujours en satellite à ses mouvements'.

32 Cited in S. Maza, *Private Lives and Public Affairs: The Causes Célèbres of Pre-Revolutionary France*, Berkeley, CA 1993, p. 180: 'Les Fastes de Cour'. Maza covers from the 1760s – i.e. the period in which Pompadour's posthumous reputation was being shaped.

33 [Chevigni], *La Science des personnes de la cour, d'épée et de robe*, new edn., 8 vols., Paris 1752, VIII, p. 399: See *Catalogue des livres*, item 2281: 'des favoris… qui leur servent de bouclier contre la haine… il faut y avoir une tête forte qui serve de but à tous les coups et qui porte les reproches de toutes les fautes et de tous les malheurs'.

34 de Catt, *Unterhaltungen mit Friedrich dem Grossen. Memoiren und Tagebücher von Heinrich de Catt*, Leipzig 1884, p. 293: 'jouet de Pompadour'.

35 cf. *French Caricature and the French Revolution, 1789–99*, ed. J. Cuno, Berkeley, CA 1989; C. Thomas, *La Reine scélérate: Marie-Antoinette dans les pamphlets*, Paris 1989.

Chronology

1715
1 September
Louis XIV, the 'Sun King', dies in his palace at Versailles. Born in 1638, he had ruled since 1643. He is succeeded by his great-grandson, the five-year-old Louis XV.

September 1715 – December 1723
Regency of Philippe, duc d'Orléans (1674–1723), Louis XV's uncle. The regent moves the royal court from Versailles to Paris.

1721
29 December
Jeanne-Antoinette Poisson born in Paris; daughter of François Poisson (1684–1754), an official linked to the Pâris financial clan, and Louise-Madeleine de La Motte (1699–1745).

14 June
Louis returns the royal court to Versailles.

1725
5 September
Louis marries Marie Leszczynska (1703–1768), daughter of Stanislas Leszczynski, the deposed and exiled king of Poland.

1726–43
16 June
Louis dismisses his principal minister, the duc de Bourbon, and declares he will rule without a principal minister. But in fact, he places his childhood tutor, the abbé (soon cardinal) Fleury (1653–1743) in charge of state business. Fleury remains as effective principal minister until his death at the age of 89.

1727
François Poisson flees the country to avoid prosecution for fraud. Madame Poisson remains in Paris and Jeanne-Antoinette is sent to be educated in the Ursuline convent at Poissy.

Jeanne-Antoinette's brother, Abel-François Poisson (1727–1781) born, subsequently Monsieur de Vandières, and then marquis de Marigny.

1730
Jeanne-Antoinette returns to Paris. Madame Poisson is protected by her lover, the wealthy financier, Charles-François-Paul Lenormant de Tournehem (1684–1751).

1733
Louis begins an illicit affair with Madame de Mailly, one of four daughters of the marquis de Nesle. In the late 1730s, Louis renounces her for her sisters, the marquise de Vintimille, then Madame de La Tournelle (made duchesse de Châteauroux).

1733–5
War of Polish Succession: France fails to reinstate Stanislas Leszczynski as king of Poland.

1741
9 March
Jeanne-Antoinette marries Charles-Guillaume Lenormant d'Etiolles (1717–1799), nephew and heir of Lenormant de Tournehem.

11 July
War of Austrian Succession begins, lasting until 1748.

26 December
Jeanne-Antoinette gives birth to a son, but the baby dies in his first year.

1743
29 January
Cardinal Fleury dies; Louis once more declares that he will rule without a principal minister.

1744
10 March
Alexandrine, daughter of Jeanne-Antoinette born.

August
The Metz incident: Louis recovers after a serious illness and is declared le Bien-Aimé.

8 December
The duchesse de Châteauroux dies.

1745
25 February
A masked ball is held at Versailles as part of the festivities concerning the marriage of the Dauphin. Louis begins a relationship with Jeanne-Antoinette.

Spring–summer
Louis leads France's armies on the northern front in the War of Austrian Succession. Jeanne-Antoinette receives tuition in court lore and manners from Voltaire (1694–1778) and Bernis (1715–1794).

11 May
French victory at the battle of Fontenoy.

24 June
Louis purchases the marquisate of Pompadour for Jeanne-Antoinette with financial help from Pâris de Montmartel (1688–1766). Her husband is paid off and receives a post as fermier-général. Jeanne-Antoinette is henceforth Madame de Pompadour.

September
Pompadour is received at court and moves into apartments at Versailles.

24 December
Pompadour's mother dies.

1747
January
Lenormant de Tournehem is appointed to the post of directeur des Bâtiments du Roi, with Pompadour's brother, Vandières, given the reversionary right to the post.

1748
18 October
The Treaty of Aix-la-Chapelle ends the War of Austrian Succession.

1749
24 April
The royal minister, Maurepas (1701–1781), is disgraced and expelled from court following the Poissonades incident.

Vandières begins a tour of Italy with Charles-Nicolas Cochin (1715–1790), abbé Leblanc (1707–1781) and Jacques-Germain soufflot (1713–1780).

December
The 'Vanishing Children' incident causes riots in Paris.

1750
November
Inauguration of Pompadour's new residence at Bellevue. Around the same time, Pompadour's relationship with Louis becomes non-sexual in nature. The king begins to have sexual relationships with other women.

1751
March
The Pope opens the church's Jubilee year. Growing pressure from the *dévot* faction at court for the king to end his extra-marital relations.

September
Vandières returns to France and, following the death of Lenormant de Tournehem, becomes *director du Bâtiments du Roi* and from 1754 takes the title the marquis de Marigny.

Publication of the first volumes of Diderot and d'Alembert's *Encyclopédie*.

First major clash of the 1750s between the King and the Paris *Parlement*. There will be a long-running feud between the two throughout the 1750s.

1752
17 October
Pompadour is made duchess, but retains the title of marquise.

1753–4
Further political crisis involving the Paris *Parlement* over the *billets de confession* issue.

1754
14 March
Pompadour's daughter, Alexandrine, dies.

25 June
Pompadour's father dies.

1755
Autumn
Quentin de La Tour's portrait of Pompadour is exhibited at the Paris Salon.

September
Austria begins secret negotiations with France through Pompadour that lead to the 'Diplomatic Revolution' of 1756.

1756
7 February
Pompadour is appointed lady-in-waiting in the queen's household.

1 May
Treaty of Versailles with Austria: 'Diplomatic Revolution', as France allies with its long-time enemy, Austria, leaving England to ally with Prussia and Russia.

9 June
The Seven Years War (1756–63) begins as France declares war on England.

June
French forces under Richelieu seize Minorca from England.

June 1756 – February 1757
Further conflict between the King and the Paris *Parlement*.

1757
6 January
François Damiens attempts to assassinate the king. He is executed on 28 March 1757.

1 February
The ministers comte d'Argenson (1696–1764) and Machault d'Arnouville (1701–1794), are dismissed from court.

28 June
Bernis is appointed Foreign Minister.

Autumn
Boucher's 1756 portrait of Pompadour is displayed at the Paris Salon.

5 November
The French are defeated by Prussia at the battle of Rossbach.

1758
9 October
Bernis is dismissed as Foreign Minister and replaced by the comte de Stainville, now made duc de Choiseul (1719–1785).

1759
25 June
In Canada, Quebec falls to the English under General Wolfe.

1761
6 August
The 'Family Pact' is signed allying the Bourbon powers, France and Spain.

1763
10 February
The Treaty of Paris ends the Seven Years War.

20 June
Inauguration of Bouchardon's statue of Louis on the Place de Louis XV in Paris.

1764
Building begins on the Sainte-Geneviève church (the future Panthéon), designed by Soufflot.

7 April
Pompadour dies at Versailles aged 42. Drouais completes the last portrait of her shortly afterwards.

List of
Exhibited Works

Figure numbers in brackets refer to
illustrations in this book.
Preceding numbers are the catalogue
numbers of the exhibited works.

1 (fig. 3)
Hyacinthe Rigaud (1659–1743)
Antoine Pâris, 1724
Oil on canvas, 144.7 × 110.5 cm
National Gallery, London, inv. NG6428

2 (fig. 7)
Jean-Marc Nattier (1685–1766)
Marie-Anne de Mailly-Nesle, about 1740–44
Oil on canvas, 81 × 101.2 cm
Musée National des Châteaux de Versailles et
de Trianon, Versailles, inv. MV 8415

3 (fig. 8)
Carle Vanloo (1705–1765)
Louis XV, 1748
Oil on canvas, 277 × 183 cm
Musée National des Châteaux de Versailles et
de Trianon, Versailles, inv. MV 4389

4 (fig. 19)
Jean-Marc Nattier (1685–1766)
Madame de Pompadour, 1748
Oil on canvas, 53 × 43.2 cm
Musée de l'Hôtel Sandelin, Saint-Omer,
inv. 0179CM

5 (fig. 20)
Jean-Marc Nattier (1685–1766)
Marie Leszczynska, Queen of France, 1748
Oil on canvas, 138.9 × 107 cm
Musée National des Châteaux de Versailles et
de Trianon, Versailles, inv. MV 5672

6 (fig. 9)
Charles-Nicolas Cochin the Elder (1688–1754)
after Charles-Nicolas Cochin (1715–1790)
*Decoration for the Masked Ball given by the King
… on the Occasion of the Marriage of Louis
Dauphin de France to María Theresa Infanta of
Spain*, 1746
Etching and engraving, 45 × 75 cm
The British Museum, London,
inv. P&D 1947-10-11-24

7 (fig. 10)
Charles-Nicolas Cochin (1715–1790) and
Gabriel de Saint-Aubin (1724–1780)
Three designs for ex-libris, 1745–55
Chalk, wash and ink on paper,
5.8 × 11.9 cm, 5.3 × 10.2 cm, 6 × 9.1 cm
Private collection
French frame with the coat of arms of
Madame de Pompadour, about 1760
Carved and gilded wood, 69 × 46.4 cm
Private collection

8
William Wynne Ryland (1732–1783) after
François Boucher (1703–1770)
Cartouche with the coat of arms of Madame
de Pompadour, before 1759
Etching and engraving, 59.8 × 40.6 cm
The Rothschild Collection, Musée du Louvre,
Paris, inv. 25540 LR (fig. 15, inv. 5996 LR)

9 (fig. 76)
Louis-François Aubert (d.1755) after François
Boucher (1703–1770)
Alexandrine Lenormant d'Étiolles, 1751
Enamel on metal in a copper frame,
2.8 × 2.4 cm
Musée Lambinet, Versailles, inv. 596

10 (fig. 17)
François Guérin (active 1751–1791)
*Madame de Pompadour and her Daughter
Alexandrine*, probably 1763
Black and red chalk with white highlighting
on blue paper, 23.5 × 19 cm
E.B. Crocker Collection, Crocker Art
Museum, Sacramento, CA, inv. 1871.403

11 (fig. 26)
François Boucher (1703–1770)
Apollo and Issa, 1750
Oil on canvas, 129 × 157.5 cm
Musée des Beaux-Arts de Tours, inv. 794-1-1

12 (fig. 64)
French console table, about 1750
Carved and gilded oak topped with marble,
88.5 × 116 × 40 cm
Musée National des Châteaux de Versailles et
de Trianon, Versailles, inv. MV 3715

13 (fig. 56)
François Boucher (1703–1770)
The Toilet of Venus, 1751
Oil on canvas, 108.3 × 85.1 cm
Bequest of William K. Vanderbilt, 1920, The
Metropolitan Museum of Art, New York,
inv. 20.155.9

14 (fig. 52)
Carle Vanloo (1705–1765)
Painting, 1752/3
Oil on canvas, 87.5 × 84 cm
Mildred Anna Williams Collection, Fine Arts
Museums of San Francisco, CA, inv. 1950.9

15 (fig. 53)
Carle Vanloo (1705–1765)
Sculpture, 1752/3
Oil on canvas, 87.5 × 84 cm
Mildred Anna Williams Collection, Fine Arts
Museums of San Francisco, CA, inv. 1950.10

16 (fig. 54)
Carle Vanloo (1705–1765)
Architecture, 1752/3
Oil on canvas, 87.5 × 84 cm
Mildred Anna Williams Collection, Fine Arts
Museums of San Francisco, CA, inv. 1950.11

17 (fig. 55)
Carle Vanloo (1705–1765)
Music, 1752/3
Oil on canvas, 87.5 × 84 cm
Mildred Anna Williams Collection, Fine Arts
Museums of San Francisco, CA, inv. 1950.12

18 (fig. 41)
François Boucher (1703–1770)
Madame de Pompadour at her Dressing Table,
signed and dated (probably in the twentieth
century) 'fBoucher/1758'
Oil on seven pieces of canvas,
81.2 × 64.9 cm
Bequest of Charles E. Dunlap, 1966, Courtesy
of the Fogg Art Museum, Harvard University
Art Museums, Cambridge, MA, inv. 1966.47

19 (fig. 30)
François Boucher (1703–1770)
Madame de Pompadour, 1756
Oil on canvas, 201 × 157 cm
Collection of Bayerische Hypo- und
Vereinsbank, Alte Pinakothek, Bayerische
Staatsgemäldesammlungen, Munich,
inv. Nr. HuW 18

20 (fig. 32)
François Boucher (1703–1770)
Madame de Pompadour seated outside, 1758
Oil on canvas, 72.4 × 57.8 cm
The Victoria and Albert Museum, London,
inv. PDP: 487-1882

21 (fig. 28)
François Boucher (1703–1770)
Madame de Pompadour standing at a Clavichord,
probably 1750
Oil on paper mounted on canvas,
60 × 45.5 cm
Bequest of Baron Basile de Schlichting, 1914.
Musée du Louvre, Paris, inv. RF2142

22 (fig. 1)
François Boucher (1703–1770)
*Madame de Pompadour standing at her Dressing
Table*, probably 1750
Oil on canvas, 62.5 × 46 cm
Waddesdon Manor, The Rothschild
Collection (Rothschild Family Trusts),
inv. 965.1995

23
Jacques-Philippe Carel (active 1723, d. before
1755)
Writing bureau, 1748
Oak and coniferous wood, veneered with
kingwood, satinwood and violet wood,
snakewood marquetry, and gilt bronze,
90.5 × 83 × 48.5 cm
Musée National des Châteaux de Versailles et
de Trianon, Versailles, inv. V 5433

24 (fig. 63)
Meissen monkey concert, about 1753, Johann
Joachim Kändler (1706-75) and Peter Reinicke
(1715-1768)
 Conductor
 17.8 × 5 cm, inv. G 83.1.675.1
 The Harpsichord (about 1800)
 13 × 9.5 cm, inv. G 83.1.675.2
 The Violin
 13.3 × 5 cm, inv. G 83.1.675.3
 The Hurdy-gurdy
 14 × 5 cm, inv. G 83.1.675.4
 The Guitar
 14 × 5 cm, inv. G 83.1.675.5
 The Bagpipes
 14.2 × 5 cm, inv. G 83.1.675.6
 The Flute
 14.2 × 6 cm, inv. G 83.1.675.7
 The Bassoon
 13.7 × 5,7 cm, inv. G 83.1.675.8
 The Trumpet (about 1765–6)
 13.4 cm, inv. G 83.1.675.9
 The Clarinet
 13.4 × 5 cm, inv. G 83.1.675.10
 The French Horn
 15.3 × 5 cm, inv. G 83.1.675.11
 The Pipe and Drum
 14.2 × 5 cm, inv. G 83.1.675.12
 Carrying Drums
 12.7 × 5 cm, inv. G 83.1.675.13
 Carrying Drums

 12.7 × 5 cm, inv. G 83.1.675.14
 Two Singers each with the score
 12.7 × 5 cm, inv. G 83.1.675.15/16
 Two Singers each with the score
 12.7 × 5 cm, inv. G 83.1.675.17/18
Hard-paste porcelain
Gift of George and Helen Gardiner, The
Gardiner Museum of Ceramic Art, Toronto

25 (fig. 49)
After Jacques-François-Joseph Saly
(1717–1776)
Hebe, before 1783
Marble, 100 × 30 × 20 cm
The Victoria and Albert Museum, London,
inv. SCP1132 1882

26 (fig. 65)
Sèvres inkstand, probably 1758–9, painted by
Jean-Baptiste Tandart the Elder (active
1754–1800)
Soft-paste porcelain, 5.5 × 30.1 × 19.2 cm
Gift of J. Pierpont Morgan
The Wadsworth Atheneum Museum of Art,
Hartford, CT, inv. 1917.1013 A-E

27 (fig. 50)
Two French sugar castors, about 1738–50
Varnished bronze and silver,
22.8 × 11.5 × 15.2 cm
The J. Paul Getty Museum, Los Angeles, CA,
inv. 88 DH 127-1-2

28 (fig. 68)
Vincennes pot-pourri Pompadour, about 1751
Soft-paste porcelain, with a replacement
cover and a later gilt-bronze stand
45.7 × 24.2 cm
Private collection. Courtesy Christie's
Images, London

29 (fig. 69)
Sèvres gondola pot-pourri, 1756–7, painting
attributed to Charles-Nicolas Dodin
(1734–1803)
Soft-paste porcelain, 35.9 × 36.8 × 20.3 cm
Gift of the Samuel H. Kress Foundation,
1958. The Metropolitan Museum of Art, New
York, inv. 58.75.88 a-c

30 (fig. 24)
Sèvres eyeglass, about 1757–60
Soft-paste porcelain, ivory, board and glass,
8.5 × 4.5 cm
Musée du Louvre, Paris, inv. OA 7856

31
Sèvres wall plaque, 1760–1, painted by
Charles-Nicolas Dodin (1734–1803)
Soft-paste porcelain, 25.1 × 19.2 cm
Gift of R. Thornton Wilson, in memory of
Florence Ellsworth Wilson, 1954.
Metropolitan Museum of Art, New York,
inv. 54.147.19

32/33 (fig. 66)
Pair of Sèvres vase candelabra, 1760, painted
by Charles-Nicolas Dodin (1734–1803)
Soft-paste porcelain, 43.5 × 26 × 18.5 cm
Acquired by Mrs Henry Walters
The Walters Art Museum, Baltimore, MD,
inv. 48.1796-7

34
Chinese vase, Qianlong period 1736–95, on a
French mount, about 1750–5
Hard-paste crackle-glaze celadon porcelain
with gilt-bronze mount,
36.9 × 41.2 × 27.9 cm
The J. Paul Getty Museum, Los Angeles, CA,
inv. 72.DI.42

35 (fig. 51)
Chinese vase on French mount, about 1750
Blue-glaze Chinese porcelain with gilt-
bronze mount, 32.7 × 57.3 × 33 cm
The Royal Collection, Windsor Castle,
Windsor, inv. RCIN 35312

36/37 (fig. 67)
Pair of Chinese Kangxi vases, about
1685–1720, on French mounts 1740–1750
Hard-paste celadon porcelain with gilt-
bronze mounts, 30 × 15.5 × 11 cm
The Victoria and Albert Museum, London,
inv. FED: 814-1882 and FED: 814A-1882

38
Jean-Baptiste Lemoyne II (1704–1778)
Louis XV, 1749
Marble, 78.5 × 58 × 36.5 cm
Private collection

39
French, after Jean-Baptiste Pigalle (1714–1785)
Madame de Pomapdour in the Guise of Friendship,
1830s
Plaster, 166.5 × 62.8 55.5 cm
Musée National des Châteaux de Versailles et
de Trianon, Versailles,
inv. MV7854

40 (fig. 58)
Étienne-Maurice Falconet (1716–1791)
Threatening Love, 1757
Marble, 91.5 × 50 cm
Rijksmuseum, Amsterdam, inv. BK-1963-101

41
Jeanne-Antoinette Poisson, Marquise de
Pompadour (1721–1764), after Jacques Guay
(1711–1797) and François Boucher (1703–1770)
Love, before 1765
Etching, 16.5 × 13.4 cm
The British Museum, London,
inv P&D 1866-11-47-747

42
Jeanne-Antoinette Poisson, Marquise de
Pompadour (1721–1764), after Jacques Guay
(1711–1797) and François Boucher (1703–1770)
Love sacrificing to Friendship, before 1765
Etching, 30 × 20 cm
London, The Victoria and Albert Museum,
inv. NAL.III.RC.L.3

43 (fig. 44P)
Jacques Guay (1711–1797)
Louis XV, before 1764
Onyx cameo mounted in a gold ring set with
diamonds, 1.6 × 1.3 cm (setting)
Paris, Bibliothèque Nationale de France,
inv. RCA 9 304 (88)

44
Jeanne-Antoinette Poisson, Marquise de
Pompadour (1721–1764)
Louis XV, before 1764
Agate cameo mounted in a gold ring,
1.9 × 1.5 cm (setting)
Paris, Bibliothèque Nationale de France,
inv. Babelon 931

45 (fig. 36)
After Étienne-Maurice Falconet (1716–1791)
Madame de Pompadour as Friendship, 1755
Soft-paste 'biscuit' porcelain,
27 × 14.4 × 8 cm
The Bowes Museum, Barnard Castle, Co.
Durham, inv. Cer.1997.5

46 (fig. 38)
Carle Vanloo (1705–1765)
*A Sultana at her Tapestry Frame with a
Companion*, about 1752
Oil on canvas, 120 × 127 cm
The State Hermitage Museum, Saint
Petersburg, inv. 7490

47 (fig. 37)
Carle Vanloo (1705–1765)
Madame de Pompadour as a Sultana, about 1752
Oil on canvas, 120 × 127 cm
The State Hermitage Museum, Saint
Petersburg, inv. 7489

48
Attributed to Nicolas-Quinibert Foliot
(1706–1776)
Chair, about 1755
Carved and gilt beech,
95 × 60.5 × 51.5 cm
Musée de l'Île de France, Château de Sceaux,
inv. 86.39.1

49 (fig. 31)
Carle Vanloo (1705–1765)
Madame de Pompadour ('La belle jardinière'),
about 1754/5
Oil on canvas, 81 × 64 cm
Musée National des Châteaux de Versailles et
de Trianon, Versailles, inv. MV 8616

50 (fig. 40)
François-Hubert Drouais (1727–1775) and
Studio
Madame de Pompadour as a Vestal, probably
1762–3
Oil on canvas, 100 × 81 cm
Stewart Museum at the Fort Île Sainte-
Hélène, Montreal, Quebec, inv. 1985.32

51 (fig. 75)
François Boucher (1703–1770)
The Flight into Egypt, 1757
Oil on canvas, 139.5 × 148.5 cm
The State Hermitage Museum, Saint
Petersburg, inv. 1139

52 (fig. 73)
François Boucher (1703–1770)
The Infant Christ blessing Saint John, 1758
Oil on canvas, 50 × 44 cm
Galleria degli Uffizi, Florence, inv. 1890

53 (fig. 74)
François Boucher (1703–1770)
Saint John the Baptist, about 1757
Oil on canvas, 163.8 × 115.6 cm
The Putnam Dana McMillan Fund,
Minneapolis Institute of Art,
inv. 75.8

54
Jacques-André Portail (1695–1759)
Saint Anthony the Hermit, 1750s
Black and red chalk, pen and grey ink, and
white highlights on cream-coloured paper,
40 × 29 cm
Musée National des Châteaux de Versailles et
de Trianon, Versailles, inv. MV 1143

55
Bartolomeo Mancini (active end of the
seventeenth century)
Bust of the Virgin, 1696
Oil on copper, 11.8 × 9.5 cm
Private collection

56
Jean-Jacques Bachelier (1724–1806)
*Still Life with a Book, Bread and Bunches of
Grapes*, 1755
Oil on canvas, 36.5 × 46.5 cm
Private collection

57 (fig. 71)
Joseph-Marie Vien (1716–1809)
The Visitation, 1752–3
Oil on canvas, 35 × 22 cm
Musée des Beaux-Arts, Rouen, inv. 862.1.8

58 (fig. 27)
Jean-Pierre-Marie Jazet (1788–1871) after
Horace Vernet (1789–1863)
*The British Standards being laid before Louis XV at
Fontenoy, 1745*, 1854–62
Aquatint, 66.2 × 105.3 cm
National Army Museum, London,
inv. 7102-33-16-9

59
Antoine-François Sergent (1751–1847)
The Lifting of the Siege of Pondicherry, 1789
Coloured aquatint, 22.5 × 14.4 cm
National Army Museum, London,
inv. 1971-02-33-299

60 (fig. 80)
British, 1756
*…[T]he English and French Fleets…at the Time of
Engagement off Mahon, May 20th 1756*
Etching, 18.5 × 38.6 cm
National Maritime Museum, London,
inv. PAF4593

61
Pierre Charles Canot (1710–1777) after
Richard Paton (1717–1791)
To the Captains other Officers & Seamen who…
Burnt the Prudent and took the Bienfaisant in
Louisburgh Harbour… the 26th July 1758, 1771
Hand-coloured engraving,
44.4 × 65.5 cm
National Maritime Museum, London,
inv. PAH7696

62 (fig. 88)
British, 1760, after Thomas Jefferys
(1699–1771) and Paul Rycaut (active mid-
eighteenth century)
Plan of the Attack against Basseterre on the Island
of Guadeloupe… 22d Jany 1759
Engraving with etching, 40.2 × 55.5 cm
National Maritime Museum, London,
inv. PAG8827

63
Francis Swaine (about 1720–1782)
The Defeat of a French Squadron… off Cape Lagos,
on 18th of August 1759, 1761
Hand-coloured engraving, 32.8 × 46.4 cm
National Maritime Museum, London,
inv. PAG8835

64
British, 1760
Conquests in the Glorious 1759
Tinted line engraving, with verses inscribed
by James Cooper, 48 × 39 cm
National Army Museum, London,
inv. 7102-33-94

65 (fig. 84)
British, 1797
A View of the Taking of Quebec, September 13th
1759
Coloured line engraving, 34.2 × 49.2 cm
National Army Museum, London,
inv. 7102-33-314

66 (fig. 86)
Edward Penny (1714–1791)
The Death of General Wolfe, 1763
Oil on canvas, 102 × 127 cm
Visitors of the Ashmolean Museum,
transferred from the Bodleian 1845
Ashmolean Museum, Oxford, inv.
WA1845.38;A38

67 (fig. 85)
Juste Chevillet (1729–1790) after François
Watteau (1758–1823)
The Death of the Marquis de Montcalm-Gozon,
1783
Etching and engraving, 49.6 × 61.4 cm
National Army Museum, London,
inv. 7102-33-325

68 (fig. 87)
Pierre Charles Canot (1710–1777) after
Richard Paton (1717–1791)
…[T]he Glorious Defeat of the French Fleet…off
Belle-Isle on the 20th November 1759, 1761
Engraving, 44.4 × 65.6 cm
National Maritime Museum, London, inv.
PAH7712

69 (fig. 91)
French, eighteenth century
The Taking of the Forts and Town of Havana by the
English in 1762
Hand-coloured etching and engraving, 30.3 ×
46 cm
National Maritime Museum, London,
inv. PAF4621

70
British, 1759
The Grand Fair at Versailles, or France in a
Consternation
Etching with a few burin retouches,
20 × 31.1 cm
The British Museum, London,
inv. P&D 1868-8-8-4122

71 (fig. 89)
British, 1759
The French King in a Sweat or the Paris Coiners
Etching with a few burin retouches,
19.7 × 34.2 cm
The British Museum, London,
inv. P&D 1868-8-8-4122

72
British, 1762
The Political Brokers or An Auction à la mode de
Paris
Etching with a few burin retouches,
23.4 × 35 cm
The British Museum, London,
inv. P&D 1868-8-8-4263

73 (fig. 77)
Jacques Guay (1711–1797)
The Alliance of France and Austria, 1756
Onyx cameo, 3.5 × 2.9 cm
Bibliothèque Nationale de France, Paris,
inv. RCA 10 6 18

74
Jacques Guay (1711–1797)
The Birth of the Duc de Bourgogne, 1751
Agate cameo coloured red on the reverse,
3.7 × 2.9 cm
Bibliothèque Nationale de France, Paris,
inv. RCA 2502 [74]

75 (fig. 101)
Jean-Baptiste Greuze (1725–1805)
Simplicity, probably 1759
Oil on canvas, 71.1 × 59.7 cm
Kimbell Art Museum, Fort Worth, TS
inv. AP 1985.03

76 (fig. 99)
Jean-Siméon Chardin, (1699–1779)
The Kitchen Boy, about 1736–8
Oil on canvas, 46 × 38 cm
Private collection

77 (fig. 103)
Carle Vanloo (1705–1765)
The Arts imploring the Fates to spare Madame de
Pompadour, 1764
Oil on canvas, 80.6 × 67.5 cm
The Frick Art and Historical Center,
Pittsburgh, PA, inv. 1970.32

78 (fig. 102)
François-Hubert Drouais (1727–1775)
Madame de Pompadour with a Fur Muff, 1763
Oil on canvas, 63.5 × 53 cm
Musée des Beaux-Arts d'Orléans, inv. 385

79 (fig. 96)
François-Hubert Drouais (1727–1775)
Madame de Pompadour at her Tambour Frame,
1763–4
Oil on canvas, 217 × 156.8 cm
National Gallery, London, inv. NG6440

80
Augustin de Saint-Aubin (1736–1807) after
Charles-Nicolas Cochin (1715–1790)
Madame de Pompadour in Profile, 1764
Etching and engraving, 24.6 × 16.7 cm
Musée National des Châteaux de Versailles et
de Trianon, Versailles, inv. LP70/683

81
Étienne Fessard (1714–1777) and Augustin de
Saint-Aubin (1736–1807) after Christophe
Huet (1700–1759)
Fidelity, Portrait of Inès, 1755–6
Etching and engraving, 23.1 × 29.1 cm
Private collection

82
Étienne Fessard (1714–1777) after Christophe
Huet (1700–1759)
Constancy, Portrait of Mimi, 1758
Etching and engraving, 23.1 × 29.1 cm
Private collection

83 (fig. 62)
Gabriel Le Rouge (active mid-eighteenth
century) after Ange-Jacques Gabriel
(1698–1782)
View of a Project for the École Royale Militaire,
about 1755
Engraving, 52 × 60 cm
The British Library, London,
inv. Maps K.Top 65.18-c

84 (fig. 16)
Louis Tocqué (1696–1772)
Abel-François Poisson, Marquis de Marigny, 1755
Oil on canvas, 135 × 104 cm
Musée National des Châteaux de Versailles et
de Trianon, Versailles, inv. MV 3776

85 (fig. 94)
Sèvres vase with a concealed statue of Louis
XV, about 1763
Soft-paste porcelain, gilt bronze, silver and
gold, 27.6 × 18.2 × 15.1 cm closed,
30.2 × 18.2 × 15.1 cm open
Gift of J. Pierpont Morgan, The Wadsworth
Atheneum Museum of Art, Hartford, CT,
inv. 1917.1065

86 (fig. 92)
William Chambers (1723–1796)
*View of the Place de Louis XV, with Bouchardon's
Statue of Louis XV*, 1774
Pen with blue and grey washes,
21.6 × 36.2 cm,
RIBA Library: Drawings Collection, Royal
Institute of British Architects, London,
inv. SD 2/13

87 (fig. 95)
Louis-Jacques Cathelin (1739–1804)
after Jean-Michel Moreau (1741–1814)
The Equestrian Statue of Louis XV, probably 1763
Etching and engraving, 68.6 × 50.8 cm
The Victoria and Albert Museum, London,
inv. PDP:27347

88 (fig. 93)
Louis-Claude Vassé (1716–1772)
after Edmé Bouchardon (1698–1762)
Louis XV on Horseback, after 1761
Bronze, 67 × 60 cm
The Royal Collection, Buckingham Palace,
London, inv. RCIN 2128

89 (fig. 104)
François-Hubert Drouais (1727–1775)
Marie-Jeanne Bécu, Madame du Barry, probably
1770
Oil on canvas, 71.1 × 59.3 cm
Timken Collection, National Gallery of Art,
Washington, DC, inv. 1960.6.9

Bibliography

PRIMARY SOURCES

Almanach Royal

Argenson, René-Louis de Voyer de Paulmy, marquis d', *Journal et mémoires*, ed. J.B. Rathery, 9 vols., Paris 1859–67

[Bachaumont, Louis Petit de], *Mémoires secrets pour servir à l'histoire de la République des Lettres en France*, 36 vols., London 1762–89

Barbier, E.F.J., *Journal historique et anecdotique du règne de Louis XV*, ed. A. de la Villegille, 4 vols., Paris 1857–64

Bernis, François-Joachim de Pierre, Cardinal de, *Mémoires*, eds. J.M. Rouart and P. Bonnet, Paris 1986

[Brantôme], *Oeuvres complètes de Pierre de Bourdeille, seigneur de Brantôme*, 9 vols., Paris 1864–82

Correspondance de M. de Marigny avec Coypel, Lépicié et Cochin, ed. M. Furcy-Raynaud, *Nouvelles Archives de l'Art français*, XIX, Paris 1903 and XX, Paris 1904

Correspondance secrète du comte de Broglie avec Louis XV, eds. M. Antoine and D. Ozanam, Paris 1956

Catalogue des livres de la bibliothèque de feue Madame la marquise de Pompadour, Paris 1765

Catalogue des tableaux originaux de différents maîtres, miniatures, dessins et estampes sous verre de feue Madame la Marquise de Pompadour, Paris 1766

Catt, Heinrich de, *Unterhaltungen mit Friedrich dem Grossen. Memoiren und Tagebücher*, Leipzig 1884

[Chevigny], *La Science des personnes de la cour, d'épée et de robe*, new edn., 8 vols., Paris 1752

Choiseul, duc de, *Mémoires*, eds. J.P. Guicciardi and P. Bonnet, Paris 1987

Collé, Charles, *Journal et mémoires, 1748–72*, ed. H. Bonhomme, Paris 1868

Contrat de mariage de la marquise de Pompadour 4 mars 1741, ed. vicomte de Grouchy, *Bulletin de la Société de l'histoire de Paris et de l'Île-de-France*, 1890

Croÿ, Emmanuel, duc de, *Journal inédit*, eds. vicomte de Grouchy and P. Cottin, 4 vols., Paris 1906–07

Diderot, Denis, *Salons*, eds. J. Seznec and J. Adhémar, 2nd edn., 3 vols., Paris 1975–83

[Diderot, D. and Alembert, J. de, eds.] *Encyclopédie, ou Dictionnaire raisonné des sciences, des arts et des métiers, par une société de gens de lettres*, 17 vols., Oxford 1751–72

Du Deffand, Madame, *Correspondance complète*, ed. M. de Lescure, 2 vols., Paris 1867

Du Hausset, Nicole, Madame, *Mémoires sur Louis XV et Madame de Pompadour* ed. J.P. Guiccardi, Paris 1985

Dufort de Cheverny, *Mémoires*, ed. P.A. Weber, 2 vols., Paris 1969

Cochin, Charles-Nicolas, *Mémoires inédites de Charles-Nicolas Cochin sur le comte de Caylus, Bouchardon, les Slodtz*, ed. C. Henry, Paris 1880

Galland, A. *Les Mille et Une Nuits*, 11 vols., 1704–17

Grimm, F.M., *Correspondance littéraire, philosophique et critique par Grimm, Diderot, Raynal, Meister, etc*, ed. M. Tourneux, 16 vols., Paris 1878

Inventaire des biens de Madame de Pompadour, rédigé après son décès, ed. J. Cordey, Paris 1939

'Journal de police sous Louis XV 1742–3', in Barbier, E.J.F., *Chronique de la Régence et du règne de Louis XV 1718–63*, 8 vols., Paris 1857–66

Kaunitz, A.W. von, *Correspondance secrète entre A.W. von Kaunitz et le baron Ignaz de Koch*, ed. H. Schlitter, Paris 1899

Lettres de Madame de Pompadour à Choiseul, ambassadeur à Rome, 1754–7, ed. de Piépape, Versailles 1917

Livre-journal de Lazare Duvaux, marchand bijoutier extraordinaire du roi, 1748–58, ed. L. Courajod, Paris 1873

Luynes, Charles-Philippe Albert, duc de, *Mémoires sur la cour de Louis XV, 1735–58*, eds. L. Dussieux and E. Soulié, 17 vols., Paris 1860–5

Malassis, M.A.P. ed., *Correspondance de Madame de Pompadour*, Paris 1888

Marais, Mathieu, *Journal et mémoires sur la Régence et le règne de Louis XV 1715–32*, 4 vols., Paris 1863–8

Marville, Feydeau de, *Lettres de M. de Marville au ministre Maurepas*, ed. A. de Boislisle, 3 vols., Paris 1896

Mehmed Efendi, *Le Paradis des infidèles. Un ambassadeur ottoman en France sous la Régence*, Paris 1981

Mercier, Louis-Sébastien, *Le Tableau de Paris*, 12 vols., Amsterdam 1782–8

Narbonne, Pierre, *Journal des règnes de Louis XIV et Louis XV de l'année 1701 à l'année 1744*, Paris 1866

[Richelieu], *Nouveaux Mémoires du maréchal duc de Richelieu, 1696–1788*, ed. M. de Lescure, 3 vols., Paris 1869

Recueil Clairambault-Maurepas: Chansonnier historique du XVIIIe siècle, ed. E. Raunié, . 8 vols., Paris 1879

[Soulavie, G.], *Mémoires historiques et politiques du règne de Louis XVI*, Paris 1902

Teleki, Joseph, *La Cour de Louis XV. Journal de voyage du comte Joseph Teleki*, ed. G. Tolnai, Paris 1943

Toussaint, François-Vincent, *Anecdotes curieuses de la cour de France sous le règne de Louis XV*, ed. P. Fould, Paris 1908

Voltaire, *Correspondance*, ed. T. Besterman, 51 vols., Oxford 1968–77

SECONDARY SOURCES

Ananoff, A. and Wildenstein, D., *François Boucher*, Lausanne 1976

Antoine, M., *Le Conseil du roi sous le règne de Louis XV*, Paris 1970

Antoine, M., *Le Dur Métier du roi. Études sur la civilisation politique de la France d'Ancien Régime*, Paris 1986

Antoine, M., *Louis XV*, Paris 1989

Argenson, marquis d', *Autour d'un ministre de Louis XV. Lettres intimes inédites*, Paris 1923

Arminjon, A., *Madame de Pompadour et la floraison des arts*, Montreal 1988

Art and Culture in the Eighteenth Century: New Dimensions and Multiple Perspectives, ed. E.Goodman, Newark, Delaware and London 2001

Baillio, J., 'Les Portraits du dauphin et de la dauphine par Greuze', *Gazette des Beaux-Arts*, 122, 1993

Bajou, T., 'Le Portrait de madame de Pompadour vers 1760: un nouveau Carle Van Loo à Versailles', *Revue du Louvre*, 43, 1995

Berg, M., 'French fancy and cool Britannia: the fashion markets of early modern Europe', *Proceedings of the Istituto internazionale di storia economica F. Datini*, Prato 2000.

Besnard, A. and Wildenstein, G., *La Tour: la vie et l'œuvre de l'artiste*, Paris 1928

Bloch, M., *The Royal Touch: Sacred Monarchy and Scrofula in England and France*, London 1974

Bonhomme, M., *Madame de Pompadour, général d'armée*, Paris 1880

Brunel, G., *Boucher*, London 1986

Bryson, N., *Word and Image. French Painting of the Ancien Régime*, Cambridge 1981

Burke, P., *The Fabrication of Louis XIV*, New Haven, CT 1992

Bussières, G., *Madame de Pompadour et le contrôleur général Bertin, 1759–63*, Paris 1908

Butler, R., *Choiseul, Father and Son*, Oxford 1980

Campardon, E., *Madame de Pompadour et la cour de Louis XV*, Paris 1867

Chastel, A., *L'Art français. L'Ancien Régime 1620–1775*, Paris 1995

Chaussinand-Nogaret, G., *La Vie quotidienne des femmes du Roi*, Paris 1990

Cleary, R.L., *The Place Royale and Urban Design in the Ancien Régime*, New York 1999

Clements, C., 'The duc d'Antin, the royal administration of pictures and the painting competition of 1727', *Art Bulletin*, 76, 1996

Combeau, Y., *Le Comte d'Argenson, ministre de Louis XV*, Paris 1999

Conisbee, P., *Painting in Eighteenth-Century France*, Ithaca, NY 1981

Coquery, N., *L'Hôtel aristocratique: le marché du luxe à Paris au XVIIIe siècle*, Paris 1998

Cosandey, F., *La Reine de France: symbole et pouvoir, XVe – XVIIIe siècle*, Paris 2000

Crosland, M., *Madame de Pompadour: Sex, Culture and Power*, London 2000

Crow, T., *Painters and Public Life in Eighteenth-Century Paris*, New Haven, CT 1985

Crow, T., 'La Critique des Lumières dans l'art du XVIIIe siècle', *Revue de l'Art*, 73, 1986

Cuno, J. ed., *French Caricature and the French Revolution, 1789–99*, Berkeley, California 1989

Darnton, R., 'An early information society: news and media in eighteenth-century Paris', *American Historical Review*, 105, 2000

Duby, G. and Perrot, M., *Histoire des femmes. iii. XVIe – XVIIIe siècles*, Paris 1991

Durand, Y., *Les Fermiers généraux au XVIIIe siècle*, Paris 1996

Dziembowski, E., *Un Nouveau Patriotisme français, 1750–70: la France face à la puissance anglaise à l'époque de la guerre de Sept Ans*, Oxford 1998

Egret, J., *Louis XV et l'opposition parlementaire, 1715–70*, Paris 1970

Farge, A. and Revel, J., *The Vanishing Children of Paris: Rumor and Politics before the French Revolution*, Cambridge, Massachusetts 1991

Félix, J., *Finances et politique au siècle des Lumières. Le ministère Laverdy, 1763–8*, Paris 1999

Fennebresque, J., 'L'Hermitage de madame de Pompadour', *Revue de l'histoire de Versailles et de Seine-et-Oise*, 1901

Flammermont, J. de, *Correspondance des agents diplomatiques étrangers en France avant la Révolution*, Paris 1894

François Boucher, 1703–72, Paris 1986

Fried, M., *Absorption and Theatricality: Painting and the Beholder in the Age of Diderot*, Chicago 1980

Fromageot, P., 'L'Enfance de Madame de Pompadour', *Revue de l'histoire de Versailles et Seine-et-Oise*, 4, 1902

Fromageot, P., 'La Mort et les obsèques de Madame de Pompadour', *Revue de l'histoire de Versailles et Seine-et-Oise*, 4, 1902

Gaborit, J.R., *Jean-Baptiste Pigalle, 1714–85*, Paris 1985

Gallet, D., *Versailles. Catalogue des dessins d'architecture*, Paris 1983

Gallet, D., *Madame de Pompadour ou le pouvoir féminin*, Paris 1985

Gallet, D., 'Madame de Pompadour et l'appartement d'en bas du château de Versailles', *Gazette des Beaux-Arts*, 118, 1991

Gallet, M., *Paris Domestic Architecture of the Eighteenth Century*, London 1972

Goncourt, E. and J., *Madame de Pompadour*, Paris 1899

Goodman, D., *The Republic of Letters. A Cultural History of the French Enlightenment*, Ithaca , NY 1994

Goodman, E., *The Portraits of Madame de Pompadour: Celebrating the Femme Savante*, Berkeley, California 2000

Goodman-Soellner, E., 'Boucher's Madame de Pompadour at her toilette', *Simiolus*, 27, 1987

Goodman-Soellner, E. and Seifert, S., 'Madame de Pompadour zwischen Kojotterie und Frömmigkeit', *Kritische Berichte: Weiblichkeitsentwürfe in der Kunst um 1700*, 24, 1996

Gordon, A. and Hensick, T., 'The picture within the picture: Boucher's 1750 portrait of Madame de Pompadour identified.' *Apollo*, 480, 2002

Gordon, K.K., 'Madame de Pompadour, Pigalle and the iconography of friendship', *Art Bulletin*, 50, 1968

Haase-Dubosc, D. and Viennot, E., eds., *Femmes et pouvoirs sous l'Ancien Régime*, Paris 1991

Hanley, S., 'Engendering the state: family formation and state building in early modern France', *French Historical Studies*, 16, 1989

Hohenzollern, J.G. prinz von, 'Die Porträts der Marquise de Baglion und der Marquise de Pompadour', *Pantheon*, 4, 1972

Hyde, M., 'The "Make-Up" of the marquise: Boucher's portrait of Pompadour at her toilette', *Art Bulletin*, 82, 2000

Hyde, M., 'Confounding conventions: gender ambiguity and François Boucher's painted pastorals', *Eighteenth-Century Studies*, 30, 1996

Intimate Encounters. Love and Domesticity in Eighteenth-Century France, R. Rand, Princeton, NJ 1997

Jean-Richard, P., *L'Oeuvre gravée de François Boucher dans la collection Edmond de Rothschild*, Paris 1978

Jones, C. *The Great Nation: France from Louis XV to Napoleon, 1715–99*, Harmondsworth, 2002

Jullien, A., *La Comédie à la cour: les théâtres de société royale pendant le dernier siècle*, Paris 1883

Kaiser, T., 'Madame de Pompadour and the theaters of power', *French Historical Studies*, 9, 1996

Kaiser, T., 'Louis the Bien-Aimé and the rhetoric of the royal body', in *From the Royal to the Republican Body: Incorporating the Political in Seventeenth- and Eighteenth-Century France* eds. S.E. Melzer and K. Norberg , Berkeley, California 1998

Kavanagh, T., *Esthetics of the Moment and Art in the French Enlightenment*, Philadelphia 1996

Kimball, F., 'The Beginnings of the Style Pompadour, 1751–9', *Gazette des Beaux-Arts*, 96, 1954

La Fizelière, R. de, 'L'Art et les femmes en France: Madame de Pompadour', *Gazette des Beaux-Arts*, 2, 1859, 1860

Laing, A., *François Boucher*, New York 1986

Laing, A., 'Boucher et la pastorale peinte', *Revue de l'Art*, 73, 1986

Lajer-Burcharth, E., 'Pompadour's touch: difference in representation', *Representations*, 73, 2001

Landes, J., *Women and the Public Sphere in the Age of the French Revolution*, Ithaca, NY 1988

Langlois, R.M., *L'Ermitage de Madame de Pompadour*, 1947

Laulan, R., 'La Fondation de l'École militaire et Madame de Pompadour', *Revue d'histoire moderne et contemporaine*, 19, 1974

Lechevalier-Chevignard, G., *Sèvres*, Paris 1908

Leith, J., *The Idea of Art as Propaganda in France, 1750–99*, Toronto 1965

Le Roy, A., 'Relevé des dépenses de Madame de Pompadour depuis la première année de sa faveur', *Mémoires de la Société des Sciences morales, des lettres et des arts de Seine-et-Oise*, 3, 1853

Leroy, A., 'The Portraits of Madame de Pompadour', *Connaisseur*, 103, June 1939

Les Français vus par eux-mêmes. Le XVIIIe siècle. Anthologie des mémorialistes du XVIIIe siècle, eds. A. de Maurepas and F. Brayard, Paris 1996

Leturcq, J.F., *Documents inédits de Guay et note sur les œuvres de gravure en taille douce et en pierres fines de la marquise de Pompadour*, Paris 1873

Lever, E., *Madame de Pompadour*, Paris 2000

Levey, M., *Painting and Sculpture in France, 1700–89*, London 1993

Levron, J., *Madame de Pompadour. L'Amour et la politique*, Paris 1975

Lipton, E., 'Women, pleasure and painting. e.g. Boucher', *Genders*, 7, 1990

Lossky, B., 'L'Apollon et Issé dans l'oeuvre de François Boucher', *Gazette des Beaux-Arts*, 96, 1954

Lougee, C., *Le Paradis des femmes: Women, Salons and Social Stratification in Seventeenth-Century France*, Princeton, NJ 1977

Louis XV: un moment de perfection de l'art français, Paris 1974

McAllister Johnson, W., 'Boucher, Cochon fils et la vogue des pantins', *Nouvelles de l'estampe*, 153, 1997

McClellan, A., *Inventing the Louvre: Art, Politics and the Origins of the Modern Museum in Eighteenth-Century Paris*, Cambridge 1994

McClellan, A., 'Watteau's Dealer: Gersaint and the marketing of art in eighteenth-century Paris', *Art Bulletin*, 78, 1996

McClellan, A., 'The Life and Death of a Royal Monument: Bouchardon's *Louis XV*', *Oxford Art Journal*, 23, 2000

Madame de Pompadour et les arts, ed. Xavier Salmon, Paris 2002

Marquiset, A., *Le Marquis de Marigny*, Paris 1918

Maza, S., *Private Lives and Public Affairs: The Causes Célèbres of Pre-Revolutionary France*, Berkeley, California 1993

Michel, A., *François Boucher*, Paris 1906

Michel, C., *Charles-Nicolas Cochin et l'art des Lumières*, Rome 1993

Michel, C., 'Les Conflit entre les artistes et le public des salons dans la France de Louis XV', in *Traditions et innovations dans la société française du XVIIIe siècle. Bulletin de l'Association des historiens modernistes des universités*, Paris 1995

Mitford, N., *Madame de Pompadour*, London 1954

Newton, W.R., *L'Espace du Roi: la Cour de France au château de Versailles. 1682–1789*, Paris 2000

Nicholason, K., 'The ideology of female "virtue": the vestal virgin in French eighteenth-century allegorical portraiture', in *Portraiture, Facing the Subject*, ed. J. Woodall, Manchester 1997

Nolhac, P. de, *Louis XV et Marie Leszczinska*, Paris 1900

Nolhac, P. de, *Louis XV et Madame de Pompadour*, 2 vols., Paris 1903

Nolhac, P. de, *Le Château de Versailles sous Louis XV*, Paris 1898

Nolhac, P. de, *Boucher, Premier Peintre du Roi*, Paris 1925

Nolhac, P. de, *Nattier, peintre de la cour de Louis XV*, Paris 1925

Nolhac, P. de, *Madame de Pompadour et la politique*, Paris 1928

Perrot, P., *Le corps féminin: le travail des apparences XVIIIe – XIXe siècle*, Paris 1984

Persan, M. de, 'Madame de Pompadour, Bernis et la Guerre de Sept Ans', *Revue de l'histoire de Versailles et de Seine-et-Oise*, 1919–20

Posner, D., 'Madame de Pompadour as a patron of the visual arts', *Art Bulletin*, 82, 1990

Quétel, C., *La Bastille. Histoire vraie d'une prison légendaire*, Paris 1989

Rand, E., 'Depoliticizing women: female agency and the French Revolution and the art of Boucher and David', *Genders*, 7, 1990

Réau, L., 'Carle Van Loo', *Archives de l'Art Français*, 1938

Rétat, P., *L'Attentat de Damiens: discours sur l'événement au XVIIIe siècle*, Lyon 1979

Ribeiro, A., *Dress in Eighteenth-Century Europe, 1715–89*, New York 1985

Ribeiro, A., *The Art of Dress: Fashion in England and France, 1750 to 1820*, London 1995

Roche, D., *La Culture des apparences. Une histoire du vêtement (XVIIe–XVIIIe siècles)*, Paris 1989

Rogister, J., *Louis XV and the Parlement of Paris 1737–55*, Cambridge, 1995

Rombouts, S., 'Art as propaganda in eighteenth-century France: the paradox of Edme Bouchardon's Louis XV', *Eighteenth-Century Studies*, 27, 1993–4

Rosenberg, P., *The Age of Louis XV: French Painting, 1710–74*, Toledo 1975

Sabatier, G., *Versailles, ou la figure du Roi*, Paris 1999

Saint-Girons, B., *Esthétiques du XVIIIe siècle: le modèle français*, Paris 1990

Salmon, X., *Jean-Marc Nattier*, Paris 1999

Savill, R., *The Wallace Collection Catalogue of Sèvres Porcelain*, 3 vols., London 1988

Scott, K., *The Rococo Interior*, London 2000

Ségur, P. de, *Le Royaume de la rue Saint-Honoré, Madame Geoffrin et sa fille*, Paris 1897

Shoolman Slatkin, R., *François Boucher in American Collections: 100 Drawings*, Washington, DC 1974

Solnon, J.F., *La Cour de France*, Paris 1987

Sonenscher, M., 'Fashion's Empire: trade and power in early eighteenth-century France', in *Luxury Trades and Consumerism in Ancien Régime Paris: Studies in the History of the Skilled Workforce*, eds. R. Fox and A. Turner, Aldershot 1998

Sorensen, H., 'Quelques meubles faits pour Madame de Pompadour à Bellevue', *Bulletin de la société de l'histoire français*, 1963

Stein, P., 'Madame de Pompadour and the harem imagery at Bellevue', *Gazette des Beaux-Arts*, 123, 1994

Stein, P., 'Amédée Van Loo's Costume turc: The French Sultana', *Art Bulletin*, 78, 1996

Steinbrügger, L. *The Moral Sex: Women's Nature in the French Enlightenment*, New York 1995

Swann, J., *Politics and the Parlement of Paris under Louis XV, 1754–74*, Cambridge 1995

Terrasson, J., *Madame de Pompadour et la création de la 'Porcelaine de France'*, Paris 1969

Thomas, C., *La Reine scélérate: Marie-Antoinette dans les pamphlets*, Paris 1989

Van Kley, D., *The Damiens Affair and the Unravelling of the Ancien Régime, 1750–70* Princeton, NJ 1984

Watson, F.J.B., 'Beckford, Madame de Pompadour, the duc de Bouillon and the taste for Japanese lacquer in eighteenth-century France', *Gazette des Beaux-Arts*, 111, 1963

Weisgerber, J., *Le Rococo, Baroque. Beaux-Arts et Littérature*, Paris 2001

Wilson, M., *French Paintings before 1800*, London 1985

Woodbridge, J.D., *Revolt in Pre-Revolutionary France: The Prince de Conti's Conspiracy against Louis XV, 1755–7*, Baltimore, Maryland 1995

Wrigley, R., *The Origins of French Art Criticism. From the Ancien Régime to the Restoration*, Oxford 1993

Photographic Credits

AMSTERDAM
© Rijksmuseum, Amsterdam: fig. 58

BALTIMORE, MD
© The Walters Art Museum, Baltimore, Maryland: fig. 66

BERLIN
Schloss Charlottenburg, Berlin-Brandenburg © Photo: Bildarchiv Preussischer Kulturbesitz.
Stiftung Preussischer Schlösser und Gärten: fig. 59

CAMBRIDGE, MA
Courtesy of the Fogg Art Museum, Harvard University Art Museums, Cambridge, Massachusetts
© President and Fellows of Harvard College, Harvard University: figs. 41 (detail on page 2), 43 (detail of fig. 41)

COUNTY DURHAM
© The Bowes Museum, Barnard Castle, Co. Durham: fig. 36

FLORENCE
Galleria degli Uffizi, Florence © Photo: SCALA, Florence: fig. 73

FONTAINEBLEAU
Châteaux de Malmaison et Bois-Préau © RMN, Paris. Photo Daniel Arnaudet: fig. 4

FORT WORTH, TX
© Kimbell Art Museum, Fort Worth, Texas: Photo: Michael Bodycomb: fig. 101

HARTFORD, CT
© Wadsworth Atheneum Museum of Art, Hartford, Connecticut: figs. 65, 94

LONDON
British Library © The British Library, London: fig. 62
British Museum © Copyright The British Museum, London: figs. 9, 89
Buckingham Palace, The Royal Collection © 2002, Her Majesty Queen Elizabeth II: fig. 93
National Army Museum © National Army Museum, London: figs. 27, 84, 85 (detail on page 123)
National Gallery © National Gallery, London: figs. 3, 96 (detail on page 11)
National Maritime Museum © National Maritime Museum, London: figs. 80, 87, 88, 91
Royal Institute of British Architects © Royal Institute of British Architects, London. Photo: A.C.Cooper: fig. 92
Victoria and Albert Museum © The Board of Trustees of the Victoria and Albert Museum, London: figs. 32, 49 (frontispiece on page 1), 67, 95
Wallace Collection © The Wallace Collection, London: figs. 5, 6, 33, 39, 57, 61

LOS ANGELES, CA
© The J. Paul Getty Museum, Los Angeles: fig. 50

LYON
© Musée des Beaux Arts de Lyon. Photo Studio Basset, Villeurbanne: fig. 72

MINNEAPOLIS, MN
© Minneapolis Institute of Art: fig. 74

MONTPELLIER
© Musée Fabre, Montpellier. Photo Frédéric Jaulmes: fig. 21

MONTREAL, CANADA
© Stewart Museum at the Fort Île Sainte-Hélène, Montreal, Quebec: fig. 40 (detail on page 9)

MUNICH
Alte Pinakothek © Bayerische Staatsgemäldesammlungen, Munich: fig. 70
Collection of the Bayerische Hypo- und Vereinsbank, Alte Pinakothek © Bayerische Staatsgemäldesammlungen, Munich: fig. 30

NEW YORK, NY
© Copyright The Frick Collection, New York: fig. 48
© The Metropolitan Museum of Art, New York: figs. 56 (detail on page 83), 69

ORLÉANS
© Musée des Beaux-Arts d'Orléans: fig. 102

OXFORD
© Copyright in this Photograph Reserved to the Ashmolean Museum, Oxford: fig. 86

PARIS
Bibliothèque Nationale © Bibliothèque Nationale de France, Paris: figs.13, 14, 44, 60, 77, 81, 97, 98
Musée du Louvre, Paris © RMN, Paris. Photo Daniel Arnaudet: figs. 22, 28, 47; Photo M.Beck/Coppola: fig. 24; Photo J.G.Berizzi: fig. 100; Photo Gérard Blot: fig. 29 (detail on page 57): Photo Hervé Lewandowski: fig. 35; Photo Le Mage: fig.15; Photo R.G.Ojeda: fig. 12

PITTSBURGH, PA
© The Frick Art & Historical Center, Pittsburgh, Pennsylvania: fig. 103

PRIVATE COLLECTION
© Photo: Christie's Images Ltd., London. Courtesy of the owner: fig. 68
© Photo: Courtesy of the owner: figs. 10, 23, 79, 99

ROUEN
© Musée des Beaux-Arts de Rouen: fig. 71

SACRAMENTO, CA
© Crocker Art Museum, Sacramento: fig. 17

SAINT PETERSBURG
© With permission from The State Hermitage Museum, Saint Petersburg: figs. 37, 38, 75 (detail on page 99)

SAINT-OMER
© Musée de l'Hôtel Sandelin, Saint-Omer: figs. 19

SAINT-QUENTIN
Musée Antoine Lécuyer © RMN, Paris. Photo Gérard Blot: fig. 2

SAN FRANCISCO, CA
© Fine Arts Museums of San Francisco: figs. 52, 53, 54, 55

SENLIS
© Musée de la Vénererie et des Spahis, Senlis. Photo Studio Mandin: fig. 11

TORONTO
© Gardiner Museum of Ceramic Art, Toronto: fig. 63

TOURS
© Musée des Beaux-Arts de Tours. Photo Atelier d'Antin/Patrick Boyer: fig. 26 (detail on page 35)

VERSAILLES
© Musée Lambinet, Versailles. Photo F. Doury: fig. 76
Musée National des Châteaux de Versailles et de Trianon © RMN, Paris: figs. 8, 31, 64; Photo Daniel Arnaudet: fig. 7; Gérard Blot: figs. 16, 20, 25, 90

WADDESDON
© Photographic Survey, Courtauld Institute of Art. Photo: Waddesdon, The Rothschild Collection (The National Trust): fig. 45
© Waddesdon, The Rothschild Collection (The National Trust). Photo: Mike Fear: figs. 34, 42, 46, 78, 82, 83
© Waddesdon Manor, The Rothschild Collection (Rothschild Family Trusts). Photo: Mike Fear: fig. 1

WASHINGTON, DC
© National Gallery of Art, Washington. Board of Trustees, Photograph 2002: figs. 18, 104

WINDSOR
The Royal Collection © 2002, Her Majesty Queen Elizabeth II: fig. 51

Index